D1423092

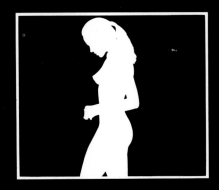

THE BOOK OF
NUDE
Photography

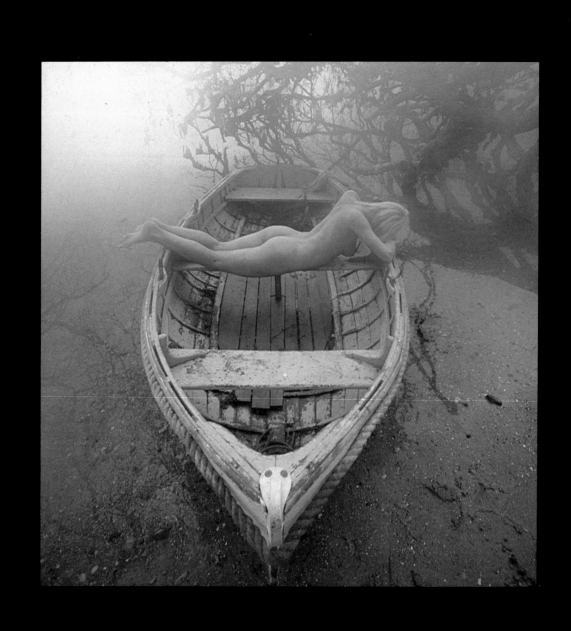

THE BOOK OF
NUDE
Photography

Text and photographs by

Michael Boys

EBURY PRESS

The Book of Nude Photography was
conceived, edited and designed by
Dorling Kindersley Limited,
9 Henrietta Street, London WC2

Project Editor
Tony Livesey
Art Editor
Steven Wooster
Managing Editor
Jackie Douglas
Art Director
Roger Bristow

Published by Ebury Press
Division of The National Magazine Company Ltd
Colquhoun House
27-37 Broadwick Street
London W1V 1FR

Second impression 1982
Third impression 1983
Fourth impression 1987

Copyright © 1981 by Dorling Kindersley Limited,
London
Text and photography copyright © 1981
by Michael Boys

ISBN 0 85223 208 X

Typesetting by MS Filmsetting, Frome, Somerset
Reproduction by F. E. Burman Limited, London
Printed and bound in Italy by A. Mondadori, Verona

Contents

Introduction

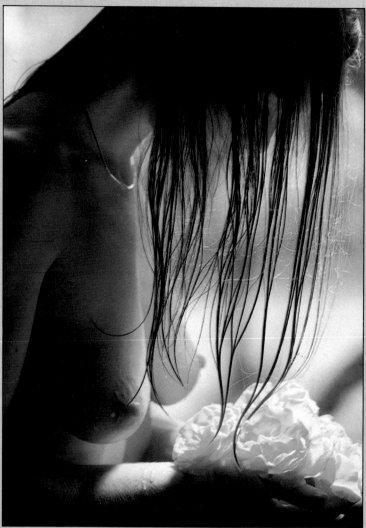

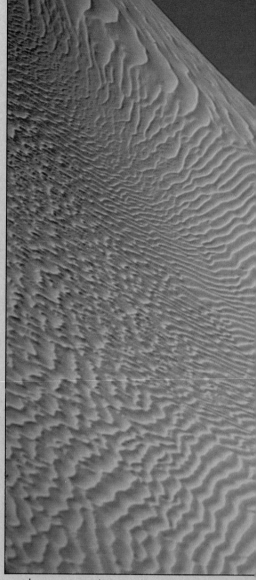

People are often nonplussed when you tell them that you are a photographer of the nude. They usually imagine that you take slightly pornographic pictures of girls as titillating objects for mens' magazines or pin-ups for newspapers. My nude photography is nothing like that. I come from a background of theatrical and decorating photography, and for many years after I had illustrated Mary Gilliatt's interiors book, *English Style*, I traveled extensively, photographing the homes of the rich or famous. I first started to photograph nudes as a simple outdoor antidote to this surfeit of interior oppulence.

The nude is a challenging form in photography. Questions of taste vie with the practical problems of execution to make one sometimes feel a sense of hopelessness, as if nothing worthwhile will ever be shot. Then, often suddenly, it all goes right, your faith is restored and you carry on with your task of making good pictures. That is what this book is about. It will show you every step along the way to making good nude pictures, from your first hesitant suspicion that you would like to try your hand at nude photography, through all the hard work to the possibility of exhibiting and even selling your successful pictures.

The technique of photography is, unfortunately, shrouded in the mystique of technology and expertise. To master basic photographic skills needs no more, but no less, application

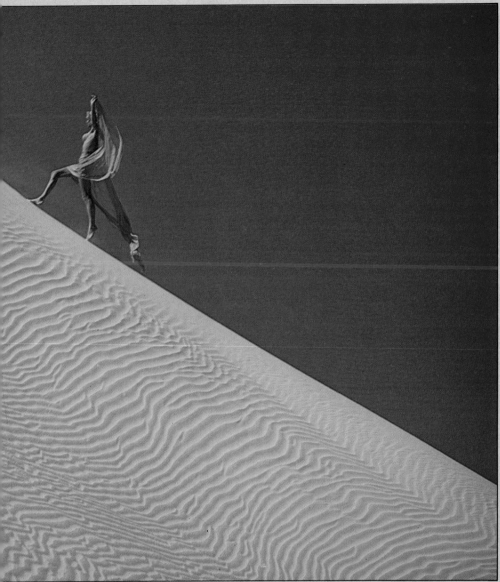

Adding artifice
In an exotic location, such as the desert (left), my contribution to a picture can be slight. Here I merely darkened the sky with a polarizing filter and tilted the camera to emphasize the slope of the dune. In the close-up (far left), however, which was taken indoors on a gray autumn day, touches of artifice became critical. The model's hair, wet by spray to form a pattern over the spotlit rose petals, is carefully arranged in front of a window with a garden view. By adding magenta and weak soft focus filters on the camera, I underlined the romantic atmosphere. *300mm, 1/250 sec. at f5.6, Kodachrome 25, polarizer (left); 50mm, 1/8 sec. at f8, Kodachrome 25, 10 CC magenta, soft filter (far left).*

than that necessary to acquire a knowledge of a foreign language or the command of a musical instrument. It certainly does not require expensive equipment or facilities; these, indeed, would prove a hindrance to a beginner, for his first task is to understand the assembly of simple images and what makes them work pictorially. Once he has an elementary grasp of this, the nude model is the ideal subject, for the undulating landscape of the human body can provide an unlimited range of pictures in both black and white and color.

This book does not gloss over the very real problem of finding good nude models with whom you can work, but we offer suggestions which may solve the problem. For example,

many of the pictures in this book were made with friends or contacts of mine who had never posed for a photographer before. I find the challenge of sensitively recording the atmosphere and mood of a model and her setting rewarding. I also enjoy the challenge of teaching a new model how to control the lines which her body and limbs can make on the finished picture, though working with a skilled model gives me freedom to explore untried styles and techniques of picture making. I personally, am therefore happy working with inexperienced models, because the pictures I enjoy making are more creative than those in the style which is now called "glamor" photography. This word has become debased by

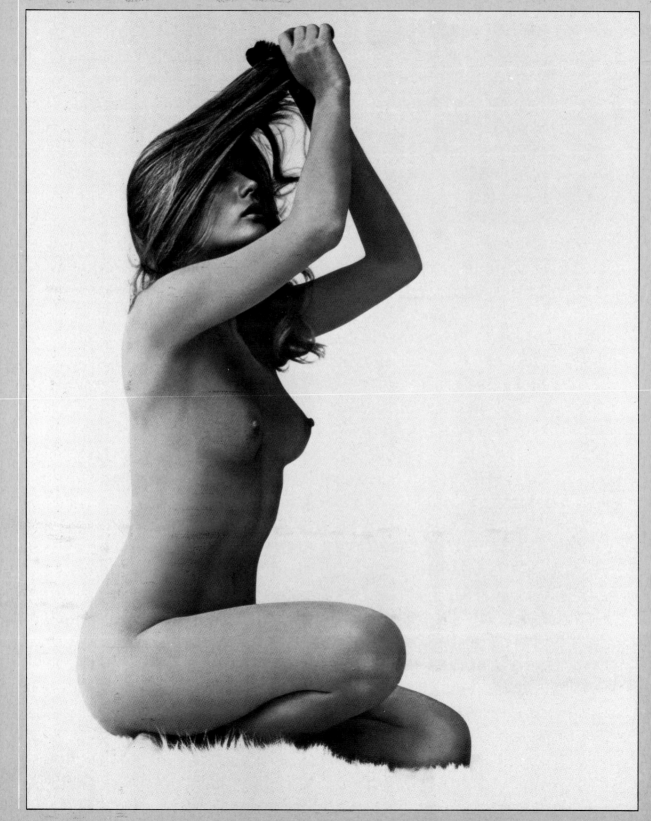

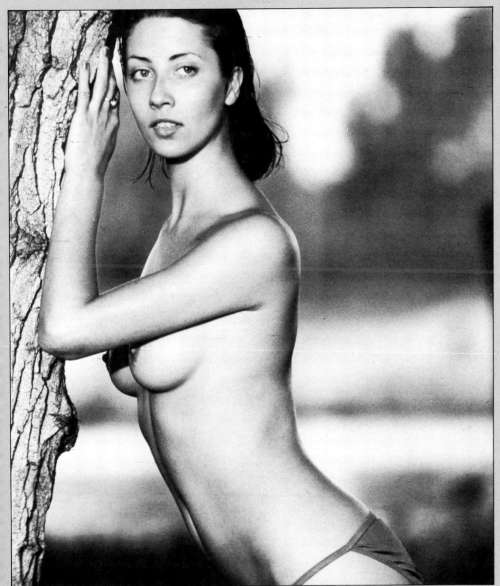

vacuous pictures in which the model's personality, intelligence and spirit have been smothered by formula elements of exclusive sexual relevance. I do not disparage overtly sexual pictures but I need more in my images.

The question of style in nude photography is complex. I believe that commercial success depends on working in a recognizably personal style. But once a style is established with the public, it can become a trap from which escape is difficult. Recognized photographers, such as David Hamilton and Sarah Moon, have not changed the basic feel of their pictures for more than a decade. If they did, I believe the public would feel cheated. Relatively few photographers are known to the public by name and

many of those that are seem to me to be imprisoned by the expectations of their public.

One exception is Sam Haskins, whose work I admire. His second book of nudes, *Cowboy Kate*, published in 1965, influenced me enormously and since then he has gathered a faithful army of supporters, as his pictures have changed and developed over the years. I am also very impressed with the dark, haunting pictures of Victor Skrebneski, the Chicago-based photographer. His rare nudes crop up from time to time and are always inspiring to me.

My inclination is toward retaining a basic personal style while experimenting when the opportunity arises. A further point about style is that it is important to make a clear distinction

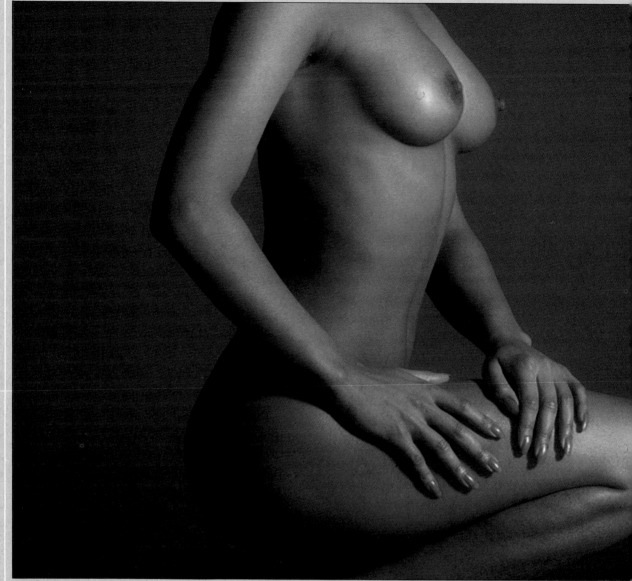

between imposed technical tricks and gim- micks and the personal philosophy which you seek to impose on your pictures.

The use of a soft-focus lens when photo- graphing pretty young blonde models does not alone constitute a style. Your esthetic point of view should come across to give different subjects a visual family relationship. This, of course, is easier to write about than to achieve but the pleasures of nude photography intensify as you begin to develop a recognizable "handwriting" in your pictures.

One cornerstone of my photographic philo- sophy was set in place at an early stage of my working life. I shared a darkroom on a small local weekly newspaper with an experienced

process engraver. He not only taught me to respect the separation of tones in my photo- graphs but also that while subtle, misty pictures can make lovely illustrations on a mantlepiece, more guts in the tones of a picture are needed if it is to survive mechanical reproduction on a fast-running printing press.

Another early, subliminal influence, which still affects me, came from the styles and attitudes of *Picture Post* magazine. This *Life*- style English black and white picture magazine of the post-war years used the pictures of talented reportage photographers like Kurt Hutton and Bert Hardy, who made honest but lively pictures. The famous Hutton action picture of two girls with their skirts caught by

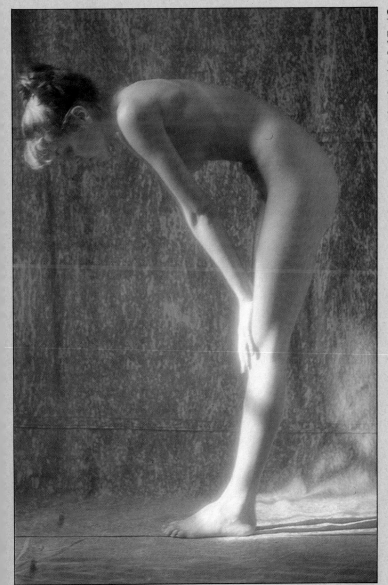

Changing the approach
The human body can be photographed in numberless ways. On the far left, for this depersonalized studio shot, I used clinically simple light from a heavily diffused plug-in flash. No intrusive elements of setting, atmosphere or color distract the eye from the perfection of the model's body. On the left, diffused direct sunlight created a sense of reality despite the painted studio background. I placed white reflector boards to prevent the shadow side of the figure becoming too dark, and by using a soft focus attachment on the lens I added subtlety to the image. *Bronica ETRC, 150 mm, 1/125 sec. at f11, Ektachrome 64, 81B (far left); 105 mm, 1/30 sec. at f5.6, Kodachrome 25, soft filter (left).*

oaster was high on sex lesty too. The image was his pictures have been ver since.

aphing nudes, I make g luscious food pictures d books. It is important, value of a variety of g life for I believe strict the full development

exceptionally challeng-ange. For the spare time follow my routine. For he, I have no reason to may be that I am fully

committed with other photography or that nobody is buying my nude pictures at that time. On these occasions, it is important to stock up ideas for nude pictures, to research and read about great photographers and to organize and exploit your existing pictures. Much more important, however, is to keep your imagination turned up to full sensitivity in order to detect the presence of that pure gold of our business – a potential model. Nor must you forget that without some good location ideas your newly found model is valueless. So even when otherwise engaged, part of my brain is plugged in to making nude pictures. Other photography provides a test for technical experiments and the trial of new materials

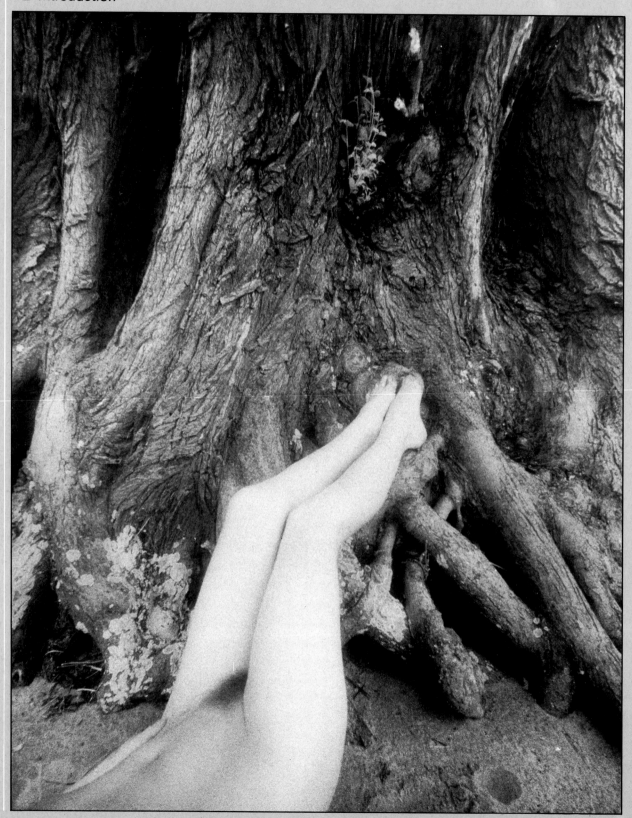

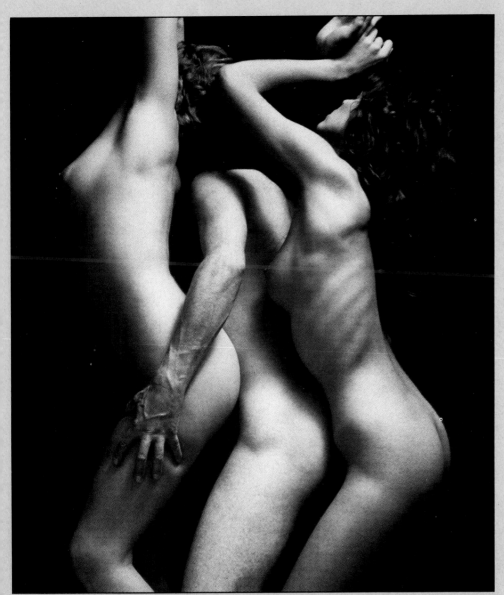

Extending the possibilities
Arresting images can be created by using materials and equipment that would superficially appear to be ill-suited to nude photography. The high speed infra-red film I used (far left) introduced an unfamiliar tonal range, while the distortion of the figure caused by my ultra wide-angle camera lens strengthened the abstract relationship between the model's legs and the tree trunk. In contrast, on the left, I used the simplest technical approach. A single plug-in flash bounced off a light-colored ceiling lit the intimate grouping. I composed the bodies tightly and concentrated on helping the models develop an intensely active mood, which kept the grouping from looking tentative. *15 mm, 1/125 sec. at f5.6, Kodak HIE (far left); 40–80 zoom, 1/125 sec. at f8, HP5 (left).*

which, if successful, will be stock-piled until my next nude picture session. Photographing the nude must be regarded as a pinnacle, so sharpen your wits and skills on other projects until you find an ideal nude subject.

In this book, I have always referred to models in the feminine gender for uniformity's sake. In the past I have only worked with women, but making pictures for this book has led me to shoot some pictures of men. I have not even scratched the surface of this subject yet but I am intrigued and I want to make more male nudes in the future. Likewise, I refer to photographers as male, but this is not meant to disparage female photographers, many of whom, such as Sarah Moon, are distinguished

professionals and rival men in imagination. It intrigues me how black and white nude work as powerful as Skrebneski's and that of Helmut Newton from Paris and many others like David Bailey and John Swannel, who work in London, seem to have so little impact on the style and content of girl pictures in mens' magazines. Clearly the sale of books like Bailey's song of praise for his wife's beauty, *Trouble and Strife*, must, in part, lie in the male buyer's interest in the erotic strength of the book. Sadly, however, the *Playboy*-style magazines seem to be stuck in another groove at the moment, repeatedly working over the same pictorial ground. I imagine they believe that the fantasy images they project rely for

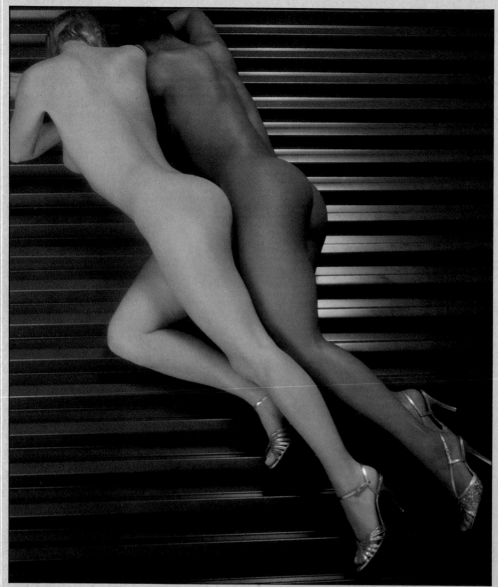

Classical rules
By exploiting texture,
contrast and pattern, within
a diagonal composition, I
created this grouping
in a studio setting, lit by a
single diffused plug-in flash.
Good photographs can
always be made by exploit-
ing the classical rules which
have guided painters for
many centuries. The design
qualities of the image are
enhanced by obscuring the
models' faces.
*Bronica ETRC, 1/125 sec. at
f11, Ektachrome 64, 81 B.*

success with the reader on believability and
the common touch, rather than the stronger
esthetic content which could be more effective.

I have not emphasized rare or expensive
equipment in this book, as good pictures can
usually be made with relatively inexpensive
cameras and lenses. My favorite camera is
the Nikon FTN, on which I made almost all the
pictures in this book. Where I have used a
different camera, it is mentioned in the techni-
cal details given under the captions. After the
Nikon, I prefer to use the Bronica ETRC, 6 × 4.5.
Both have automated exposure systems which
simplify the problems of inconsistent daylight.

It may be thought that some of the practical
advice and technical information in the book

implies an undue level of ignorance in the
reader. This is not intended. My aim has been
to allow for the uneven depth of knowledge
and experience in my readers, some of whom
may be approaching nude photography for
the first time.

Whether you are an experienced worker or a
beginner, the satisfaction that can be found in
nude photography reflects, in part, the aims
you set for yourself. Fulfilment, I believe, comes
from identifying an attainable pictorial goal,
preferably at the extremes of your ability.
Though your results may not always come up
to your expectations (nor do mine) you will at
least be extending your ability and better
pictures will be the eventual reward.

THE SIMPLE
APPROACH

The camera and the model

It is a common but mistaken belief that photographing the nude is a daunting process, exclusively the province of professionals in possession of expensive and complex equipment. This is far from the case. I took the photographs on these two pages by natural light and with a second-hand camera bought for the price of two rolls of film. Although the camera had no built-in meter or rangefinder, I was able to get these results by using new, fast, highly tolerant black and white film and by bracketing generously for exposure and distance. Similarly, the photographs on pages 18–30 were taken with a normal lens on my favorite Nikon FE, using only natural light.

For your first session of nude photography, try to use equipment with which you are familiar so that you can work confidently and give all your attention to your model and the composition of your picture. Any camera, preferably using 120 or 35 mm fast film so that you can shoot even with low light levels, can produce good results. The camera should have a normal-length focusing lens and, ideally, through-the-lens metering and a choice of speeds. Even these refinements are not essential, however.

Your chances of success will be greatly increased if you have a tripod and a cable release. The tripod is a valuable accessory, not only because it allows you to shoot at slow speeds but also because it enables you to leave the camera in a fixed position while you arrange the shot.

Finally, and perhaps most important of all after the camera, you should have a white reflector. Without this your pictures will contain too much contrast, with few intermediate tones, although this will not always be apparent when you view your composition through the viewfinder before shooting. The ideal reflector is at least as tall as the model and as wide as the span of your arms. Any white surface is suitable but expanded polystyrene, though inflammable, is perhaps best, although a white bedsheet can produce almost as good results. Do not be tempted at this stage to use lights; they are an added complication that you would be advised to leave until later.

The room in which you take your photographs must be private and warm. It need not be big but it should have a reasonably large window, preferably facing open sky, which you can cover with two thicknesses of either nylon net, tracing paper or white tissue paper to diffuse the light and soften shadows.

Despite having the right set-up, your pictures will be disappointing unless you have spent some time planning shots that will suit your model. Once you have found her (see p. 150), analyze her good and bad points and search for picture ideas that will emphasize the former and eliminate the latter (see Assessing a model p. 152, Sources of inspiration p. 148).

There is no point in embarking on nude photography until you have a clear idea in your mind of the sort of images you want to produce, but for your first session it is wise to stick to simple shapes that give you the chance to express the beauty of the body and not get involved with props. Nor should you begin shooting until you are fairly sure of what the pictures you are about to take will look like.

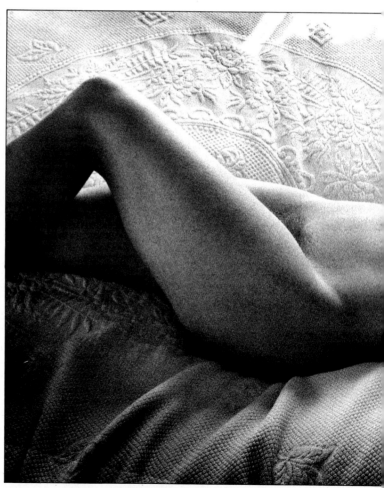

Shadow detail ▷
To make this shot against the light, I photographed through a hole cut in the middle of a white bedsheet. This created enough reflection to give good shadow detail.
Cosmic Symbol, 40 mm, 1/15 sec. at f8, XP1

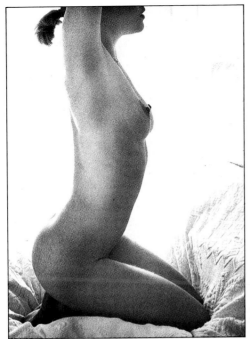

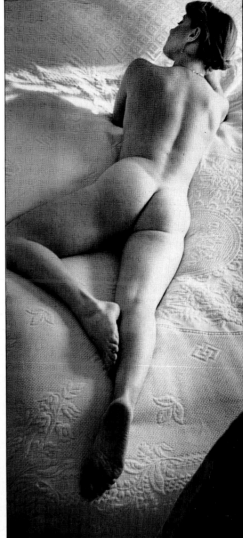

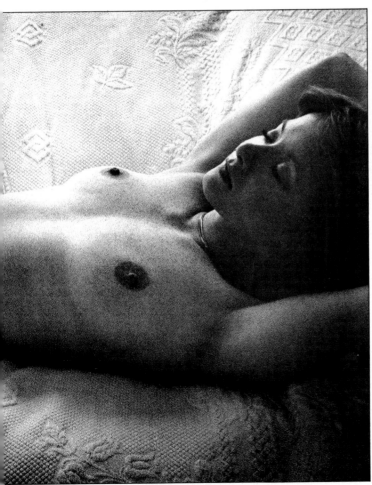

◁ **Enhancing texture**
Shooting against the light and processing the film in contrasty developer emphasized the texture of skin and fabric in this natural and relaxed composition.
Cosmic Symbol, 40 mm, 1/15 sec. at f8, XP1.

Diffused light △
A partially net-covered window produced a strong side light, with shadows filled in by a large white reflector. By lifting her head, the model enhanced the length of her neck and revealed her profile, which was essential to the mood of this shot.
Cosmic Symbol, 40 mm, 1/15 sec. at f16, XP1.

Shooting silhouettes

The realism and immediacy of photography make it easy to forget that a camera is a machine for recording lines, light and tone and that the final photograph is merely a sophisticated form of mechanical drawing. To take successful nude photographs, it is first necessary to master the skills of "drawing" – that is, the way in which you pose your model to record the lines of her body on the shot. The drawing of your photograph can be controlled by altering the relationship between the model and the camera. It is possible to shoot from a low level and lengthen the model's legs. Broadening the back or narrowing the waist is controlled by changing the shooting position or turning the model. While you are looking through the viewfinder visualize the scene in flat terms, as if drawn on a piece of paper. Try photographing silhouettes, where you have only the drawing to consider: there is no foreground tone, no expression, nothing else to control. However, you must remember that details such as the opening of the mouth also contribute to your message.

Unlike the human eye, which can adjust, the camera's inability to record differing light levels simultaneously enables you to achieve silhouettes easily. Just place the model in an unlit room against any window or door looking out on a daylit scene.

Adding pattern ▷
To give this silhouette image extra interest, an overall pattern was used to add depth by placing heavy netting between the camera and the model. The background was achieved by shooting the silhouette against a tracing paper-covered window looking out into a garden.
50 mm, 1/8 sec. at f4, Ektachrome 400 pushed 1 stop.

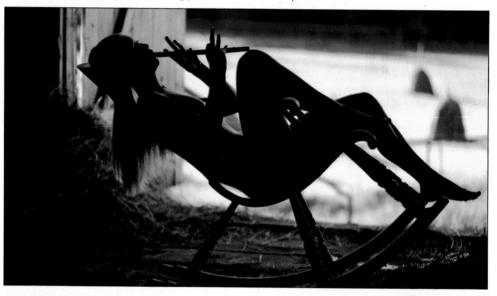

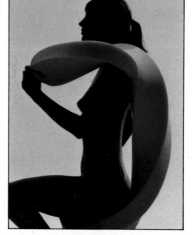

◁ Creating mood
The scene was set in a barn loft so that the outdoor elements appear at a distance. The doorway provided a framework for the composition and masked the backlighting from the camera to create a silhouette. The flute gave an inexperienced model the confidence to use her hands effectively and is in sympathy with the rocking chair and the mood of summer. The fall of long, blonde hair feminizes the image by adding soft texture to the stark silhouette.
50 mm, 1/125 sec. at f4, Kodachrome 25.

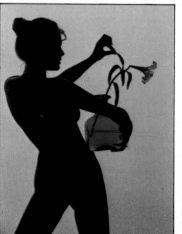

◁ Introducing graphic props
To produce this background, I covered a large window with tissue paper to diffuse the light (below). A translucent vase and a lily were introduced to enliven the simple design.
50 mm, 1/60 sec. at f4, Kodachrome 25, 10 CC magenta.

◁ Additional light
Tracing paper was placed against a background window but in this case modeling light was also provided by a skylight. In this way, parts of the plastic foam were highlighted to give meaning to its form, but the figure remained in sharp silhouette.
50 mm, 1/60 sec. at f4, Kodachrome 25, 10 CC green.

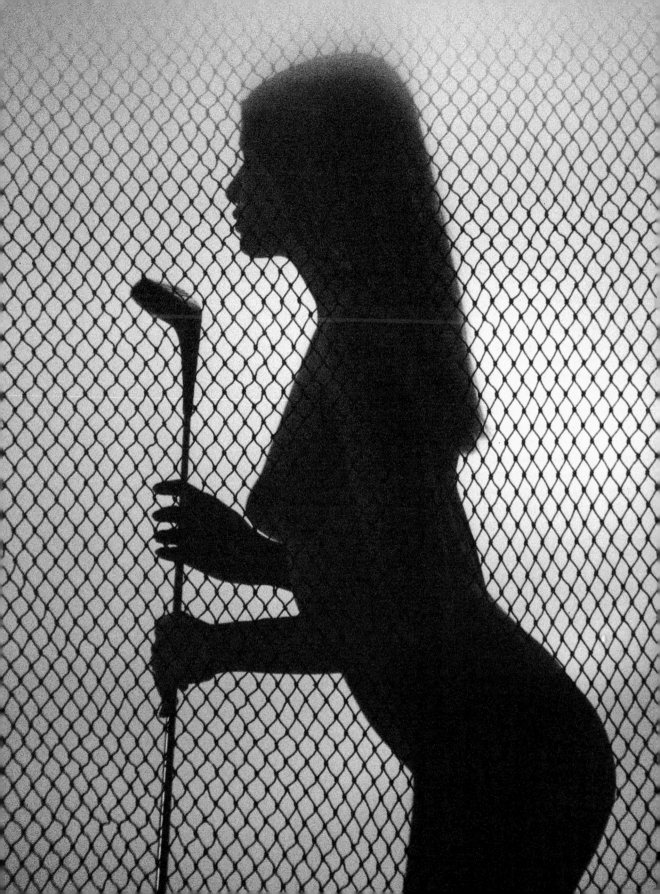

Beginning with backs

However well you know your model, you will probably both be shy at the beginning of the session and taking some simple back shots is a good way to break the ice. Shooting backs is also a useful exercise in controlling the drawing and introducing tone without the distraction of expression and sexuality.

Back shots need not be boring. Suggesting the right action can enable the camera to catch the model's mood and thoughts. A photograph can also succeed by stimulating the imagination, and with back shots the mood of the picture can be interpreted in your own way as you cannot see the model's eyes.

When shooting, soft light must fall on the back at an angle if you want to give the contours of the back gentle modeling; too strong a light acts aggressively to produce harsh skin quality. You are certain to need your reflector, either as the main source of soft, diffused light or to soften the shadows produced by direct light hitting the back. Pay particular attention to the shape of the hair on the drawing of the head and shoulders.

Camouflaging blemishes ▷
This shot, taken in clear, low sun, generously filled in with a white reflector, depends on slight under-exposure of the skin highlights to retain texture. The bamboo leaf masks a small skin blemish.
50 mm, 1/250 sec. at f8, Tri-X, 50 CC green.

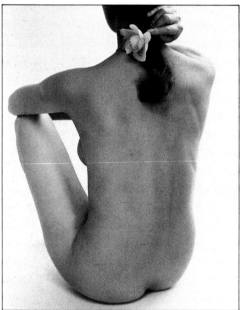

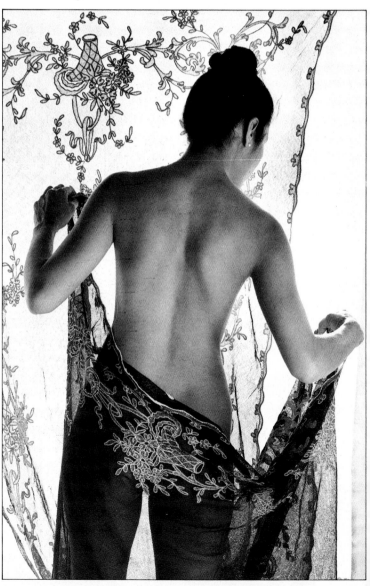

Wrap-around light △
Circumstances forced me to make this photograph in a cramped room with distracting, patterned furniture. To overcome these problems, I posed the model on a sheet of white cardboard with another to form a background. Two more sheets of white card were used to reflect daylight from a north-facing window and create a wrap-around of soft light.
50 mm, 1/30 sec. at f2, HP5.

Using props ▷
The composition (below) was created in front of a window covered with tracing paper and a delicate net curtain. The curtain was looped under the model's feet and held up against her back. To avoid a silhouette image, a large reflector provided fill-in light.
50 mm, 1/125 sec. at f5.6, FP4.

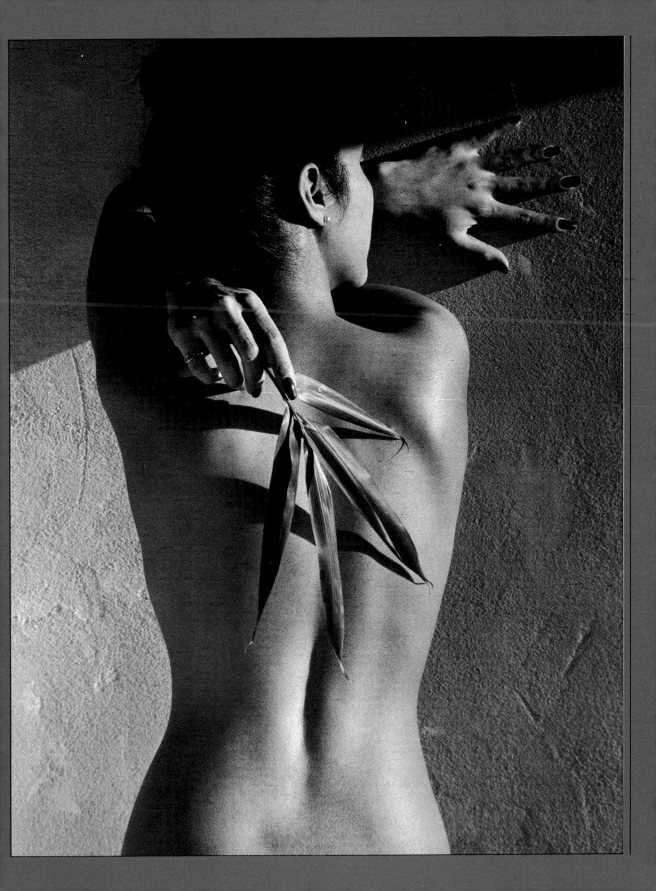

Discovering texture

Texture, or surface quality, is inherent in all subjects, whether rough or smooth. The ability to introduce this quality is vital in nude photography, for texture not only gives extra dimension to the flat photograph but can often provide a pictorial solution to dramatize and give life to an otherwise ordinary situation.

There are three main areas in nude photography where texture contributes: the skin of the model herself; added texture to the skin, and background texture. Wherever you are working you are surrounded by texture potential; all you need do is touch objects and learn to look about you for any interesting surfaces. The one crucial element in revealing textures is correct lighting. A simple experiment with a flashlight or desk lamp will show that the more obliquely the light falls on a surface the more intense the feeling of texture becomes. The rising and setting sun are the most obvious sources of this light, while noonday sun is the hard overhead light that is difficult to manipulate. When shooting, therefore, use soft but directional side lighting, which will leave the model's skin natural and attractive but will pick up the elements of texture.

The sense of touch ▷
Sidelight from a full-length window enhanced the soft feel of the soap on the body and also emphasized the contrast between the soap and skin and the abrasive wash glove.
50 mm, 1/50 sec. at f8, Kodachrome 25, 10 CC magenta.

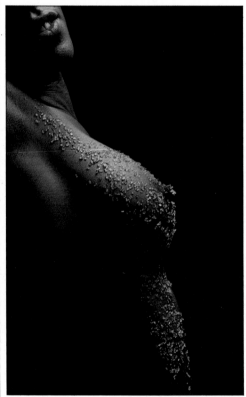

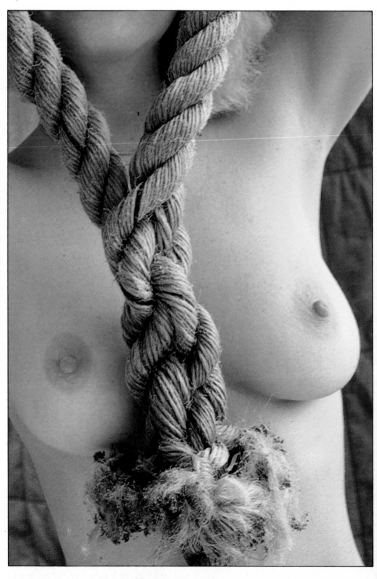

Applied texture △
By dampening the model with water, I got these sugar crystals to adhere to her skin. Needing a short exposure at small aperture to gain maximum depth of field without subject movement, I shot close to a sunlit window, which I liberally covered with net.
50 mm, 1/60 sec. at f11, Kodachrome 25, 81A

Contrasting textures ▷
The impact of the rough rope set against soft skin created a visual tension in this simple shot, which was set indoors and was sidelit by a window.
50 mm, 1/60 sec. at f5.6, Ektachrome 64, 81B.

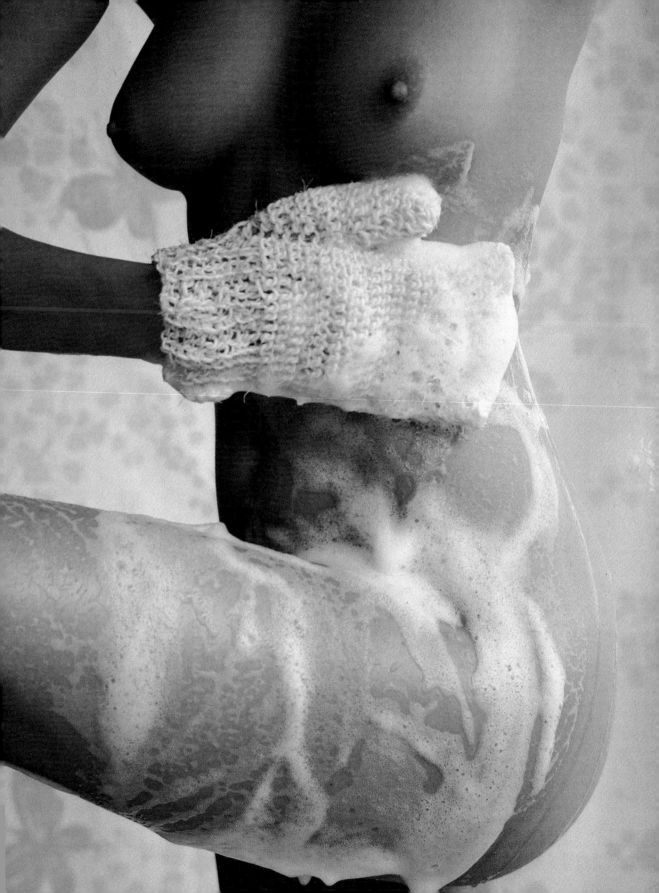

Pattern, the repetition of lines and shapes, can be either arranged or found and its inclusion in nude photography is a basic graphic device to enliven pictures and catch the viewer's interest. Pattern can be found almost everywhere, from urban environment to country scenes. Care must always be taken, however, for in nude photography it is usually a subsidiary feature and all too often can inadvertently overwhelm the principal subject.

In nude photography many opportunities for using pattern are formed by the situation and the play of light. For example, shadows cast by sunlight can, with the help of controlled fill-in from reflectors, dramatize an otherwise ordinary shot. Pattern falling subtly on skin will emphasize the body's curves and can also add a strong sense of mood. Shadow pattern, which implies the presence of the warming sun, can also be used to change the apparent time and place of shooting by avoiding give-away symbols of the winter season, like leafless trees, and in color shots by choosing a warming-up filter (81B) to take the chill out of the northern sun. When the light pattern covers the entire scene rather than the model alone, it creates drama and depth by accentuating perspective, making sumptuous settings unnecessary.

The eye naturally investigates patterned shapes and this can be exploited by using man-made pattern, such as slatted window blinds or fabrics which, if chosen with an eye to complementing the model, can emphasize the flow of her body and fill the frame with interest

without dominating the figure. Translucent fabrics are ideal in this respect, but it is easy to make patterned backgrounds yourself by painting on glass or nylon net, or by using cut-outs of colored acetate or paper. Then, using a hard, shadow-forming source of light, your chosen design can be projected across the model's body or the whole scene. If you prefer, the fabric can be backed with tracing paper and taped to a window background.

Deliberate pattern ▷
Late afternoon sunshine streaming through a full-length window created the perfect conditions for experimenting with shadow patterns. The shadow lines were created with thin strips of wood nailed on to a simple wooden frame (below). It was crucial that I shot during the few minutes when sunlight glanced obliquely across the wall.
50 mm, 1/125 sec. at f8, FP4.

Perspective from pattern ▷
Critical timing of the sun's position ensured the geometric regularity of shadows cast from vertical blinds. Perspective effect was created by choosing the moment when the central shadow lines pointed at the camera, and those to either side radiated outward.
50 mm, 1/125 sec. at f5.6, Kodachrome 25.

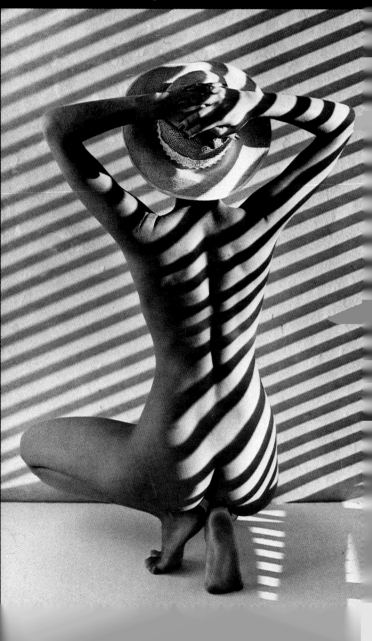

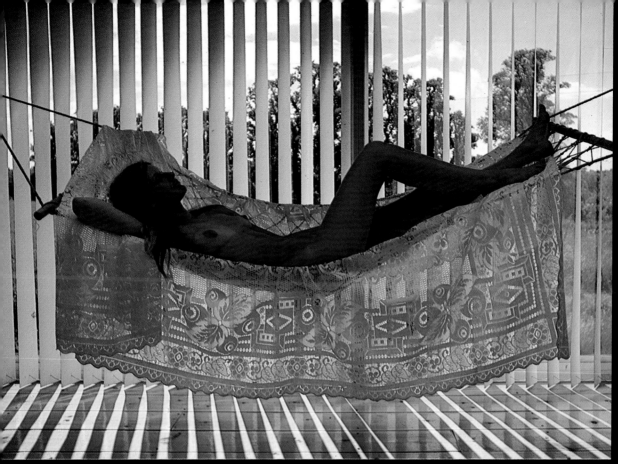

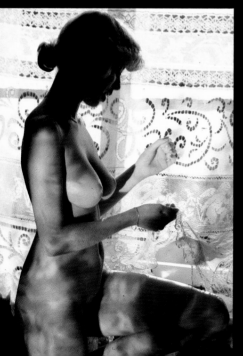

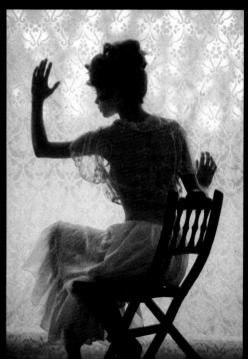

◁ **Projected pattern**
Sharp, low-angled sunlight patterns reflected from a large mirror transferred the background curtain design on to the figure as well as providing a fill-in light.
50 mm, 1/60 sec, at f5.6, Ektachrome 64.

Pattern from props ▷
Patterned lace stretched across a first floor window supported the style of the lace of the bodice and the lattice work of the chair. I prevented the shot being solely a silhouette by backlighting from a large window, filled in by a white reflector.
50 mm, 1/250 sec. at f4, Ektachrome 400 pushed 1 stop.

Composing in the viewfinder

Composition – or, as I prefer to call it, "putting the picture together" – consists of arranging elements in the viewfinder by changing your viewpoint, by changing the lens, or by rearranging the model, the props or the setting. Composition is a personal aspect of picture-making. Your photographs are your own and it is for you alone to arrange them.

Remember that what you see through the viewfinder is but a small part of the scene that your eye naturally sees: you must, therefore, give careful consideration to your chosen shot as it will appear in isolation. Establish a regular routine to ensure well-composed pictures. First, research your idea before beginning the composition. Second, arrange the model's limbs, visualizing their effect as lines on the finished picture. Then adjust the lighting to sympathize with the pose. Swiftly scan the image in the viewfinder, moving down the frame so that you examine every element to make sure that when reduced to two dimensions they will present a satisfying appearance.

On location you should always be on the look out for situations that create a sense of visual tension. The elements in the scene – trees, bushes, buildings and so on – are known as "found" composition and you must arrange the model in such a way that the result will attract and hold the eye of the viewer.

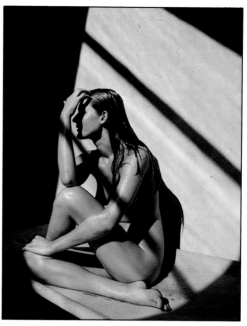

◁ **Controlling the pose**
Limbs and shadows were composed angularly in hard, noonday sunlight from a high window (diagram above). There was no reflector and the shot was underexposed to retain highlight detail and to intensify shadows.
50 mm, 1/125 sec. at f5.6, Kodachrome 25, 81EF.

Counteracting horizontal lines ▽
Photographing a model in a built-in shelf provided straight lines to contrast with her soft body curves. To stop the eye from sliding straight across the picture, I left the model's arm hanging down. A white sheet on the floor reflected diffused light from a high window behind the camera, emphasizing the design element by removing all the distracting shadows.
50 mm, 1/30 sec. at f4, Kodachrome 64, 10 CC magenta.

Precise viewpoint ▷
I created tension by choosing a viewpoint which made the model the focal point. Overexposure would have destroyed the silhouette effect.
50 mm, 1/125 sec. at f8, Kodachrome 64, 80B.

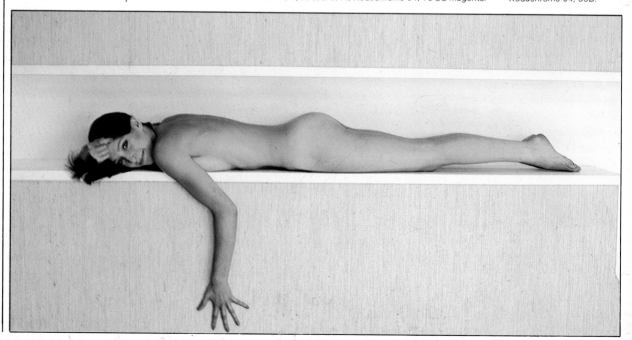

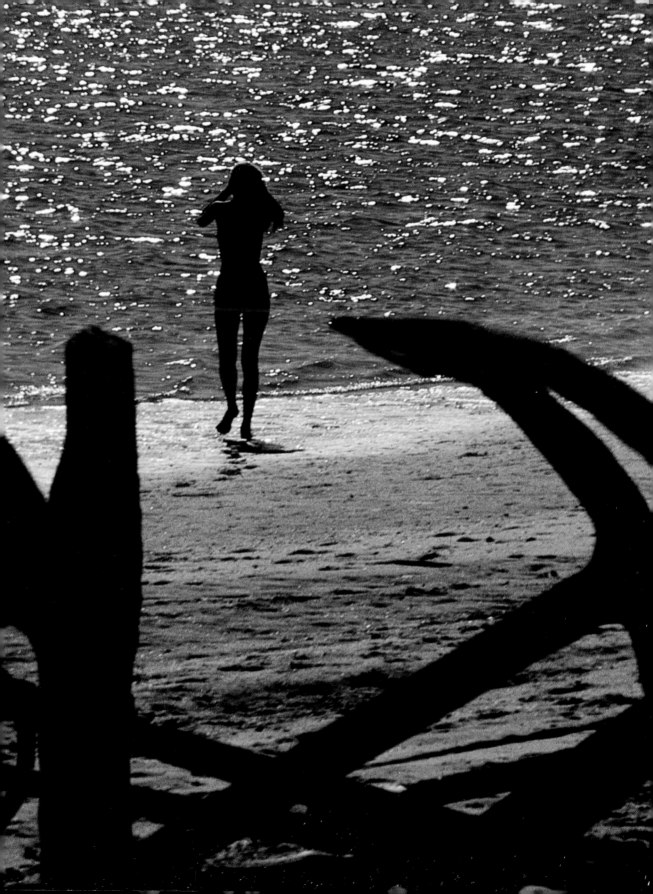

Arranging scenes

When you introduce elements of your own choosing into a photograph – "additive" composition – you must assemble them in such a way that they combine subtly with your model and the location. I personally start by examining the location some time before the shooting session, visualizing the model and how she can be most effectively arranged. It will often be evident that some areas of the picture need extra help, and even a simple prop may provide the necessary lift. Give the choice of prop some thought: a vase or hat may seem to work but will only do so if it suits the theme, color and style of the scene, for we are now beginning to create not only a design but a sense of mood in pictures. Often the disparate elements of the scene can be tied together by the right prop, leading the eye from one section of the composition to another.

The preliminary planning need not entail much expense. You can often find suitable props around your home or borrow them from friends. When selecting a prop to give your picture added meaning, consider your model and how she is to be occupied. A prop chosen to give a sense of purpose to the model's position not only helps her, but helps to bring your picture to life.

Unifying the composition ▷
By adding the helium-filled balloon on a string, the two elements of the picture – girl and window – were united. Light from another window behind the camera filled in shadows (diagram above).
50 mm, 1/8 sec. at f4, Kodachrome 64, 10 CC magenta.

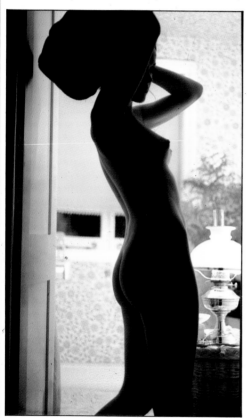

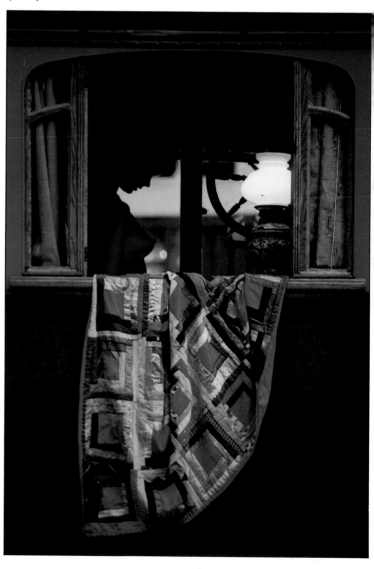

Subtle props △
The model's perfect shape needed only three subtle touches – the oil lamp, supporting basket and green plant – to bring the scene alive. The overexposure of the out-of-focus background lit by a desk lamp avoided confusing the figure drawing.
50 mm, 1/10 sec. at f2, Kodachrome 64, 80B.

Brightly colored props ▷
The self-imposed discipline of taking a vertical shot of a horizontal window caused me to introduce the patchwork, which also gave color excitement to an otherwise somber shot. The patchwork came to dominate the scene.
50 mm, 1/2 sec. at f8, Kodachrome 25, 10 CC magenta.

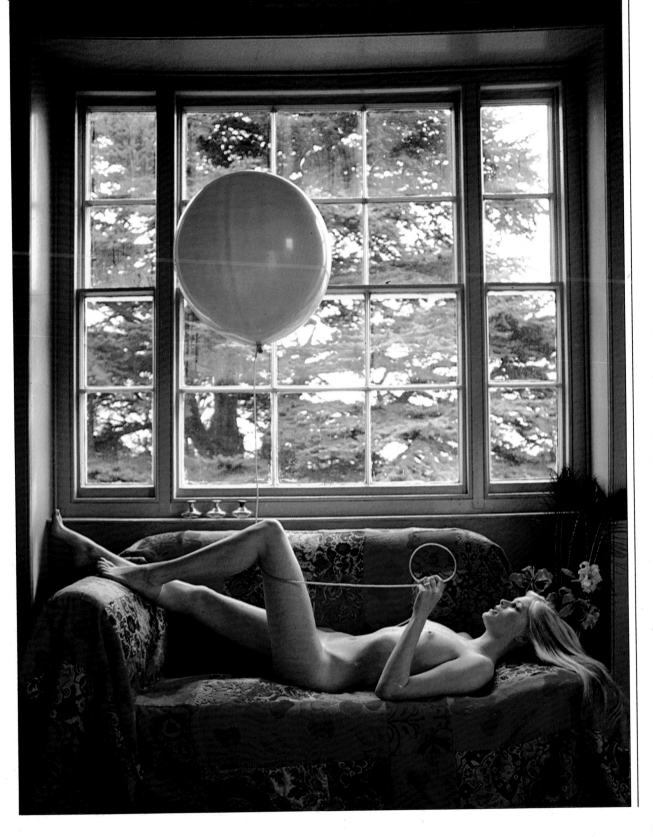

Composition through framing

One of the most satisfactory solutions to the problems of composing a photograph is to take advantage of any framing which the location offers. Consider a looking glass, window or door frame, indeed any device which will draw attention to the model, making the rest of the scene subsidiary to her. Framing is, therefore, particularly helpful if you have an attractive model but a poor situation, for you can employ the frame to concentrate on the girl.

Take the time to work out the position for the camera and the model that will make the best use of the frame to emphasize the model's good qualities. If she works best in long shot, try the frame near the camera and out of focus, using flowers or leaves to soften the edges. (Plastic flowers will do for this out-of-focus use.) In shots like this, the model must make well drawn, simple shapes. For a close-up, the frame can be used to isolate the best part of the body, but here the frame needs to be sharper.

Finally, remember that it is not necessarily a bad thing if part of the frame cuts across a subject, for the straight lines of the frame can contrast well with the model's softness and the curves of her body.

◁ **Including surroundings**
Inability to open the fixed right hand section of this window unexpectedly strengthened the shot by emphasizing the model's curves. Harsh sunlight was softened by a muslin scrim and white reflector, (diagram above), and to be sure that the model was relaxed, I arranged a telephone call to her to create temporary distraction. *50 mm, 1/60 sec. at f5.6, Kodachrome 25, 81A and polarizer.*

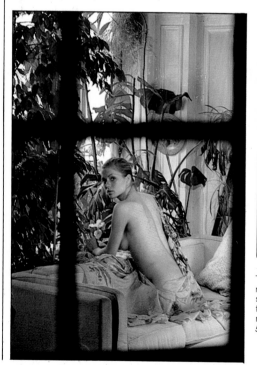

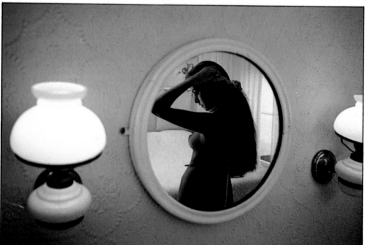

◁ **Subduing a busy setting**
The model was framed by a glazed internal door so that the rather busy setting did not overwhelm her. Light from the setting sun was reflected off a white bedsheet, which was fixed over an adjacent window. Beware of loss of sharpness when shooting through glass.
50 mm, 1/2 sec. at f4, Kodachrome 25.

Framing with a mirror △
A chance glance behind me revealed this unexpected view in a dressing-room mirror. When focusing by distance you must focus on the image within the mirror and not on the mirror itself.
50 mm, 1/4 sec. at f4, Ektachrome 64, 50 CC blue.

MASTERING TECHNIQUE

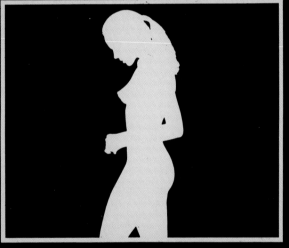

Wide-angle lenses

If you have original, interesting ideas, a model and sufficient light, any modern lens can provide you with satisfactory photographs. Certainly the normal lens that comes with most 35 mm cameras is adequate under most conditions. In some situations, however, a more specialized lens can be a most useful aid to good photography.

If you have to photograph in confined conditions, so that the camera is unavoidably close to the model, or if you want to include at least some of the setting but lack of space prevents your moving far enough back, a wide-angle lens is the solution. The forced perspective of short, wide-angle lenses, say from 15 mm to 24 mm on 35 mm cameras, can lengthen legs or create perspective interest in the design of the picture. You must watch carefully in the viewfinder, however, to be sure that the distortion which you are introducing is still esthetically pleasing.

To avoid undue distortion when photographing in a confined space, the medium short lenses, from 28 mm to 35 mm, are ideal. They often have good definition, a reasonably wide aperture to allow work in poor light, and will operate satisfactorily when hand-held at speeds down to 1/30th of a second. Unless you are employing them to create perspective effects of distortion deliberately, you need to compose the picture extremely flatly. You should think of your model as being drawn in two dimensions on a piece of paper and present her flatly to the camera. If the camera is above or below the model, she needs to incline her body so that the lower limbs and head are roughly the same distance from the camera. By using this technique, it is possible to take successful pictures with short lenses without undue distortion. Once the model is farther from the camera and occupying a smaller part of the frame, the distorting effect of the shorter lenses will not affect her, but will, of course, still affect the perspective of the room and its foreground contents.

Creative cropping ▷
Because I was working in a tiny shower room, I originally photographed with a wide-angle lens on 6 × 4.5 cm film. This transparency showed unattractive elongation of the legs as they stretched toward the camera. The problem was solved by recomposing the picture, cropping it to fit a 35 mm mount. Bright sunlight from a skylight, partially diffused with tracing paper, emphasized the contrast between water and nail polish. Potted plants were used to mask a mirror in which the camera would have been reflected. *Bronica ETRC, 40 mm, 1/500 sec. at f5.6, Ektachrome 64 pushed 1 stop, 81B.*

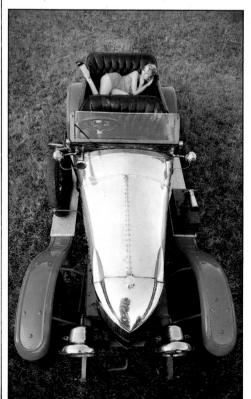

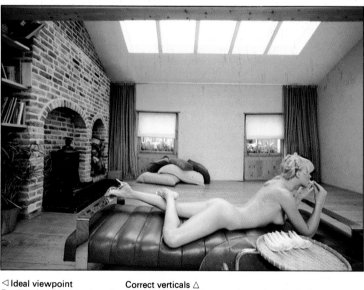

◁ Ideal viewpoint
By shooting from the top of a pair of steps, I emphasized the length of the car to increase perspective and lead the eye to the figure. The model's slip harmonizes with the paintwork and strengthens the contrast with the background. *24 mm, 1/125 sec. at f5.6, Kodachrome 25, 81A.*

Correct verticals △
To prevent the walls appearing to lean inward, as may happen with an extra-wide lens, I set up the camera paying particular attention to correct verticals and horizontals. I did this by making sure that the camera was not only level but parallel to the back wall of the room. Having lined up the camera accurately for the setting, I arranged the furniture to give the model a suitable working position at a distance from the camera where the "pull" (foreground elongation) of the extreme wide-angle lens would not be excessively apparent. *15 mm, 1/8 sec. at f8, Kodachrome 25, double 81EF.*

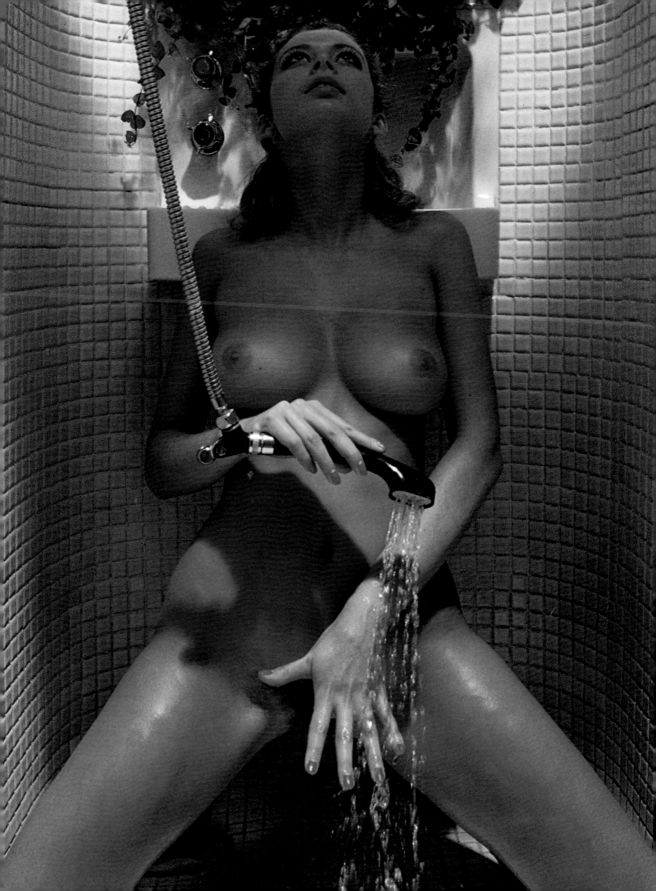

Long lenses

Long lenses (more than 80 mm) are the photographer's binoculars, allowing him to take close-up shots from a distance. These lenses are particularly useful in nude photography, for the distance between you and the model in an outdoor situation may have to be considerable to avoid the closer elements of the location dominating the composition. Sometimes, however, working out of earshot of the model can be turned to advantage. The model, of course, can then be directed by you only in a general way beforehand, but this allows her to use her imagination for movements and expressions that will appear spontaneous. Moreover, the model will not feel the camera is peering intently at her, as she may when being photographed with a short lens. Remember that while long lenses can be used to eliminate the surrounding scene, they also have a limited depth of field.

Medium long lenses (80 mm to 250 mm) avoid problems of perspective and distortion associated with short lenses by increasing the distance between you and the model. In this range there are still fast lenses (that is, with large maximum apertures) which can be used

in poor light. For shooting at greater distances, long lenses (250 mm up to 1000 mm or more) are required. These, however, pose certain problems, for often their widest apertures are only f5.6 or f8, which inevitably means using a tripod and a long exposure. In addition, depth of field becomes even more limited on longer lenses. But these problems can themselves be exploited. A figure taken in an ordinary situation with no graphic or color interest can be made exciting once it is set, sharply drawn, in a totally out-of-focus background.

Zoom lenses can be used in place of a range of long lenses but they sometimes produce poorer quality results, especially when working into the light. However, zoom lenses offer the possibility of employing special and exciting techniques (see p. 132).

Isolated subject ▽

Shallow depth of field intensified the tactile quality of the model's hair and back. The shot was composed simply on a deserted beach and, by turning the model's back to the early morning sun (filled in with light reflected from a white bedsheet), the rounded quality of the body drawing was enhanced.
300 mm, 1/250 sec. at f5.6, Kodachrome 25, 81B.

Shallow depth of field ▷

By softening the otherwise distracting broken shadows behind the model, the shallow depth of field introduced by the long lens solved a compositional problem in this sunlit shot. Careful color matching of the background touches with the red cherry strengthened the picture. The high cost of an optically perfect filter for use on the big front of a very long lens forced me to use a gelatine filter, securely fixed to the back of the lens.
300 mm, 1/30 sec. at f4, Kodachrome 25, 81A.

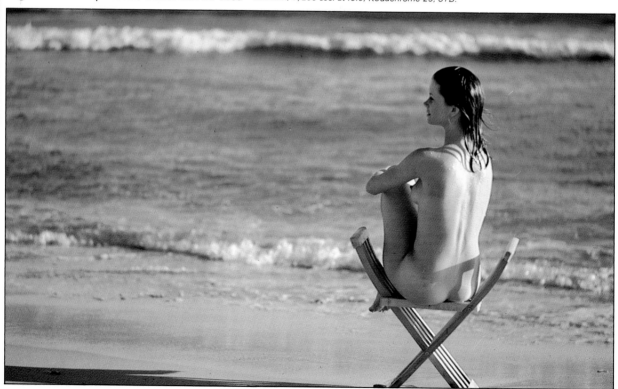

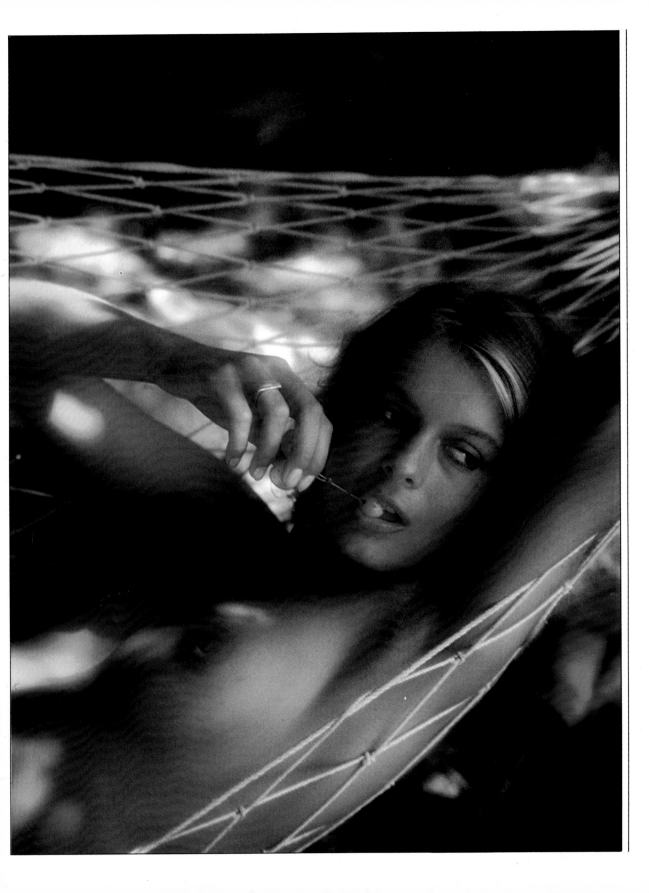

Adding basic filters

Every type of film has its own quirks of personality and reacts differently to varying light conditions. One way of overcoming such quirks if you want to is to use cheap gelatine or acetate color correcting filters over the lens when shooting transparency film. For example, pale skin photographed in cold light from gray sky may need warming up with a pale brown filter. Print film cannot be manipulated on the camera in the same way but must be corrected in the darkroom.

Sensitivity to color filters added to the camera varies enormously from film to film and it is often difficult to assess visually the eventual effect that the filter will have on the shot. The answer to this problem is to continue to use one film until you have mastered its qualities and limitations, keeping notes of the results you achieve for future reference.

There are other filters useful to the nude photographer. A polarizing filter will cut out unwanted reflections from skin and will also give better color and texture when used to eliminate scattered gray or blue light from the sky. In addition, by turning the filter it can be used to darken some reflective elements of a shot deliberately. Graduated filters are clear in one half, with a graded color or tone content in the other. This is sometimes gray or blue for intensifying skies, sometimes brown for creating warmth. They are most effective with short lenses (below about 40 mm).

Polarized sky ▽
Darkening a clear blue sky with a polarizing filter whe photographing at noon in the Sahara apparently lightened the sand and cut out unwanted blue reflections from the sky in the body color.
28 mm, 1/250 sec. at f5.6, Kodachrome 25, polarizer.

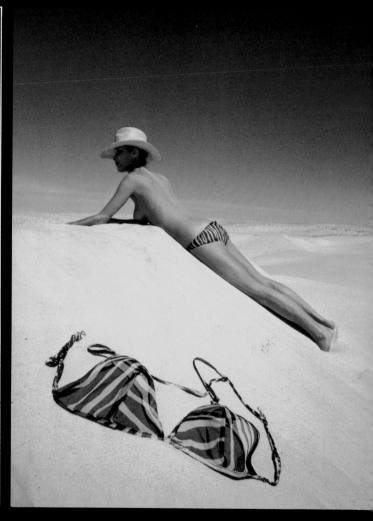

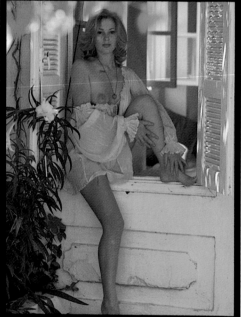

Color variation
Uncertainty over the correct filtration made necessary alternative versions of this daylight picture. To warm the untanned skin of the model above, 81C was ideal. Adding a 10 CC magenta filter (right) cleaned up the muddiness of the light reflected from surrounding dirty surfaces and sharpened the rich pink of the bougainvillea.
105 mm, 1/30 sec. at f5.6, Kodachrome 25 (both pictures).

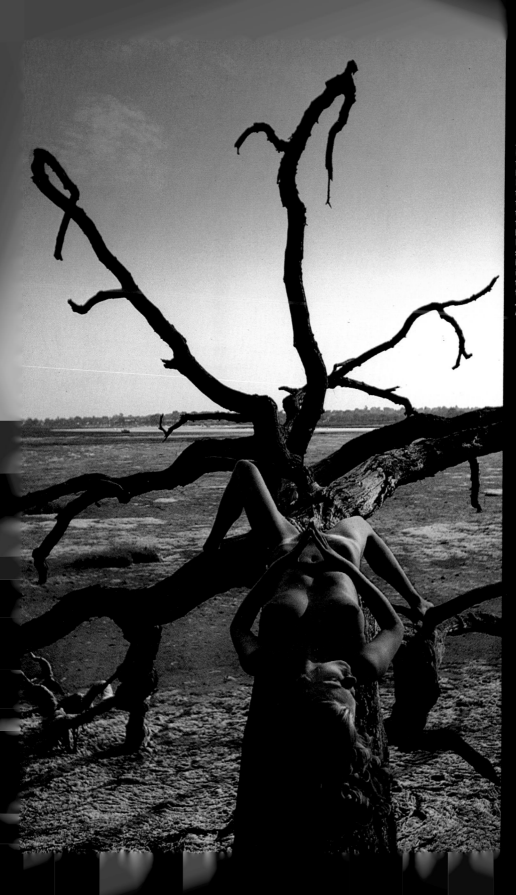

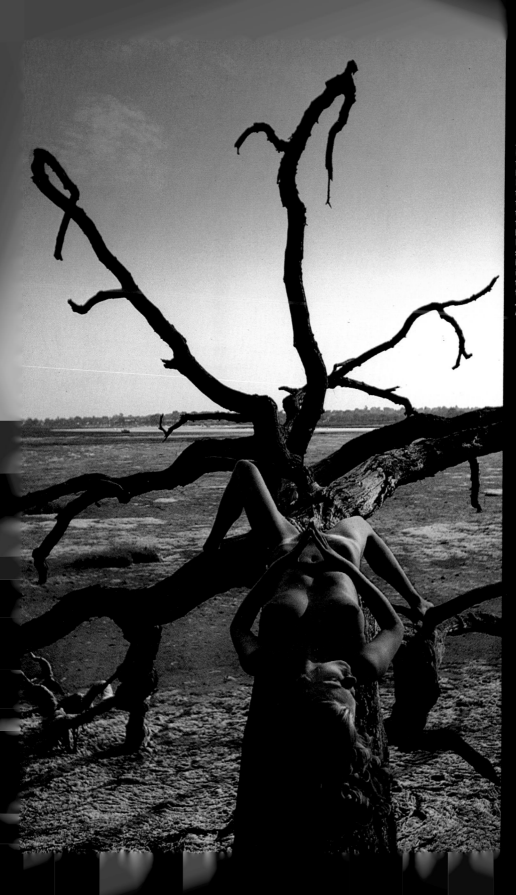◁ Improving the sky
A graduated filter (half blue,
half clear) added intensity to
the colorless sky in this
bleak English estuary
landscape, relieved only by
the graphic quality of the
tree. The model is seen
through the clear portion of
the filter and is unaffected
by it. I took the picture in
low afternoon sun, which
strikes well across the body
but could not be reflected
into the shadows because of
the height of the tree stump
from the ground.
*28 mm, 1/60 sec. at f5.6,
Kodachrome 25.*

Exploring perspective

Capturing perspective is one of the most effective ways of representing three-dimensional objects on a two-dimensional surface and giving the scene a realistic impression of depth. Careful use of perspective will provide strong, dynamic images because perspective adds drama, movement and, if use is made of diagonals, direction to a picture. Linear perspective, where lines converge toward a vanishing point on the horizon, is the classic form of perspective and can be employed as a photographic device to lead the eye to the focal point of a picture somewhere on the converging lines. An alternative method is to capture perspective in the foreground, even using the model herself for this purpose. This is perhaps the most difficult way of using perspective to good effect because of the

ugliness that distortion can give but, by carefully controlling the distortion, it can produce extremely dramatic results.

Perspective can also be used as a background to a subject, when it appears to recede behind a model. Landscape can often be effectively used in this way.

All lenses can capture linear perspective but greatest effect is obtained with a wide-angle lens. Scenic perspective, the recession of aerial tones by distance, is recorded better on longer lenses. Remember, too, that the effect of perspective can be further exaggerated by changing the viewpoint and shooting from either higher or lower than eye level. This point applies particularly to the less-than-tall model, where shooting from well below waist level lengthens her body.

Perspective positioning ▷
By holding the camera high over my head and using the model as an eye-stopping element at the end of a bleached Mediterranean jetty, a satisfying perspective composition resulted from simple elements.
24 mm, 1/60 sec. at f8, Kodachrome 25, polarizer.

Background perspective ▽
A discarded truck found on a garbage dump seemed to offer few picture opportunities on a cold, wet spring day. But a sudden burst of sunshine in the late afternoon provided the opportunity to make this perspective shot.
15 mm; 1/60 sec. at f5.6, Kodachrome 25.

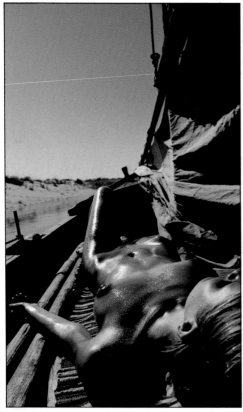

Confined conditions △
Lack of space on a Portuguese fishing boat tempted me to compose the lines of the boat with the limbs of the model and the receding shoreline to give strong perspective. The noonday sun, which created deep shadows and emphasized the drawing in the picture, forced me to exclude the model's eyes, which were closed against the bright light.
28 mm, 1/500 sec. at f8, Kodachrome 25, polarizer.

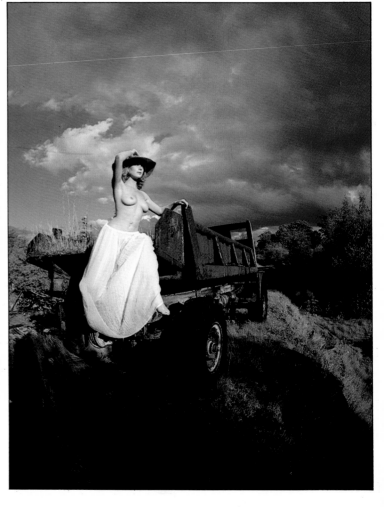

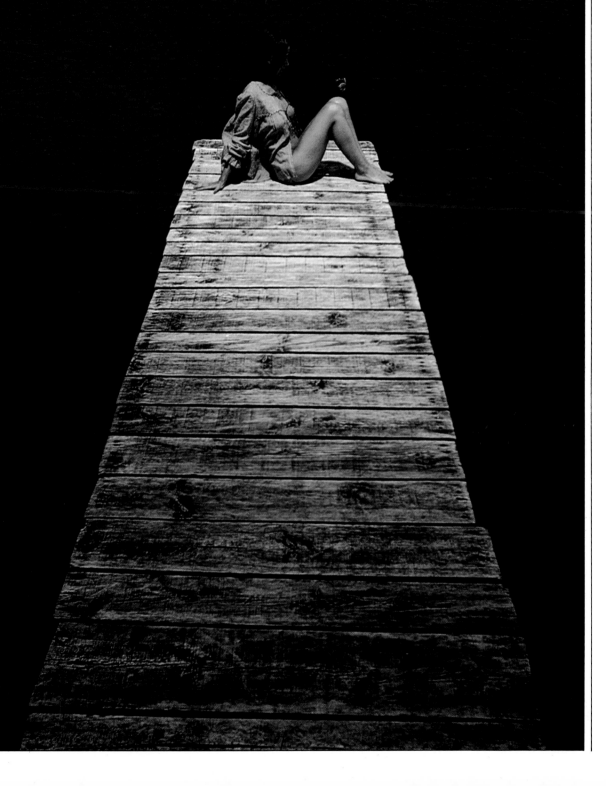

Using scale for effect

Picture-making is partly to do with catching the eye with the unexpected, the dramatic or amusing. By adjusting your model's apparent size in relationship to her surroundings, you can create pictorial tension in an otherwise simple setting. By increasing the difference in scale between the model and a powerful element in a picture, you will be able to produce a feeling of depth.

Scale can be emphasized by using different lenses. For example, when using a wide-angle lens a subject in the foreground will be disproportionately large while the background appears greatly diminished because of the perspective effect. A long lens, on the other hand, appears to exaggerate the size of the background and also reduces the difference between the size of the elements in the foreground and background.

A great advantage in a longshot which uses contrast of scale is the voyeuristic, secret onlooker quality, which can sharpen the story element. A figure photographed near at hand will not have that quality, of course, but can in contrast be used to give the viewer a sense of tactile intimacy with the subject.

Bird's eye view ▷
An adjacent roof-top afforded an opportunity for this photograph of a sunbathing model. Despite her potential insignificance in the shot, careful timing of the light meant that she was not unnoticed. The spotlight effect which separates her from her surroundings would have been lost had the sun still been striking the white wall beside her.
Bronica ETRC, 50 mm, 1/125 sec. at f5.6, Ektachrome 64, 81A and polarizer.

Dominant figure ▽
Using space to exploit the difference in scale between the model and the cottage created the visual tension to justify this simple picture. Photographing nudes in public poses problems of privacy. I asked the model to lie nude in the back of the car, but covered with a sheet, while we drove to the location. When we arrived, my assistant removed the sheet and stood with it by the car while I shot a few quick frames.
28 mm, 1/8 sec. at f8, Tri-X pushed 1 stop.

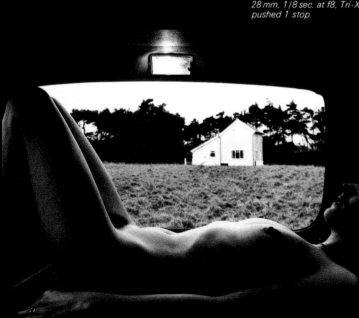

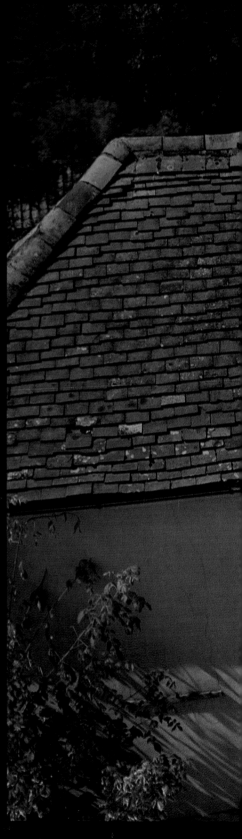

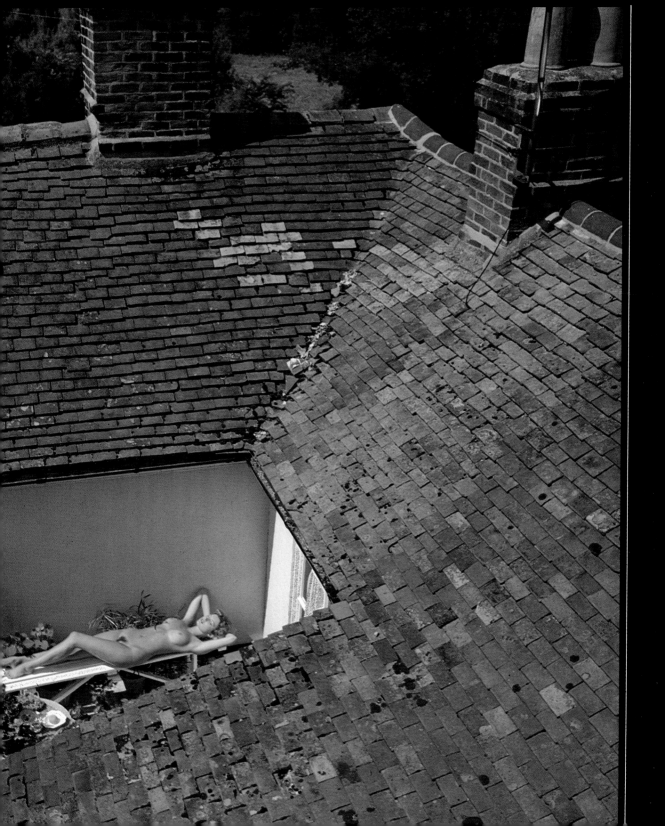

Understanding daylight

The photographer's most important skill in capturing the beauty of the nude body is an ability to control light. Daylight is simple to use in comparison with artificial light but it has to become your servant and to achieve this you need to understand it.

The first point to grasp is the difference between soft and hard light. Soft light is diffused light, which casts a gentle shadow. Typical of this is the sort of light coming through a clear patch when working under dense trees on a bright but cloudy day — in other words, a beam of scattered light. Watch how this light falls on the model's face, casting hardly any shadow from nose and chin. I call it "beauty light" because it is so flattering. Furthermore, it combines well with highlights from multiple sources behind the subject, which add modeling and shape to the shot. Sunlight reflected from water is a typical source of this sort of backlighting.

Hard, noonday sunlight is the opposite of beauty light, casting vicious shadows and creating high contrast. In this situation, it is better to keep the model's face in darkness or turn her head up toward the sun so that the nose throws hardly any shadow. She must then, of course, work with her eyes shut. Aggressive, hard sun is tamed by nature with soft clouds but on a clear day the photographer has to use a couple of layers of nylon net stretched on a wooden frame above the model. Nevertheless, this overhead direction of the light is not ideal. A simple solution is to find a sunlit white wall or hang up a bedsheet, using the reflection as your beauty light while you and your model work out of reach of the rays of the direct sun. Since the beauty light is fixed, you must choose your camera position and turn your model until the light falls on her to the best advantage.

The direct sun can itself be a beauty light but only when it is low in the sky and has lost some of its bite. I make many of my favorite pictures at this time of the day.

Many of these lighting schemes by bright sun can make the model screw up her eyes. For this reason, do not under-rate the plain, gray skies of northern areas. This cold light can be warmed up with an 81 series filter and controlled with a big, white umbrella or an overhanging tree branch. These will cut out top light and by using a white reflector on the ground you can bring the angle down to beauty light level. You will then have a gentle source, which is ideal for enhancing texture of skin, hair and fabrics.

Although I have described artificial ways of creating beauty light, it in fact exists constantly in ordinary situations. As you go about your daily life, watch the faces of people around you and you will see this low, soft light source at work. In this way you will learn to find picture situations where you can use it.

Using the noonday sun ▷
Though taken in harsh noonday sun in the Sahara, this semi-silhouette works because most of the model's body and her eyes are shaded from the direct sunlight. The uncluttered background sets off the figure well and the choice of a sand-colored hat and leather bracelet heighten the monochromatic feeling of the shot.
105 mm, 1/250 sec. at f11, Kodachrome 25, double 81EF.

Diffused daylight ▽
Soft, oblique daylight coming through a gap in a Swedish forest on a bright but cloudy day enhanced all the textural contrasts of this shot. Harsher light would have destroyed the intensity of color and the subtle relationship between the hair, the fabric and the green bracken.
105 mm, 1/125 sec. at f5.6, Kodachrome 25, polarizer.

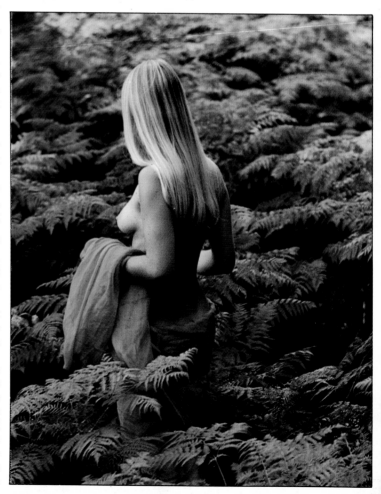

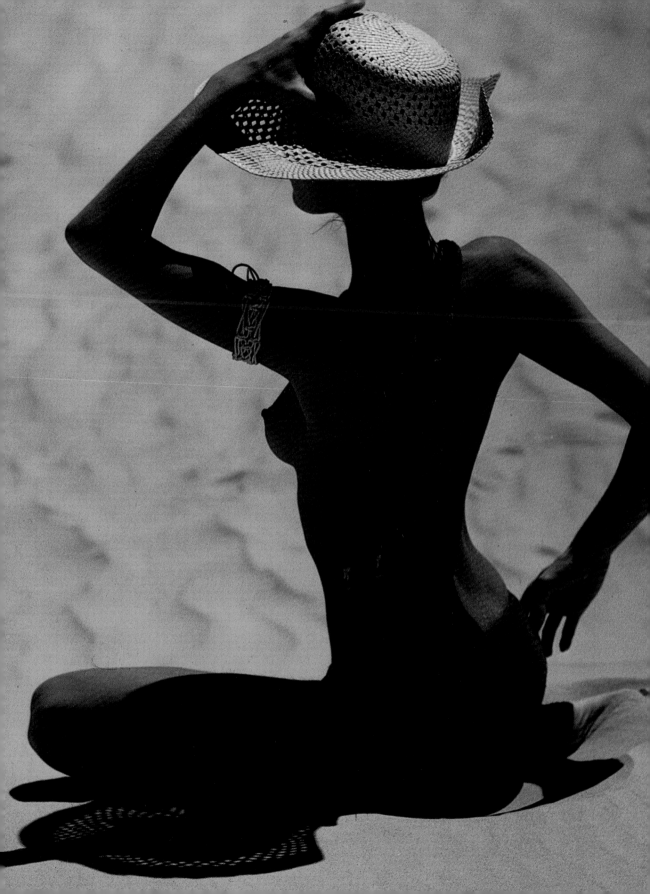

Controlling daylight indoors

Once you have developed a feeling for hard and soft light and its effects, you will be able to exercise greater control over the tones in your pictures. Choose a window to suit the shot you have in mind. Working on a still shot with very fast black and white film, small windows which give a light that is easier to control are ideal but for action pictures or when working with slower films the greater volume of light from a large window is desirable. Always remember that it is you and your positioning of the light, not your location, which decides whether you have a light figure in a dark setting or vice versa. When you have decided which you want, you can achieve the required effect by channeling the light to different areas of the shot. For instance, when you work with a darkish background and a light-skinned model, the background can be considerably lightened by seeing that most of the light reaches the background and nowhere else. You can make certain of this by screening the model from the light with a black baffle. You also need a supply of black paper or cardboard, to keep the light off other parts of the shot. Just as when you are composing a picture, always take time to improve the detail in the shot, remembering that lighting control can subdue unwanted elements by putting them into shadow.

The opposite of shading is highlighting. By using a full-length mirror close to a bright source of light, you can redirect the beam into the dark problem areas of the shot. This light needs careful handling and you should keep a piece of net handy to soften your mirror light if the effect is too strong.

The aim of all these skills is to produce a shot that has an entirely natural look, as if the light just *happened* to be right. Your skills should never be evident to the viewer, for indetectability is the principal mark of good daylight control indoors.

Avoiding silhouette ▽
Photographing toward a window (just out of shot) and using two white reflectors near to the camera to reflect the diffused daylight (diagram below) resulted in a strong but rounded image with clean highlights and rich shadows. Gray daylight was improved with filters.
80–250 mm zoom, 1/15 sec at f5.6, Kodachrome 25, 81B and 10 CC magenta.

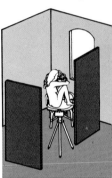

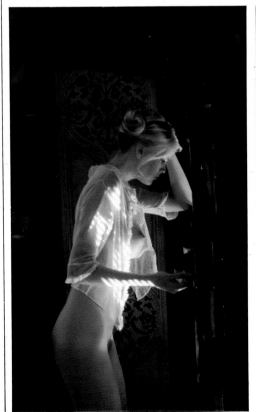

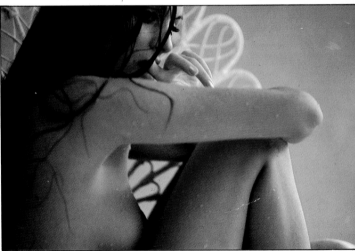

◁ **Mirror light**
Striped under-lighting in this shot was created by positioning a mirror to catch sunlight hitting the floor of an exterior balcony and reflecting it through the louvers of a Moroccan door shutter (diagram right). A reflector gave subtle molding to the model's back.
50 mm, 1/15 sec. at f5.6, Kodachrome 25, 81B.

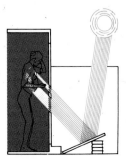

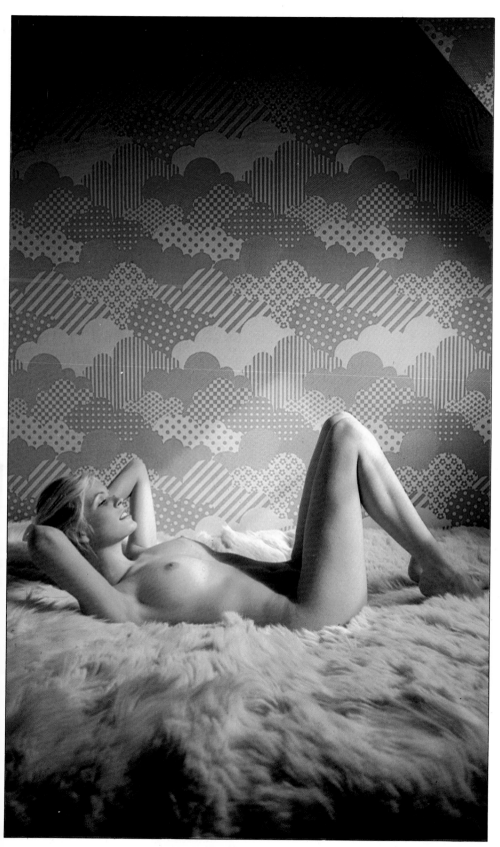

◁ **Emphasizing the subject**
Sunlight softened by tracing
paper fell conveniently
through a dormer window
to create a pool of light,
allowing the fussy details of
background and foreground
to darken and the subject to
stand out. A white wall on
the left side of the model
filled in the body shadows
(diagram above). A magenta
filter counteracted green
reflection coming from
the wallpaper.
*50 mm. 1/30 sec. at F5.6.
Kodachrome 25, 10CC
magenta*

Shooting into low sun

Shining brown skin lit by low, warm sun provides the perfect subject for most nude photographers. The reduced power and low angle of late afternoon sunlight when the sun is nearer the horizon is esthetically pleasing and also has an emotional effect on the model, for no-one can be expected to radiate warmth and gaiety if cold. The same favorable conditions obtain during the hour immediately following sunrise, but in most countries it is colder then than in the evening and there is the further problem that you will have far less time to plan your shot and arrange the scene beforehand.

My ideal routine is to start shooting about two or three hours before sunset with a backlit idea, shooting against the sun but taking care to shade the lens from direct rays. There is enough punch left in the light at this time to allow action shots even with slow film. A reflector or two close by the camera can throw back a gentle beauty light on the model. Be generous with the reflected light for these shots to make sure that your against-the-light

pictures are not composed only of extremes of dark and light. Since you need to keep the reflectors close to the subject, you should avoid long lenses for full length work as the reflectors would get in the way of the shooting. The main drawing of the shot will be etched in an outline of white light and provide an ideal opportunity to try out some shots with a soft focus lens attachment (see p. 128). It is never easy to calculate exposure for backlit subjects as the highlights tend to affect built-in meters and correction needs to be made to avoid possible underexposure.

As I make my backlit shots, I am waiting for the moment when the sun's rays weaken just enough to allow the model to look toward the sun without screwing up her eyes too much. This is the time to stop shooting into the sun, to change your whole approach and shoot with the sun behind you.

Action against the light ▷
Shooting directly into late afternoon sun (with the le. well shaded to prevent flar and using a mirror and re- flector to fill-in the shadov (diagram above), gave me enough light for this action shot to be taken in my garden. The rose petals were a readily available prop, which gave the mod something to do.
105 mm, 1/250 sec. at f4, Ektachrome 200.

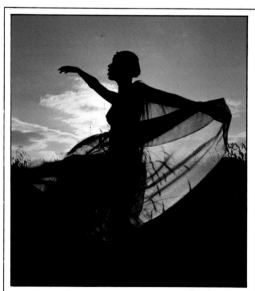

Contrasting viewpoints
By changing camera height and exposure, two pictures came out of this situation. Early morning light in a rye field tempted me to shoot the model on the right but, while making it, I noticed a cloud about to pass the sun. I dropped down to a very low angle, changed to a shorter lens and advanced the ASA by one stop to mislead the TTL meter, and then bracketed to make sure of a silhouette for the darker picture.
28 mm, 1/500 sec. at f11, Kodachrome 25, 82B (above);
105 mm, 1/250 sec. at f5.6, Kodachrome 25, 81EF (right).

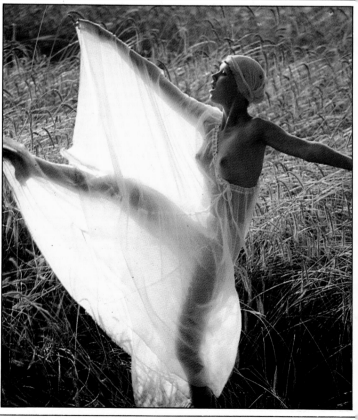

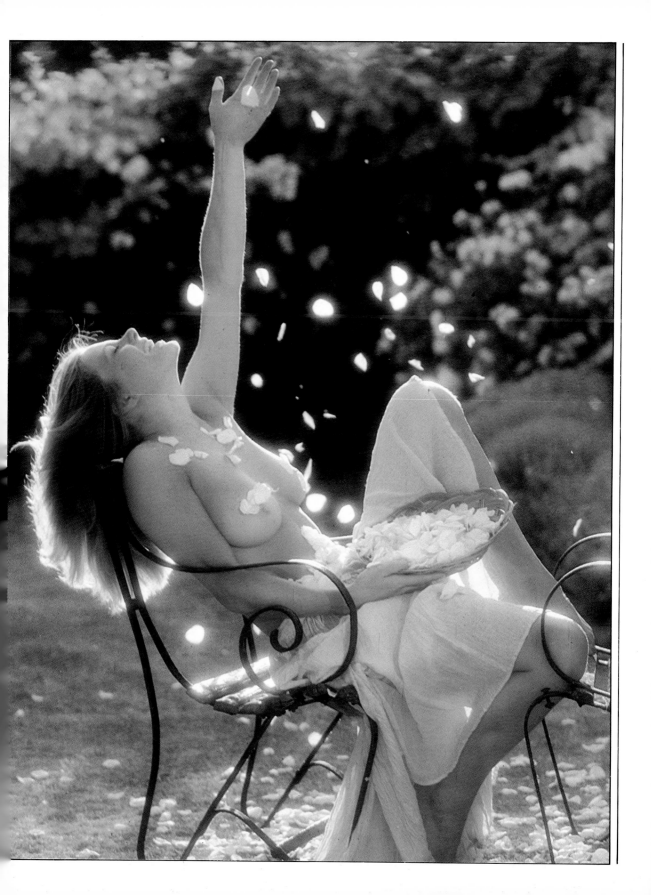

Shooting with low sun

The clear, low, warm light in the minutes before sunset emphasizes texture, creates patterns with long shadows and adds glamor to the model and the setting. If at first the light is a little too strong for the model you may need to create shade with a hat, dark glasses or some other prop. Even if this throws her eyes into shadow, you may have added mystery by letting the viewer read his own message into the unseen eyes.

As the sun sinks toward the horizon, the color changes to the warmer end of the spectrum and for a correct rendering of color a set of 82 blue correction filters is useful. The need for color correction during this magic hour depends in part on the accuracy of color rendering required and also on the type of film that you are using.

The benefits of low-angled sun can also be exploited indoors with a large window facing either east or west. But remember, the fast-moving angle of the sun at this time of day means that you have to be very quick to finish shooting your scene before the light changes.

Highlights from the sky ▽
The last rays of the dying sun gave textural contrast between fabric and skin. Weakness of the sun at this time means that the blue sky behind the figure takes on a backlight role, picking up the skin on the back. Prominance was given to the figure by choosing a position in which the model was in the sun but the background, softened by the use of a long lens, was in shadow.
300 mm, 1/60sec. at f5.6, Kodachrome 25.

Changing light at dawn
These photographs were shot in 5 minutes. The top picture was lit by the bright sky before the sun rose over the horizon. The lower picture shows the change in effect when the sun's rays began to reach the model.
50 mm, 1/4 sec. at f5.6, Kodachrome 25, 20 CC magenta (top); 50 mm, 1/30 sec. at f5.6, Kodachrome 25 (bottom).

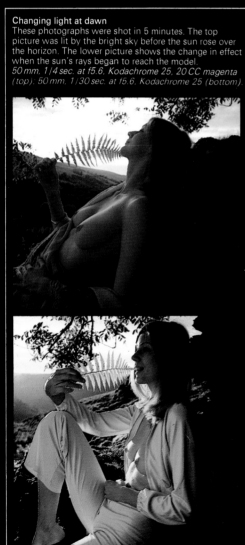

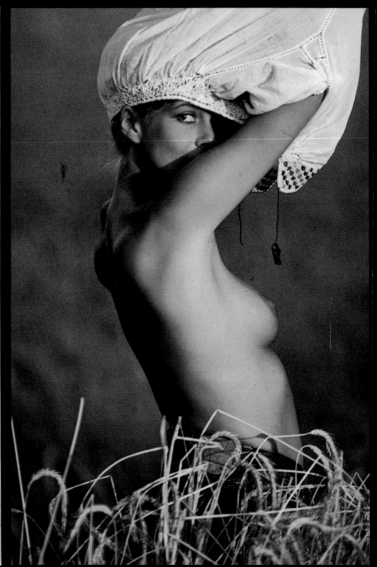

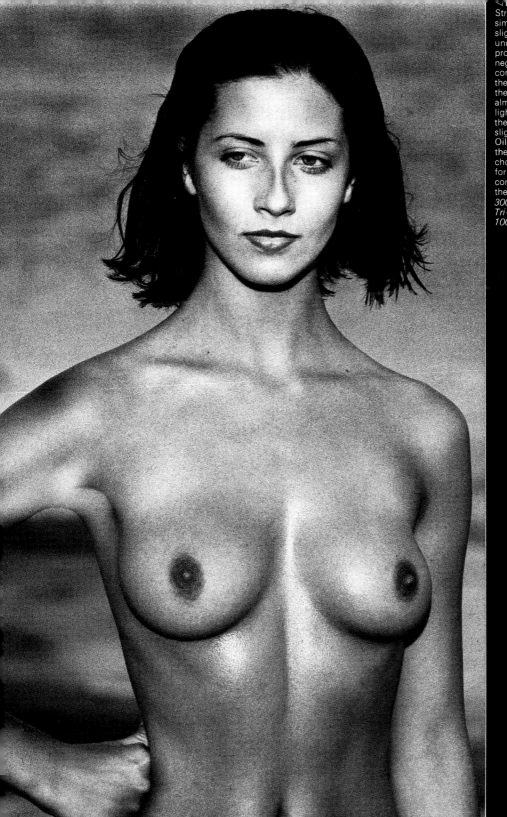

◁ **Beauty light**
Strong skin texture in this
simple picture came from
slight underexposure and
underdevelopment,
producing a soft, thin
negative that prints well on
contrasty paper. Positioning
the model accurately to face
the setting sun created an
almost shadowless beauty
light for the face, but forced
the model to drop her eyes
slightly to avoid dazzle.
Oiling the skin enhanced
the body texture, while
choosing simple mid-tones
for the distant background
consolidated the mood of
the shot.
*300 mm, 1/250 sec. at f5.6,
Tri-X downrated to
100 ASA.*

Shooting the sun

Using the bright sun as part of your composition used to be taboo but improvements in lenses and films can now enable you to add this dramatic touch to your pictures, provided you follow some basic rules. The most important rule is to use only short lenses (below about 40 mm) to avoid flare and diffusion, which occurs inside the multiple elements of the longer focus lenses and will leave you with a rather indistinct image. Watch out for multiple blobs (reflections from the insides of the lens element) which tend to occur if the sun's image is near to the edge of the shot. This effect can often be stronger on the transparency than it appears to be in the viewfinder. Next, it is always necessary to check in the viewfinder to see if there is any improvement in the image quality when you hold the camera with one hand and then mask the sun out of the shot with the other.

The same technique – one hand keeping the sun out of the image – is necessary to make an accurate assessment for the exposure of the shot if you are using a TTL meter, though a little underexposure (less than a stop) of the foreground is necessary if you want the sun to be shining brilliantly out of a clear sky. This problem can, of course, be solved by the use of a gray graduated filter (see p. 36) to hold back the sun. When using gelatine or acetate filters on this type of shot, there will be less risk of multiple reflections if you attach the filter to the back of the lens.

These rules do not apply, of course, to rising or setting sun pictures, which depend for their success on the longest lens you can get. As the mind's eye tends to magnify the size of the setting sun, it can seldom be successfully recorded on lenses under 200 mm, and if you can get hold of a 500 or even 1000 mm lens so much the better.

As with shooting the sun on short lenses, you may need some exposure adjustment when working with long lenses but this time the other way round. You need to overexpose the sun by, say, 1 to 1½ stops, as it usually falls on the meter cell in the middle of the scene and inflates the reading on the TTL meter, leaving you with too dark a landscape surrounding it.

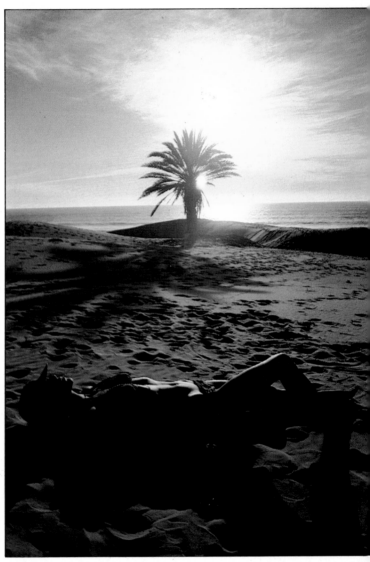

Against the light at sunset △
Driving down the Moroccan Atlantic coast in the late afternoon, I spotted this solitary palm tree. Because the setting sun was beginning to haze over, I took a risk that the optical qualities of my 24 mm Nikon lens would give me a clear image without flare. The contrast between the dark figure and the light sky would have been improved by the use of a graduated filter or an on-camera flash, but I feared that by the time I had run back to the car to get them the sun would already have vanished beneath the horizon and my shot would have been lost. To avoid the meter underexposing the shot because of the brightness of the sky, the meter was adjusted to overexpose by one stop. *24 mm, 1/50 sec. at f8, Kodachrome 25, 81EF.*

High, hard sun ▷
I call the 16 mm lens the square fish-eye because of its curved field within the 35 mm format. This is a very forgiving lens because, unlike some short lenses, it does not produce a chain of iris images when the bright sun is placed on the edge of the frame; such images would have ruined the water texture. Because of the impossibility of judging correct density for this shot I used a wide bracket. *16 mm, 1/500 sec. at f5.6. Kodachrome 25.*

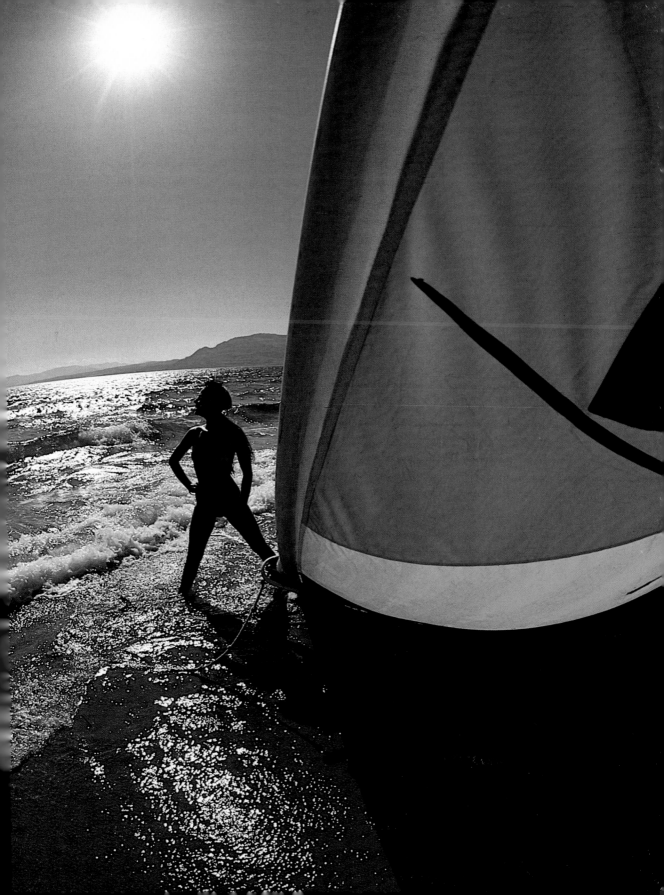

Managing with existing light

Nude photography and black and white film seem to have been made for each other. The dramatization of body shapes and tones in isolation from cluttering detail can make extremely satisfying, simple prints. Soft indoor illumination reflected from light walls provides a perfect complement to the curves of the naked body. Whether the light source is netted windows or diffused artificial light, it can be mixed to achieve beautiful effects.

The ideal existing light source is a single soft light, casting one soft shadow. Multi-source illumination creates miriad shadows, confusing the body lines and destroying the smoothness of the skin. Where multiple light sources are unavoidable, direct all except one lamp to reflect off a light wall or ceiling, thereby creating soft fill-in for the shadows which are caused by the one hard "key" light remaining. An important aid to the control of electric light is a dimmer switch such as you can get from an electrical supplier. Equip it with a plug on one end and a socket on the other to control the amount of light produced by any portable light source plugged into it.

If the light is poor, remember that fast film can have its emulsion speed pushed in development to easily double (see p. 68). The resulting grain can be a positive advantage in rendering skin tone, as the break-up of detail in the image helps mask minor skin blemishes and can be easily retouched on black and white prints. Remember that the contrast between black and white rises sharply in "pushed" film and you must work in fairly flat light situations (a ratio of one stop between highlight and shadow) or use your reflector for filling in deep areas to get a printable negative.

In black and white photography do not hesitate to mix daylight with domestic room lighting (lamps or fluorescent tubes) to create a soft light and highlight mixture which makes pleasing tones; it is in color photography that mixed light becomes hazardous (see p. 54).

Indoor highlights ▷
Existing indoor daylight
from more than one window
produced highlight and fill-
in light for this relaxed and
candid end-of-session shot.
Underexposing on fast film
gave good highlight detail
and preserved the atmos-
phere in the shot.
*80–200 mm zoom, 1/30 sec.
at f5.6, HP5.*

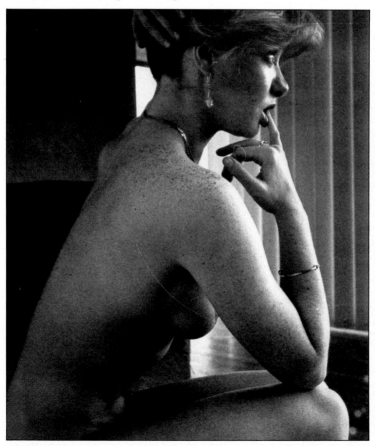

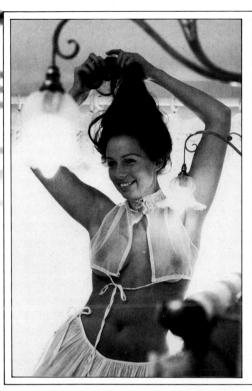

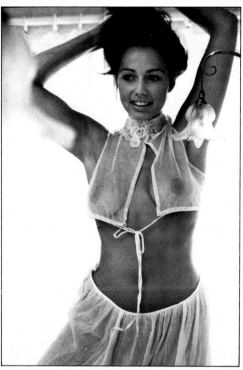

Making minor adjustments
Strong daylight filled in with white reflectors in the bedroom shot (far left) was not affected by the small electric lamp. However, the curling metal bracket became an important part of the design of the shot. With the light out (left), it was necessary to increase the exposure, making the background detail less clear. *50 mm, 1/60 sec. at f2, Tri-X (far left); 50 mm, 1/30 sec. at f2, Tri-X (left).*

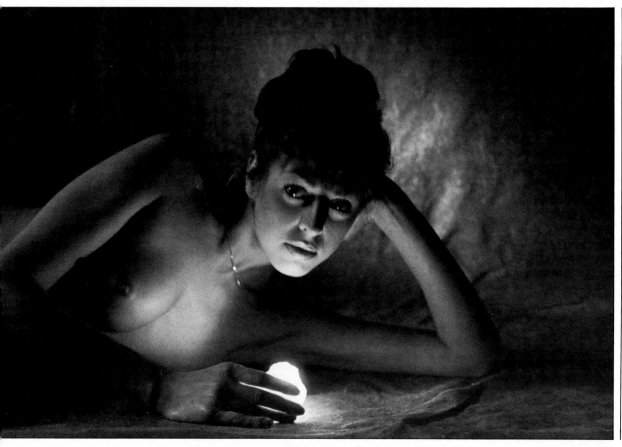

Mixing light sources

Successfully recording the mixture of daylight and artificial light in color photography is not easy but is highly rewarding when mastered. The problems arise when you want to photograph, especially indoors, during daylight hours and use an electric light to fill in shadows and add atmosphere to the shot. Most color film is manufactured for use in either artificial (tungsten) light or natural daylight, not both. For neutral results, choose your film on the basis of the dominant light source for the shot, but control color film reactions by the use of blue or yellow-brown filters.

The most simple and easily controlled lights are photoflood bulbs. These over-run tungsten filament bulbs, which can be used in either ordinary lamps or simple aluminum reflectors, produce a brilliant light. They come in two sizes – 275 watt and 500 watt. Because they are over-run they have only a few hours life and get extremely hot so they must not be left on for more than a few minutes at a time without special ventilation. Though their intense light is slightly more blue than standard tungsten, it is still yellow compared to daylight. If used alone, try bouncing such light from a white reflector and shooting on fast tungsten film with a 81A filter to warm up the slightly blue photoflood. Though the reflected light is not strong enough to allow short exposures, it avoids hard shadows and highlights caused by direct illumination.

To add depth and realism to your picture, introduce a touch of controlled daylight from behind the model to create cold, bluish highlights, while the main part of the picture is being softly lit by warm, reflected photofloods. You will then see the effect of mixed light on your tungsten film and its potential for creating mood and atmosphere.

In a more spacious interior location, where your reflected photofloods cannot compete with the power of the available daylight, you may be tempted to use flash (see p. 62). But if you prefer the predictability of photoflood light, wait until dusk. Then your photofloods are relatively stronger. Start shooting on daylight film before the outdoor light has faded. At this stage use a blue filter (82B or C) to reduce the yellow. When the artificial light starts to dominate the shot, switch to tungsten film with an 81B or C filter to stop the daylight content cooling down the shot too much.

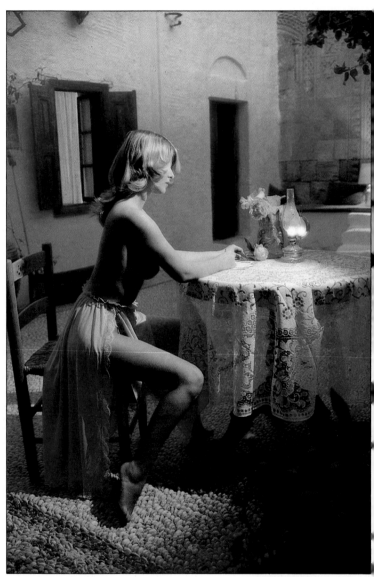

Mixing light at dusk △
Whitewashed walls in the courtyard of an old Greek house provided the perfect setting for this simple, mixed light shot. By photographing in the few minutes in which the lighting balance between the strength of the table lamps and the blue light of dusk was perfect, I was able to create an atmosphere which then only needed the addition of one photoflood lamp, fitted with a snoot (right). The position of the photoflood was dictated by the need to echo the direction of the existing domestic lighting in the courtyard. I originally attempted the shoot on daylight film, using an 82B filter to counteract the yellow of the tungsten content and increase the blue of the daylight, but at dusk I switched to tungsten film and an 81 EF filter.
Bronica ETRC, 50 mm, 1/8 sec. at f4, Ektachrome 160, 81 EF.

Simulating room light ▷
Two photofloods in reflectors, one lighting the room, the other pointing toward the camera to backlight the model and the paper sculpture but carefully positioned so that no direct light fell on the camera, simulated normal room light. This arrangement allowed a shorter exposure for the night interior shot, taken from outside an upstairs window.
105 mm, 1/125 sec. at f5.6, Kodachrome 25, 82C.

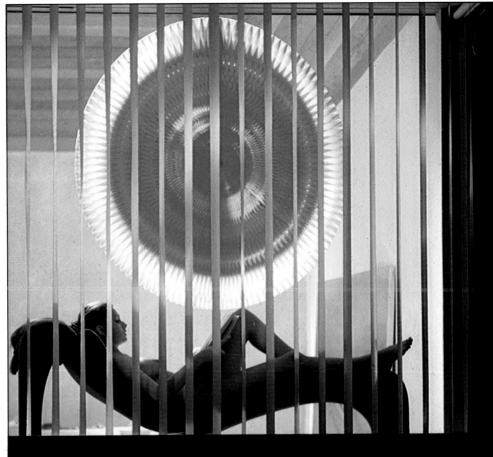

Using domestic fittings ▽
A pair of bedside table lamps, behind the curtains, might have produced enough light for this shot, but I replaced the bulbs with small photofloods and temporarily removed the shades to gain enough light to avoid having to work on the fastest color film. The overall yellow quality in the surroundings meant that the use of a warming-up filter to counteract the slightly cold quality of the photofloods was unnecessary.
28 mm, 1/15 sec. at f4, Ektachrome 160.

Motivating mood ▷
A mixture of three light sources contributed to the illumination in this indoor shot: weak winter daylight from the window; a photoflood in a reflector, creating the clip light around the model's head and taking the coldness out of the gray daylight, and finally the oil lamp, which I included more for mood than illumination (below).
105 mm, 1/8 sec. at f8, Kodachrome 25.

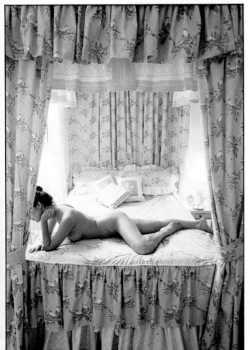

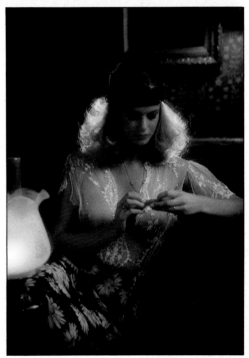

A whole new world of photography becomes open to you once you have acquired some floods and possibly a spotlight or two. But remember that more lights is no guarantee of better pictures; the secret is more control.

Although you now have more than one light to work with, it is wise to conceive and set up your shot with a single lamp and a reflector board to get your basic lighting correct before you introduce second and third lamps to do specific jobs. One useful rule is that each lamp must perform an independent task and not create a shadow in an area being served by another lamp. The effect of using a reflected flood to fill in the main light shadows on the subject must be very subtle. Similarly, if you are using an additional lamp to light the background, it is best to avoid spill from this lamp lighting other parts of the shot.

Of your newly acquired lights, the spotlight, with its sunlight-like capacity for fine rim lighting when shooting toward it, is the one which provides the greatest chance for picture excitement. It can also cast dramatic shadows when used in front of the model and is particularly useful in its ability to pick out specific parts of the shot with the help of a snoot or barn doors.

Manufacturers tend to sell lights with too few accessories. You will do far better with one light less and a full set of diffusing scrims, barn doors, snoots and a french flag or two. These are the essential tools for lighting nudes, for sensuality is usually best introduced by understatement and as a general rule the half-shadowed is more fascinating than the overlit.

Double clip light ▷
By putting two flood lights equipped with snoots on either side of the background (diagram right), a continuous rim light was created. The model kept the outline of the shot simple and the lighting separated the figure from the background.
Bronica ETRC, 50 mm, 1/15 sec. at f4, HP5.

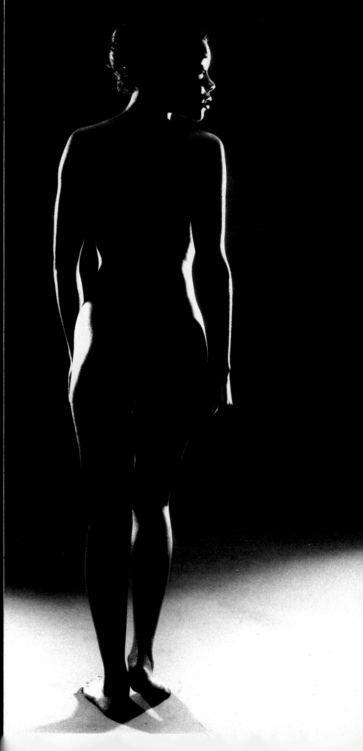

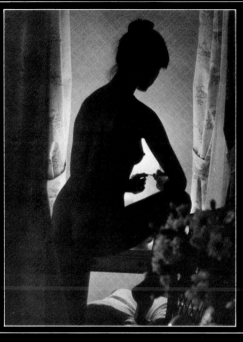

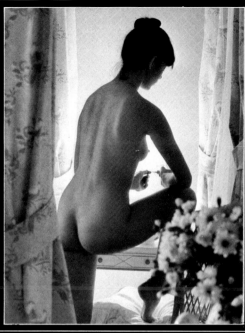

The effect of fill-in

By using a photoflood in the domestic fitting, I was able to make the far left version of this backshot. However, the use of an additional flood, bounced off the bedroom wall (diagram below), filled in the shadows of the back and gave the rounded effect in the picture on the left.
105 mm, 1/30 sec. at f5.6, HP5 (both pictures).

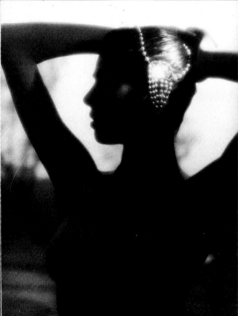

Spotlit silhouette △
A single spotlight above and to the right of the model, lit only the decorated hair in this late dusk silhouette shot. By fitting the spotlight with barn doors, the light was reduced to a narrow beam with no spill.
Bronica ETRC, 150 mm, 1/15 sec. at f4 HP5 soft filter.

Simulated daylight ▷
A daylight look was created by surrounding the model with white cardboard reflectors and bouncing floodlights off them. A spotlight used to create the effect of sunlight is detectable from the cast shadow on the right edge of the shot.
105 mm, 1/30 sec. at f4, Tri-X.

Extending the small flash

My small on-camera battery flash is the one piece of equipment that I always carry in my bag. Though seldom used as the only source of light in a shot, it has often enabled me to take pictures in otherwise impossible situations. Any small flash gun is useful, irrespective of power and whether synchronized to the camera by "hot shoe" or synchronizing cord.

If your flash gun has "converter lenses" which reduce or widen the basic light beam, together with a slot to accept filters to warm, cool or soften the light, you will have the basic equipment for many varied picture situations. An additional advantage comes when the flash gun is self-metering, or better still if the exposure is controlled through the camera meter, for with this sophistication there is no need to calculate exposure allowances when using filters.

The basic on-camera use of the flash gun direct, aided by no other light source, is limited in nude photography to fairly shallow shots with interesting backgrounds within touching distance of the model. Even here, however, the rapid fall-off of light (see Inverse square law, p. 165) will often produce muddy tones in parts of the shot farthest from the flash, unless the figure is very flatly drawn (see Wide-angle lenses, p. 32). Once there is a secondary source of light, the flash gun really comes into its own.

Filling in the hard shadows thrown by bright sun in close-up pictures is an established technique. At dusk or dawn, out of doors or inside, the flash gun can gently light the model in the foreground while the exposure is adjusted to give a richly colored background. In these moody light situations, because of the yellowing of the light in the late afternoon, care must be exercised in choosing a color filter for the flash to match the existing light in the shot. If you use a powerful battery flash gun or have flash synchronization at speeds above 1/125th of a second (found with between-the-lens shutters) there is another whole world of single flash pictures to explore. Drama and mystery can be added to nude pictures while working in daylight by using a reduced camera exposure to darken the sky and background. A hand-held flash connected by a synchronizing cord to a camera on a tripod can become the main light in the shot, with daylight providing the backlight and some fill-in.

Extra flashes with their own stands or with clamps to fix to doors and furniture can also extend the range of your shots.

Selective fill-in ▷
The beam pattern of a normal on-camera battery flash appears as narrow as a spotlight when using an ultra wide-angle lens on the camera (diagram below). By exploiting this quality, the fill-in flash in this shot did not destroy the mood of the sunset. Attaching pale amber acetate to the flash, to match it to the sunset color, and falsifying the ASA rating on the flash to create underexposure in the fill-in, guaranteed the subtlety of the result.
16 mm, 1/125 sec. at f4, Kodachrome 25.

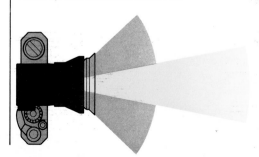

◁ **Multi-flash silhouette**
This exotic-looking
silhouette was created in the
studio by using two small
battery flash guns (diagram
above), one of which was
fired by photo-eye and the
other covered with green
acetate. One lamp created
the silhouette, which was
kept sharp by the model's
position close to the blind;
the second lamp lit the
leaves, which without the
green acetate would have
appeared colorless. When
using flashes for set-ups
similar to this, care must be
taken to baffle the light to
avoid undue spread from the
unshaded heads of the lamps.
*50 mm, 1/125 sec. at f8,
Ektachrome 200.*

◁ **Dominant flash**
With some of the more
powerful battery flash
packs, or when using a
between-the-lens shutter
with short synchronizing
speeds, it is possible to
increase the power of the
flash so that its light
dominates the picture. This
has the effect of darkening
skies and surroundings and
throwing the subject into
prominence. Here a single,
powerful battery flash gun
held above and behind the
camera increased the spread
of the light but this would
not have worked so well
had the daylight exposure
been greater.
*Bronica ETRC, 50 mm,
1/125 sec. at f8, Ektachrome
64, 81C on flash.*

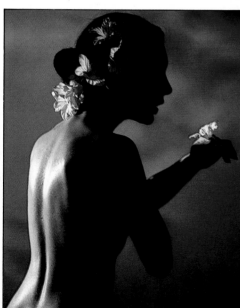

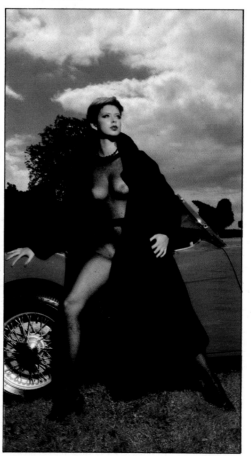

Single backlight △
Only one small flash, facing
obliquely toward the
camera and the model but
shaded from the camera
lens, was used for this
studio shot. Background
shapes were cast by the
mirror (diagram right).
*105 mm, 1/125 sec. at f4,
Kodachrome 25, polarizer.*

Ring flash

A glance through the fashion pictures in a glossy magazine will show you that the dominant lighting style for beauty pictures is a relatively shadowless light, coming from a point close to the camera. Such light used to involve a cumbersome arrangement of large, white reflectors, or umbrellas, with lamps pointing at them. A new device called a ring flash has solved the problem. First designed for shadowless medical and industrial close-ups, it has been adopted by fashion photographers to create a new light for the 1980s. A ring flash is highly portable, needs only a small power pack and consists of a circular flash tube attached to the camera encircling the lens to

produce a crisp light that fills in its own shadows. Because the light comes from close to the lens, it tends to light up the inside of the eye and "red eye" can be a problem, particularly in color work. I cure this by pointing a strong light at the model from a position close to the camera, causing the pupils of her eyes to contract.

Until ring lights are generally available, you may wish to experiment with making your own. All you need are four silver-domed domestic tungsten bulbs in an aluminum trough, surrounding the lens.

◁ **Umbrella ring**
Grouping three light umbrellas tightly together and then shooting through the gap produced a ring light effect for this tungsten shot (diagram above). Because of the lack of contrast between subject and background, and to give the soft umbrella light more bite, the fast film was uprated by one stop and overdeveloped to enhance the contrast.
135 mm, 1/125 sec at f5.6, HP5, soft filter.

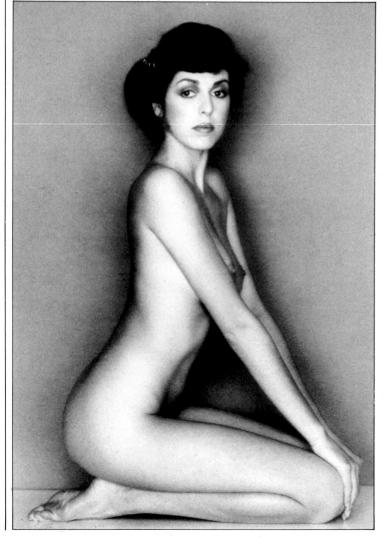

Plug-in ring lighting ▷
I used a prototype professional plug-in ring flash for this location shot. By shooting on a short lens from a low level, the model's height was exaggerated. The texture of the skin highlights and the brickwork were diffused by a weak, soft filter. The negative was slightly underexposed and under-developed to retain highlight detail.
Bronica ETRC, 50 mm, 1/125 sec. at f8, FP4, soft filter.

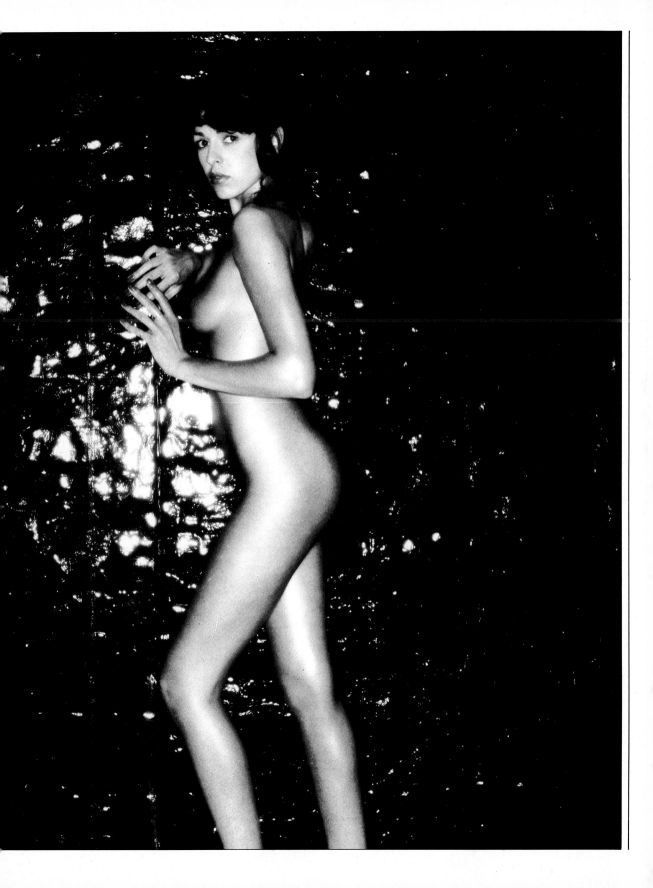

Studio flash technique

To attain the deceptively simple studio results found in fashion magazines, many pieces of equipment are in fact used. Foremost among them is plug-in flash, which provides high power for covering large areas, consistent soft light and balanced color.

When photographing a nude model in your own home or a reasonably small location, a practical plug-in flash outfit is one comprising two heads of approximately 500 joules each, with a photoflood guide lamp which is controlled in matching proportion to the output of the heads. The unit should also be able to accept a diffusing umbrella and a spot-type snoot. I personally prefer the smaller units in which the electronic components of the flash generator are in the same housing as the flash tube rather than being separately accommodated in a box on the floor. In any event, if you decide to equip yourself with either type you will find it has an extensive range of uses, from providing soft fill-in for strong sunlight situations to repeat stroboscopic images by multiple flashing.

Remember that flash units must never be touched when switched on or charged.

Simulated exterior ▽
Three powerful plug-in flashes (diagram below) created an outdoor impression for this studio shot. Seamless paper, lit without shadows, simulated the sky, while the strongly cast shadows of the palm tree gave a sunny feeling.
105 mm, 1/125 sec. at f8, Kodachrome 25, 81C.

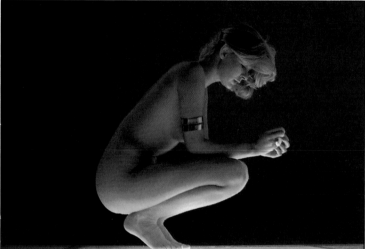

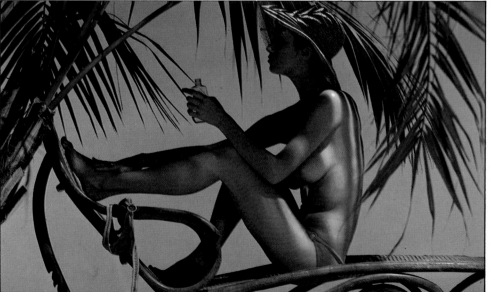

Light table △
The fixed glass of a modern table top was lined underneath with tracing paper. A plug-in flash head was placed under the table, pointing upward toward the model and masked from the camera by black cardboard. Additional low power fill-in light from an umbrella flash threw some light onto the background and the shadow areas of the model.
50 mm, 1/125 sec. at f8, Kodachrome 25, 81EF.

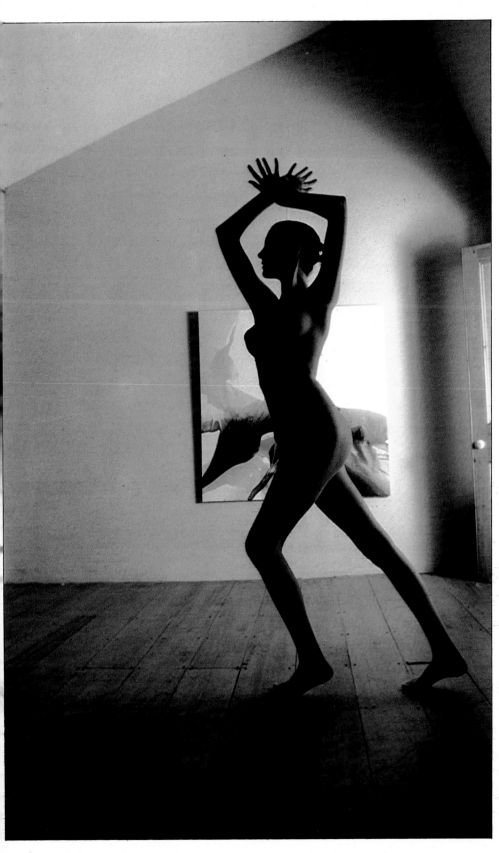

◁ **Softening the flash**
The ample power of a plug-in umbrella flash enabled me to place the light in an adjoining walk-in closet so that its white walls reflected light into the room, highlighting the painting and backlighting the model (diagram above). The doors controlled the beam of the light and left the model in silhouette to heighten the drama of the shot.
28 mm, 1/125 sec. at f5.6, Kodachrome 25, 81A, 10 CC magenta.

The language of black and white

Nude subjects lend themselves admirably to black and white photography since both subject lighting and the print can be manipulated with comparative ease to produce creatively satisfying results. If you have access to darkroom facilities, your printing skills can be used to produce a result which reflects your view of the subject.

Black and white is not the poor cousin of color nude photography, but rather the reverse. To succeed, however, it is essential that you plan your pictures from a tonal point of view. The effects that can be achieved in black and white by controlling tone and contrast at the shooting and processing stages are not difficult. Differing moods can be conveyed by using predominatly light, medium or dark tones in a picture. Even if you do not intend to process and print your film yourself, the desired final effect can be achieved by passing on your specific instructions to the custom photo laboratory.

Usually, it is best to decide on the tonal scheme of your picture before the shooting session but keep on the alert for happy accidents. Pictures which are basically all in light tones are called "high key", those all in dark tones "low key". You will only give a picture an ethereal quality, all in light grays and white, if the shot is arranged without large dark areas and is lit with relatively shadowless light and given a generous exposure. Low key pictures convey a heavier mood, and can often be made with only one or two unshaded back or side light sources, carefully placed to draw highlights round the figure but barely illuminating the background. Here a degree of underexposure can heighten the atmosphere.

Contrast also adds to mood. Pictures containing subtle gray tones in close harmony give a quieter feeling than the excitement of a dramatic mixture of black and white. You must decide on the mood you wish to project in the print and then choose the light and content of the picture for the contrast you want. For high contrast, use hard light from a point not too near the camera to intensify the difference in the tones. Conversely, softer, reflected light from close to the camera will help create a low contrast shot. Choice of film, adjustment of exposure, film development and printing papers can also be used to control contrast. For a beginner in black and white nude photography, however, the secret is to remember that tones in your print should give the viewer an instant feeling of the mood, be it airy, bright or dark, menacing or mysterious. Anything positive will work but do not simply let the automatic camera produce efficient, technically correct but dull results which do not project your intentions or feelings in any way.

High key ▽
By working in a white room with a white floor and plenty of soft, reflected photoflood light, I created this high key atmosphere in a cottage bedroom. To disguise the model's dark hair, I made her a scarf from a piece of white fabric. *28 mm, 1/60 sec. at f5.6, HP5.*

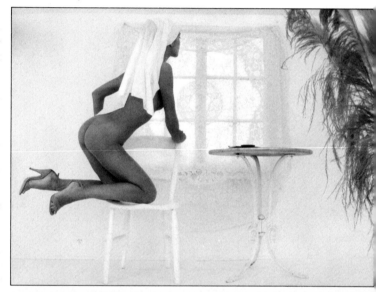

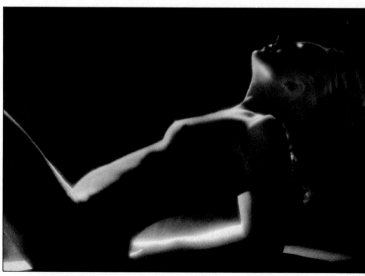

Low key ▷
I placed my main light on the far side of the model and facing toward the lens, with the light shaded from it. With this type of highlight shot, avoid overexposure to retain subtle qualities in the highlights.
Bronica ETRC, 150 mm, 1/8 sec. at f5.6, FP4, soft filter.

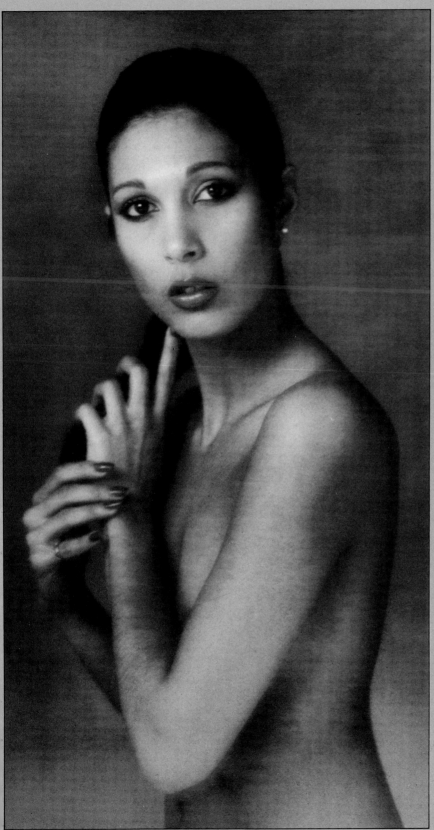

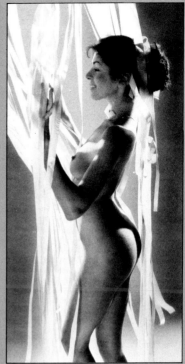

Contrasting tones △
White satin ribbon, brightly lit and frozen against a dark background by flash, is a naturally contrasty subject. Slight under-exposure and overdevelopment produced a crisp result, composed of sparkling highlights and shadows.
150 mm, 1/125 sec. at f4, HP5.

◁ Mid-gray tones
The model's air of calm led me to make a picture in tones of gray, which underlines her serenity. Lighting was from a diffusion box (fish fryer), which also lit the white paper background. I exposed generously and the negative development was slightly shortened to subdue the contrast. I then printed on a soft grade paper to emphasize the middle tones.
Bronica ETRC, 150 mm, 1/15 sec. at f5.6, HP5.

The language of color

Color has an emotional value in nude photography that cannot be overestimated. Control of the color elements in a shot can make sizzling images from quite ordinary material by simplifying the often complex mixture of colors in real life. Robust combinations of primary colors on the one hand, and sensitive arrangements of hues and tones of one color on the other, can be equally effective, but you should always ask yourself which will better reflect the message you are trying to convey. As a general rule, most nude photographs benefit from the use of only one main color, or at most two, with small touches of contrasting colors added to give emphasis.

Modern color photography can be extremely accurate but in nude photography, where we are trying to convey feelings rather than pure reality, the mood which color imposes is more important than scientific purity. Choosing the color "feel" is one of my first concerns when planning a picture. Practical considerations often limit the colors available in a shot, but these can be controlled by lighting. For example, moving a color into a brighter light in the shot dilutes it, in much the same way as adding white to colored paint produces a tint. Conversely, by allowing less light to reach a color it darkens.

Another influence on your pictures is the intensity with which color films reproduce color. This is called degree of saturation and is weaker in fast films than in slow films.

Contrasting primary colors ▷
The presence of the umbrella in the picture owes more to chance than skill, for my assistant gave it to the model to use as a screen when a truck approached. I liked the effect so much – the dazzling white soothes the aggressive mix of bright colors – that I included it in the picture.
50 mm, 1/125 sec. at f8, Kodachrome 25, polarizer.

Harmonizing colors ▽
By choosing the sympathetic brown color of the sofa as a setting for the model in her bright red slip, and drawing the two colors together by lighting them with warm, late afternoon sun, I created a harmonizing effect, which is enhanced by the gentle color rendering of the fast film.
105 mm, 1/125 sec. at f8, Ektachrome 200.

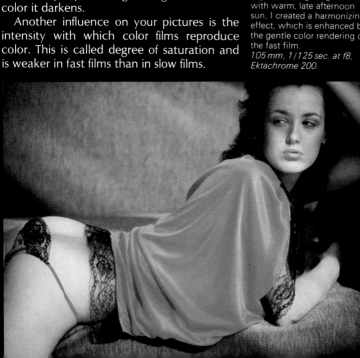

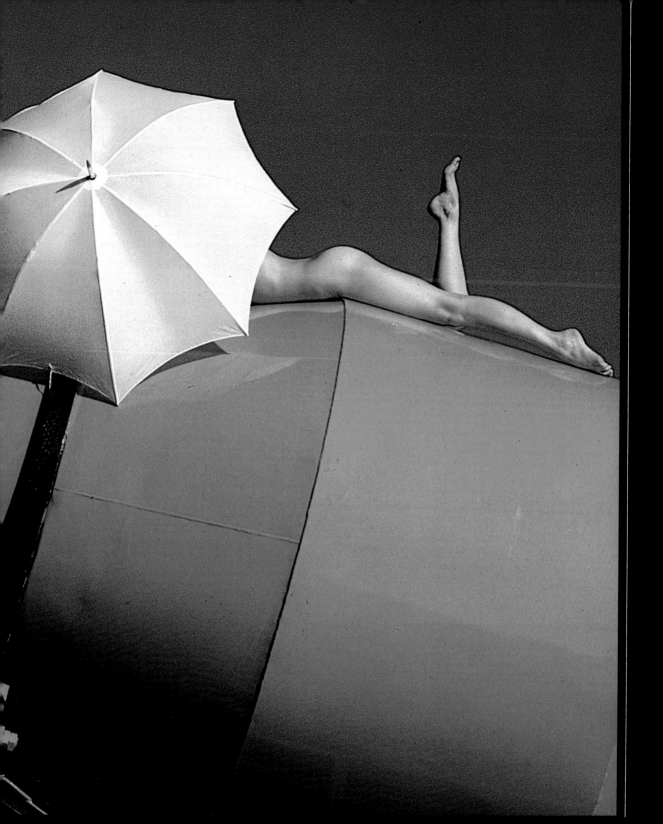

Black and white extended

You should already have an abundance of ideas for different treatments and styles when you first meet your model to plan a shooting session. Sometimes ideas arise from simple, practical limitations that you may be able to turn to your advantage. For instance, when organizing an indoor session it may be apparent that your model's liveliness can only be recorded with short exposures on fast film. In this case, work in soft, even light, then try developing your film in a diluted print developer that will push up the contrast and allow the film to be uprated two or three stops to produce strong grain.

All black and white films have different personalities. With the slower types of film, contrast is extremely high and grain almost invisible, while faster films usually have lower contrast but produce more grain. There is also the new family of non-silver films, which have extremely high latitude.

Try to get to know the characteristics of one or two black and white films by keeping notes of your experiences and experiments with them. For instance, increase the development times to above the manufacturers' recommendations, especially for shots made in extremes of light and shade, to create a "soot and whitewash" look. These high contrast pictures with no middle tones have impact where the subject drawing is simple and the situation composed of solid masses of tone. The image can be manipulated in the darkroom, so seek the unexpected result.

Improvised grain ▽
Technical improvements which have taken place with even the fastest of today's black and white negative films make grain a characteristic that is rarely used. I cheated here and sandwiched a commercially produced grain screen negative with a strong picture of a girl, and then printed them together on a hard grade of paper.
50 mm, 1/15 sec. at f5.6, Tri-X.

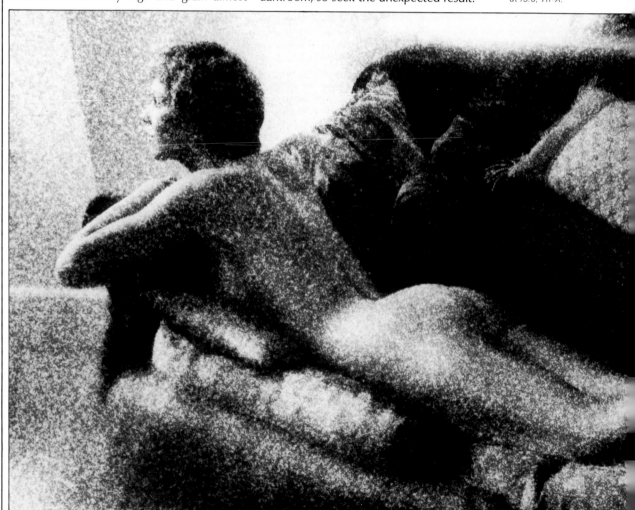

◁ Mysterious tonality

A more predictably correct range of gray tones would have robbed this studio picture of some of its atmosphere and excitement. I kept the exposure of the negative short and increased the processing time to achieve a contrasty result in which some middle tones are retained. This enhanced the effect of the surplus cardboard mounts which I stuck together to form a frame for the model to look through.
105 mm, 1/60 sec. at f5.6, HP5.

No middle tones ▽

A well modulated scale of middle grays may be technically correct but the power of solid black and white areas, especially in presenting the nude figure, must not be overlooked. Here I used bright, sunny daylight falling on the model's front, which I reflected on to her back via a mirror. Because I did not use a fill-in reflector near the camera, the shadow areas stayed black.
105 mm, 1/125 sec. at f11, HP5.

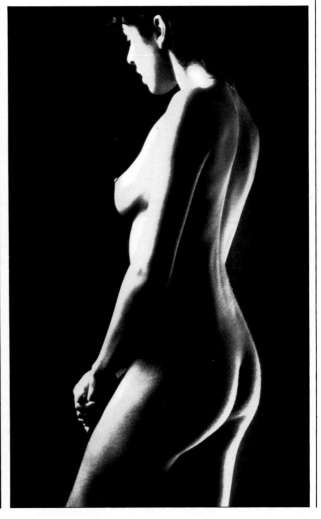

Restrained color

The nude photographer does not create, he records. Within his choice of subject and its setting, however, he can express his feel for color through control of light, films and props. The restrained colors in the pictures on these pages are the result of two quite different approaches, but the common factor in both is the careful planning of color content before the pictures were made, for when visualizing a picture I take care to relate the colors and tones in the shot to both the available light and the type of film to be used.

Films of differing speed and manufacture have widely varying color performance and choosing the right film for your shot will enhance the restrained color style. For most of my work I prefer Kodachrome 25 film, which does not give a particularly restrained result. I have to be fastidious, therefore, in my choice of props, clothes and setting.

Starting with one or two props in the right color, I ask the model or my stylist to search out harmonizing colors for clothes and other accessories that will build up the shot. Color is not the only consideration in styling for a muted effect. I try to limit the tones in the picture by keeping them either to shades of light or dark, or even better to a range of mid-tones, to avoid harsh contrasts of light and dark which would destroy the mood.

The result of this care is to give the shot a calm, quiet feeling with subtle color relationships which have then to be sensitively recorded on film. To achieve this, it is important to use the right color correction filter.

Co-ordinating colors ▽
Having chosen the fabrics and cushion colors for this daylight picture, I chose the model's clothing and eye-shadow to blend subtly with them. As the gray light from an overcast sky was coming through two thicknesses of glass in a double glazed skylight, I used an 81A filter to warm up the light, and 10 CC magenta both to help the pinks in the picture and to counter any green from the double glazing.
50 mm, 1/60 sec. at f5.6, Kodachrome 25, 81A and 10 CC magenta.

Color from filtration ▷
As this scene originally lacked any positive color, I added strong yellow/brown filtration to the camera lens. This affected the mid-tones in the picture, such as the skin and the cat, while leaving the white of the robe and the black of the background less tinted. I lit the picture by daylight from a window and used two reflectors (diagram above).
105 mm, 1/125 sec. at f8, GAF 400, double 81EF.

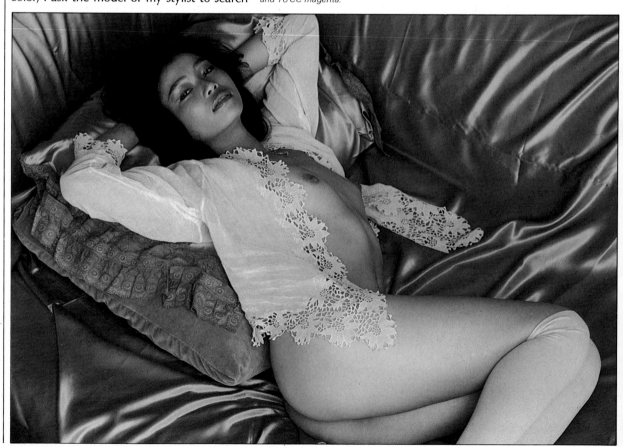

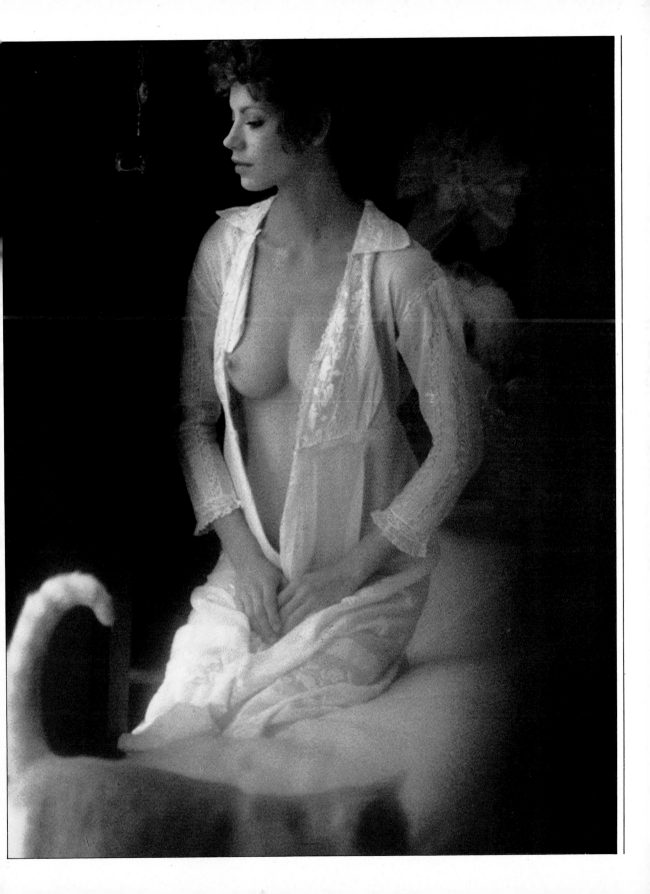

Working in tones of one color

Early color film could not reproduce the brighter colors of the spectrum. Constant research has since extended the color range of film but with this emphasis on increased brilliance it is easy to forget that clear, accurate color is not necessarily ideal for all subjects. In nude photography the "less is more" philosophy usually applies, so that the value of subdued tones and a limited color range must not be underrated.

Creation of mood rather than color accuracy can be achieved by using only tones of one color. Relatively colorless mid-tone subjects set in fairly plain backgrounds often make good monochromatic shots which benefit from the use of a single color. Heavy filtration, either on your light or your camera, to the shade required and a wide exposure bracket are necessary. The addition of a fog filter or a strong soft focus attachment will heighten the atmosphere, but you must then accept the loss of detail which will inevitably result. As with any technique, the secret is to know when to use it; learn by experimenting.

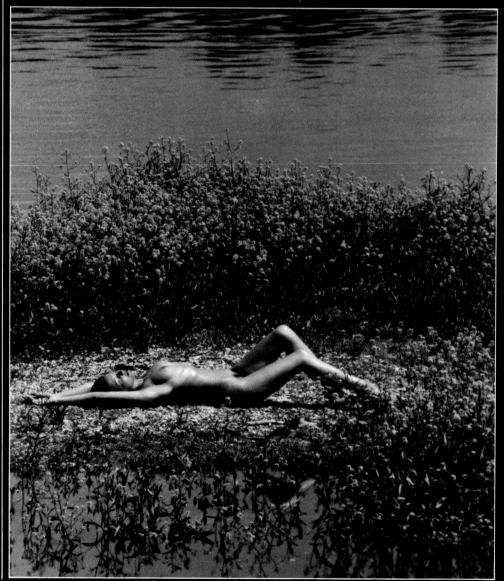

◁ **Restful tonality**
Some black and white photographs, usually those of simply presented subjects which contain a full range of middle tones with touches of bright highlight and deep shadow, can lend themselves admirably to color toning in one of the many currently available after-bath processes. This print of a model sunning herself on an island in the Seine river, France, would not have worked had the image been confused by other graphic elements.
300 mm, 1/125 sec. at f8, HP5, polarizer.

Imposed color ▷
Simply drawn arrangements using a nude figure in a bare interior can often be conceived and executed in tones of one color. Here I used an acetate lighting filter on the camera to produce a more effective result than a picture containing the full range of color tones. The background, which was an image thrown on a wall, was sympathetic in color to the final result (diagram below).
50 mm, 1/4 sec. at f2, GAF 400, blue filter.

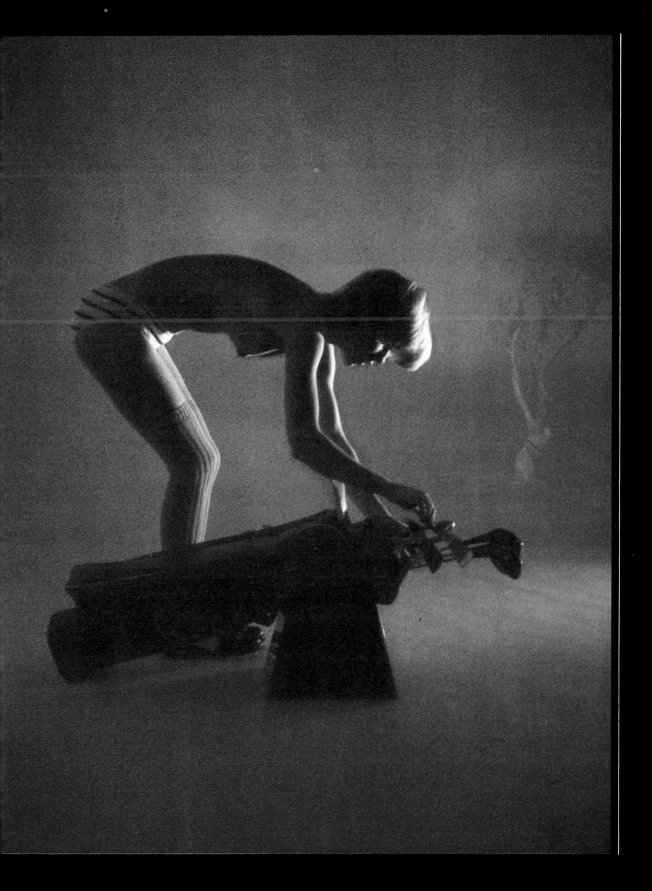

Professional black and white

Professional photographers stress that there is no great difficulty in making good black and white pictures; all that is needed is the patience to take endless care at every stage in the process. Care must, of course, be given to the choice of location, model, lights and film, and to the manner in which a picture is printed, finished and mounted. These stages are routine to professionals. For example, they will shoot two or three frames at the end of every black and white roll in conditions identical to those in the earlier part of the film; these can be cut from the roll and processed as a "clip test" before the bulk of the film is developed. From this test they can evaluate the ideal development time (a critical factor in attaining perfect print quality) and make adjustments accordingly. Similarly, in the printing stage the professional will sometimes print the same negative on two or three grades of paper to determine the best contrast for the finished result.

Another touch of quality which the professional brings to his work is the care with which the print is spotted with a dye, matching the image color, to fill in white dots on the print caused by specks of dust or small scratches on the negative at the time of printing. For the highest quality work many photographers still prefer to use fiber-based papers, which enable them to use a retouching blade to scratch away unwanted dark areas, such as shadows under a model's eyes.

Finally, professionals give a print the respect it deserves by mounting it on stiff cardboard to protect it from damage. They may also laminate the print between two sheets of heat-sealed plastic to protect it further.

Pursuing a vision ▷
The intensity of images which exist in the professional photographer's mind drive him to demand exactly the effect he wants from all those who work with him. Having found the two models whom I felt ideal for the picture on the right, I arranged the light, directed the shooting session and made the print without ever losing sight of the image I was trying to create. Little was left to chance, for even the smallest deviation from my plans may have ruined the result.
50 mm, 1/125 sec. at f5.6, FP4.

Emphasizing quality through restraint ▽
The professional photographer, like the good chef, knows the vital importance of the quality of his basic ingredients. Even the simplest picture will be pleasing if good ingredients are well presented. Here the quality of the model left me nothing more to do than place my seamless background paper to receive daylight favorably from two windows, apply a soft filter to the camera and expose and process the negative and print with care at every stage. *Bronica ETRC, 50 mm, 1/4 sec. at f8, HP5.*

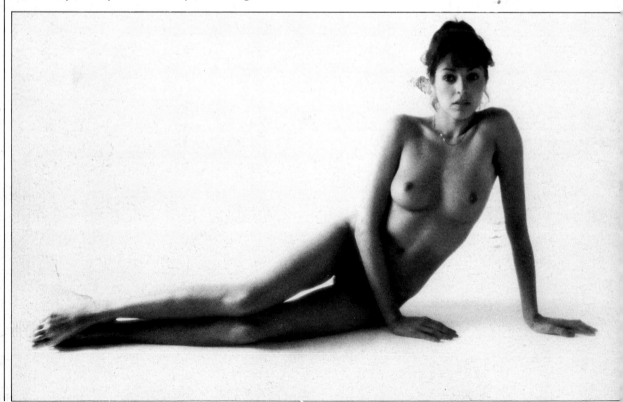

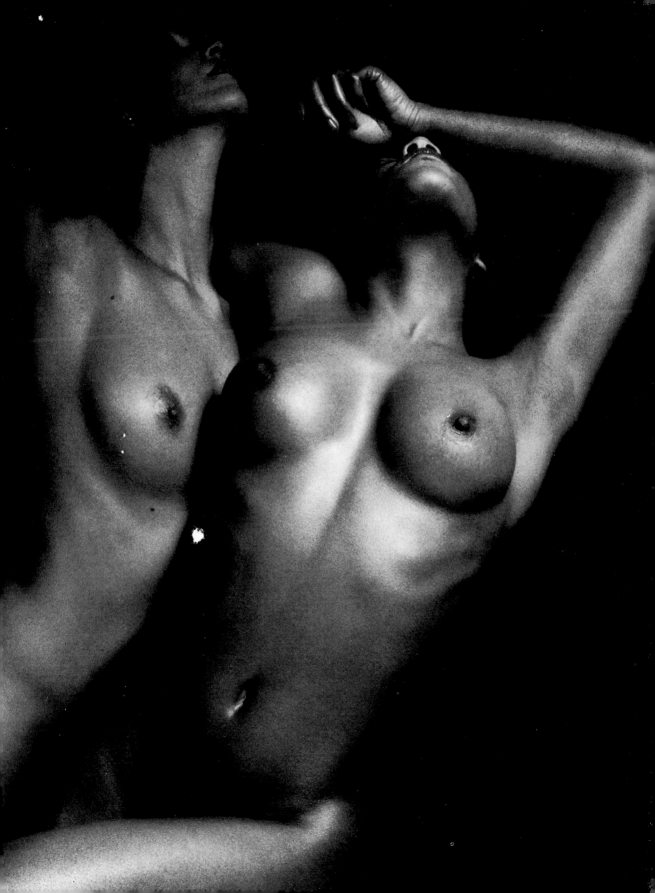

Choosing color for effect

Even the prettiest model looks better when pictures have an effective color "feel", chosen to fit the mood of the photograph. Sometimes this color content is planned well in advance, with careful choice of contrasting touches in props and clothes to enrich the main color of the composition. For an unplanned picture, the tonal bias and contrasting touches may have to be the inspiration of the moment, such as a red wild flower used to relieve the green of the grass in an exterior shot. Though such color touches are small in the picture, their presence sharpens the main color.

In my experience, nude pictures usually need an atmosphere of warmth and should be shot in warm colors. When I am working in a cold, gray-blue atmosphere, therefore, I may choose a yellow oil lamp as a color touch, both to warm the mood of the picture and to provide a reason for the positioning of the spotlight on the model. On the other hand, as the sunset pictures on these pages illustrate, when it is warm and the model happy, you can dispense with color touches.

Perfect conditions ▽
When the sun sinks into the sea and you and the model have the beach to yourselves, you have a recipe for success. Do not forget, however, that sunsets are not as red as you may think and a strong effect filter must be added to the camera to achieve a warm, convincing result. *105 mm, 1/250 sec. at f5.6, Ektachrome 200, 50 CC red.*

Gray daylight ▷
Even weak winter daylight indoors can be a good maker of mood. In this experimental shot I used nylon curtain net stretched on a frame supported over a plastic mirror, and lit from a window. This made a cold, tent-like background in which the warm lamp shone like a beacon. A carefully placed 300 watt spot lit the model and the camera filtration prevented the daylight blue from swamping the picture.
Bronica ETRC, 150 mm, 1/4 sec. at f4, Ektachrome 160, 81EF.

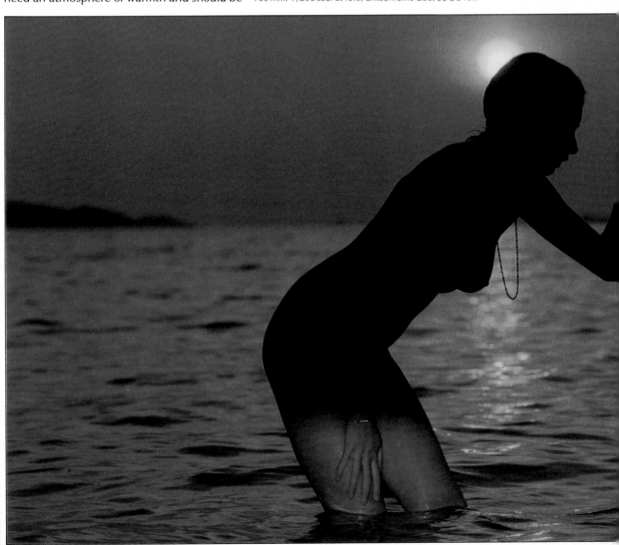

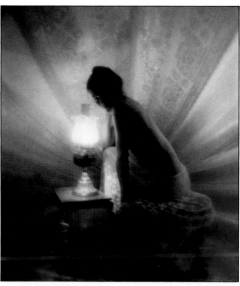

◁ Pre-planned color
I had been watching the field of yellow flowers near my home for some days, and hoping for sunshine. When it came, my brightly-colored kite gave just the right touch of color contrast for the expanse of yellow.
28 mm, 1/125 sec. at f5.6, Kodachrome 25, 81A and polarizer.

◁ Flower power
A neighbor's rye field just before sunset gave me a green setting, which worked even better when I found the contrasting poppy to give color relief. I asked the model to crouch down so that she was completely below the heads of grain, which simplified the picture.
50 mm, 1/125 sec. at f8, Kodachrome 25, 81B.

Improving the image

In nude photography, black and white negatives have one big advantage over color transparencies: once you possess a successful negative and have reached a sufficient technical and creative skill in printing, there opens before you a wide variety of possible darkroom treatments. Even if you do not produce your own prints, custom photo laboratories can work to your instructions.

At the simplest level, techniques such as enlargement diffusing, sepia toning, solariza-tion and posterization (see p. 138) and many more are available. Before printing, it is important to look at your best black and white pictures objectively, deciding on the style of treatment appropriate to the feeling you are trying to convey. Never be afraid to experiment in the darkroom. Treat your best nude negative as the starting point of a voyage of discovery and, when you find a method that pleases you, you may also find that discarded pictures have been given a new lease of life.

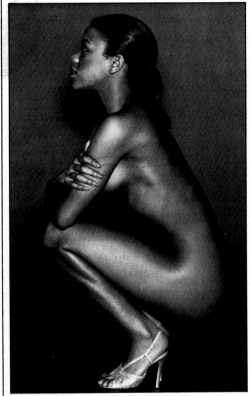

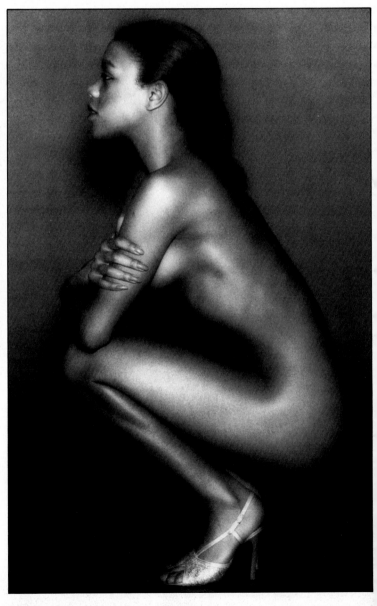

Enlarger diffusion
I am constantly trying to produce the highest level of technical quality in my work but the perfectly sharp, clear image is not always the most effective for nude prints. The correct print (above) gave the model's skin an unattractive appearance because of its contrast and sharpness. For the picture right, I printed the same photograph on the same grade of paper but used a nylon stocking, stretched on a square frame, as an enlarger diffuser between the lens and the paper during most of the exposure. This reduced the contrast and diffused the image.
105 mm, 1/125 sec. at f8, FP4.

EXTENDING THE SUBJECT

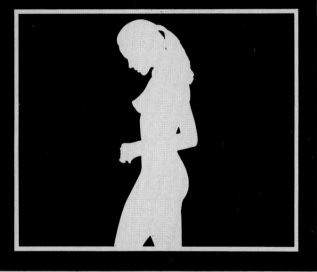

Sensitive grouping

A model's personality must be captured by the photographer and to do so successfully depends in large measure on the relationship between the two of them. When you are photographing more than one model in a natural style, however, the situation changes. It is then the relationship between the models themselves that becomes of dominant importance. A convincing father and child study conveying trust and love, for example, will never be made by a dominant photographer stamping his directing style on the picture. Success in getting quiet, happy shots depends on skilful planning, with sympathetic lighting and setting, to create the right mood.

For such intimate work, use equipment and techniques with which you are familiar. Preferably, shoot in a daylit setting, either indoors or outside, with plenty of soft light bounced off reflectors.

Romantic group ▷
I chose white and green clothes for the models and used a soft focus attachment on the camera to give romance to the scene and to modify the spottiness of the wild white daisies in their dark green setting. By asking one of the models to arrange the hair of another and asking the third to stand behind and look on, the shot was given mood and the models something to do.
50 mm, 1/125 sec. at f4, Ektachrome 200, 81EF, soft filter.

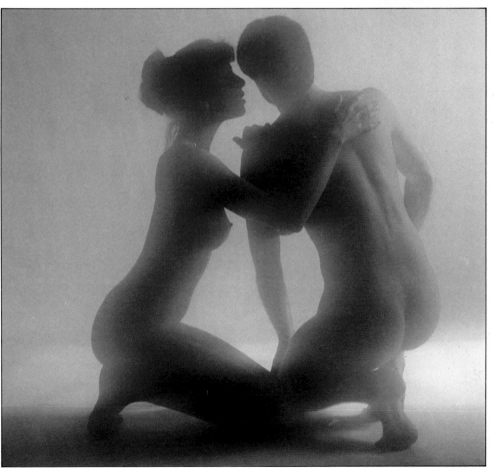

◁ Simple composition
Thinly smeared petroleum jelly on an unused skylight filter produced the image-softening effect for this daylight interior shot. Because of the simplicity of the figure shapes, the softness did not destroy the message of the picture. The mood of the shot was strengthened by the strong lighting contrast, which I achieved by posing the couple on a sheet of seamless white paper in a room lit only by a shaft of sunlight coming through a large window. The light fell on the white paper immediately beyond the models to make this semi-silhouette image.
105 mm, 1/8 sec. at f8, Ektachrome 200, 50 CC blue and soft filter.

Graphic groups

Group photography can take a number of directions – natural style, soft mood groups as illustrated on the previous page or more aggressive, design-oriented pictures as shown on these pages.

Strong pictures of adult groups often need a unifying factor. This can be provided by props or location and careful choice will simplify the directing of the shot, for it is not easy to tell two or three people what to do simultaneously. It is therefore essential that there is a rapport between the photographer and the models and a general understanding of the shots involved before the session begins.

When planning group photographs which depend on graphic quality, do not concern yourself only with the relationship between the models that you are using. The success of this style of work is frequently increased by the graphic strength created by careful positioning of the models, not on the intimacy between them. In fact, the photographs on these pages were made with models who had never met each other previously, but had only been consulted in advance as to their willingness to help me make this type of picture.

Photographing nude groups by artificial light can be daunting. However, if you have a clear design idea and can direct the models vigorously, an effective composition can result. Tension is the most important quality, so by working in an urgent, staccato style, and not giving the models a chance to relax, the lines of the figures remain tight. For lighting, I prefer a style which underlines the sculptural potential of the subject. This means deep, rich shadows and a strong tactile quality, sometimes helped by oiled skin. I use this atmosphere of moody tension to avoid uncertainty, both at the time of the shoot and in the final picture.

I also believe that shadows build drama into a shot. I like to work with an anonymous, dark background and to arrange the figures on different levels to facilitate the composition of limbs and bodies. For this I use boxes covered with dark carpeting; these are not comfortable and therefore do not allow the models to lose the tension I have created.

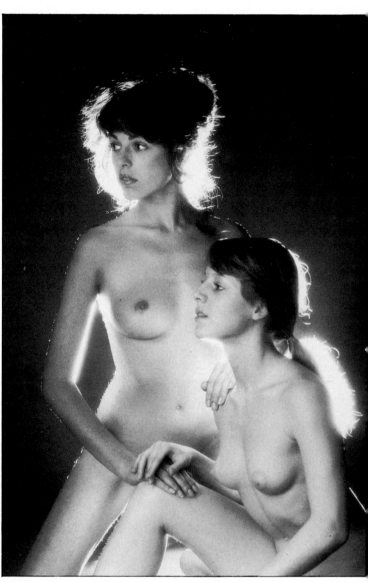

Atmospheric lighting △
A 500-watt tungsten spotlamp, hidden behind the two models, provided all the light for this studio shot. The model on the left was mainly lit by reflected light from the body of the right hand model. Two reflectors were used beside the camera (diagram right). *Bronica ETRC, 1/15 sec. at f5.6, HP5.*

Dynamic tension ▷
I exploited the pattern potential by placing the figures close together in the frame. I used bounced flash off a light-colored ceiling and a large white reflector below the models to fill in the shadows. The action-stopping quality of the flash enabled me to shoot just as the models reached the peak of their stretching action. *40–80mm zoom, 1/125 sec at f11, HP4.*

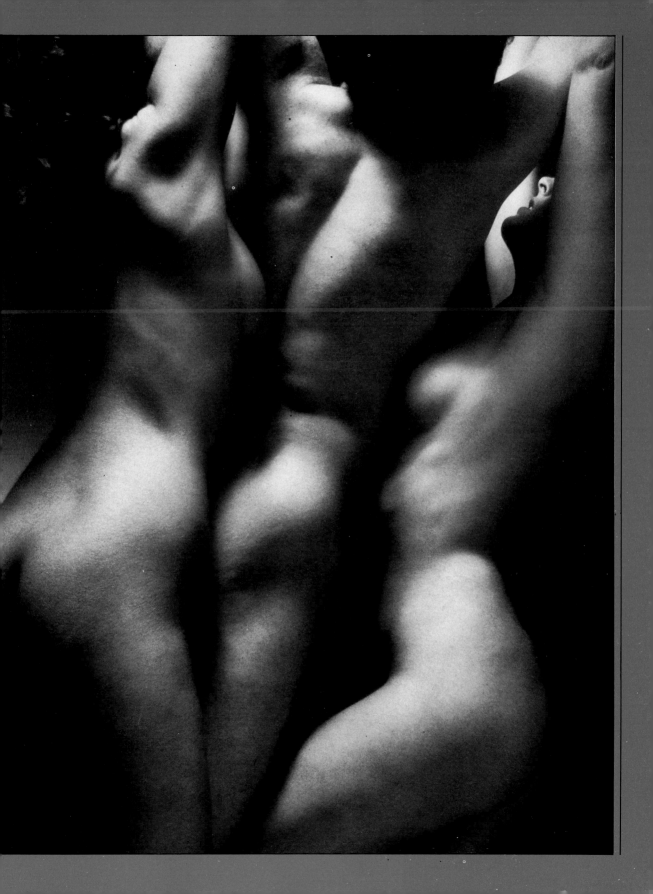

Exterior locations

Just as you can assess the good and bad points of a model and make successful pictures by exploiting her best qualities, so you should analyze locations for outdoor nude photography. To this end I use a check list of factors to be considered. Does the location offer privacy? Does it have good picture potential? Is there any protection against inclement weather, such as shade or cover from the rain and wind? Are there changing facilities for the model and, finally, does the distance from home make the session practicable in terms of cost and time?

It is not necessary, of course, to have a "yes" answer to all these questions, for many successful pictures have been taken in less favorable conditions. Nevertheless, your location should certainly have at least some of these features if you are to have any chance of achieving good results.

Picture potential is often farther down my list than some of the other factors. With good ideas, thoughtful planning, appropriate props, a kindly climate and guaranteed peace, success can often be achieved in a featureless location without other aids.

I find it helpful to set up a make-shift dressing-room, with a white sheet on the ground for props and clothes and a small mirror attached to a tree or wall to help the model arrange her hair and make-up. If the imagined idyll of a long day on a hot, deserted beach with a beautiful model is not in reality to become a nightmare of sunburn and of sand in the camera, you will need some sort of base to work from.

If cost is not a limiting factor in deciding the distance you need to travel, then common sense should be. In other words, driving time is shooting time. To reach your destination tired and to find that the light is already behind a hill is profitless. You must, therefore, do your research beforehand, seeking out locations and judging the best time of day to exploit them for good light. Remember, too, that you need not settle for a country scene, for you may have the opportunity to make some good shots on a screened balcony or even a deserted roof top in the city.

When you are photographing nude models out of doors you must be aware of the laws in effect wherever you are working. Needless to say, you should never obtrude on others, but in some countries even modest exposure is not only considered objectionable but is punishable under law. Therefore always seek privacy and have a wrap ready for your model.

Wide-angle background ▷
After unsuccessfully trying to take a good bicycling picture, the model accidentally fell and I seized the opportunity to get an unposed shot. By using a short focal length lens it was possible to keep most of the flowers in reasonably sharp focus, though I took care to avoid distorting the figure.
24mm, 1/125 sec. at f4, Kodachrome 25, 81B and polarizer.

Chance location ▽
The pile of gravel beside a highway provided me with a chance, secluded shot while traveling between locations. All I had to do was to position the model and wait for a break in the clouds.
28mm, 1/125 sec. at f5.6, Kodachrome 64, 81B.

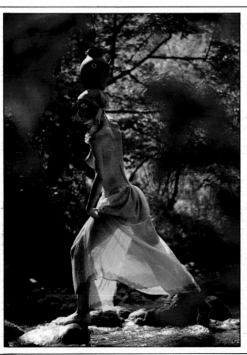

Exploiting situations
This French mountain stream offered such picture potential that I worked by it for some days, using different models and ideas under a variety of light conditions.
105mm, 1/60 sec. at f5.6, Kodachrome 25, 10CC magenta (both pictures).

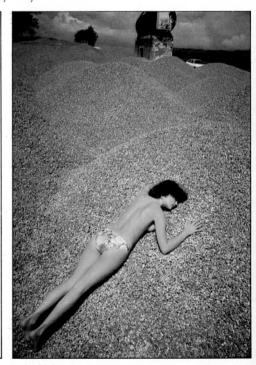

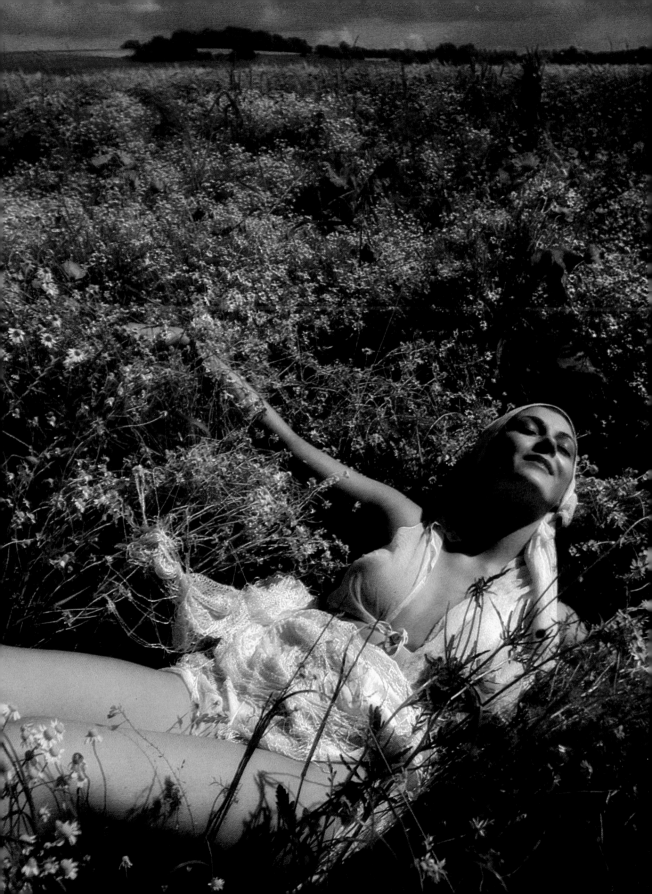

Problem interiors

A small interior location, far from being a drawback, can often be turned to your advantage. For example, the framing effect of working in an empty closet can be highly pictorial. As long as you can move the furniture and make yourself some clear space, the size of your location is immaterial.

Far more important is the light. Small spaces need less light, a reasonably large window and a few lamps being sufficient. Moreover, if the walls are white you will not need many reflectors. (In color photography, of course, unless the walls are white you will have color casts in your reflections.)

Large or cluttered interiors can also provide pictorial atmosphere. Here, however, you must place the model in such a way as to prevent her being overwhelmed by decorations and furniture. You can do this quite easily by isolating her and ensuring that the light she receives is stronger than that which falls on the rest of the room.

Indoor locations offer one great advantage over exteriors: they are not subject to nature's forces. But for this very reason it is doubly important that you keep your pictures fresh with good, imaginative ideas.

Complicated location ▷
The picture potential of this gloriously cluttered artist's studio was exploited by shooting from a low level on an ultra-wide lens, with the camera fixed to the back wall. I chose a shooting position in a dark corner of the room, looking toward the windows and with the figures in a better-lit area. Though the low light level forced a long exposure, I felt that any additional artificial light would have ruined the atmosphere.
15 mm, 1/4 sec. at f5.6, HP5.

◁ **Confined space**
The limitations of this bedroom closet were in fact an aid to posing and lighting the model. The white walls bounced the soft light around generously and created a "beauty light" atmosphere. A discarded kitchen chair, painted white, just fits the space and makes the shot easier for the model. The striped socks accentuate the model's nakedness and give a touch of contrast to the otherwise monotone arrangement.
28 mm, 1/30 sec. at f4, HP5.

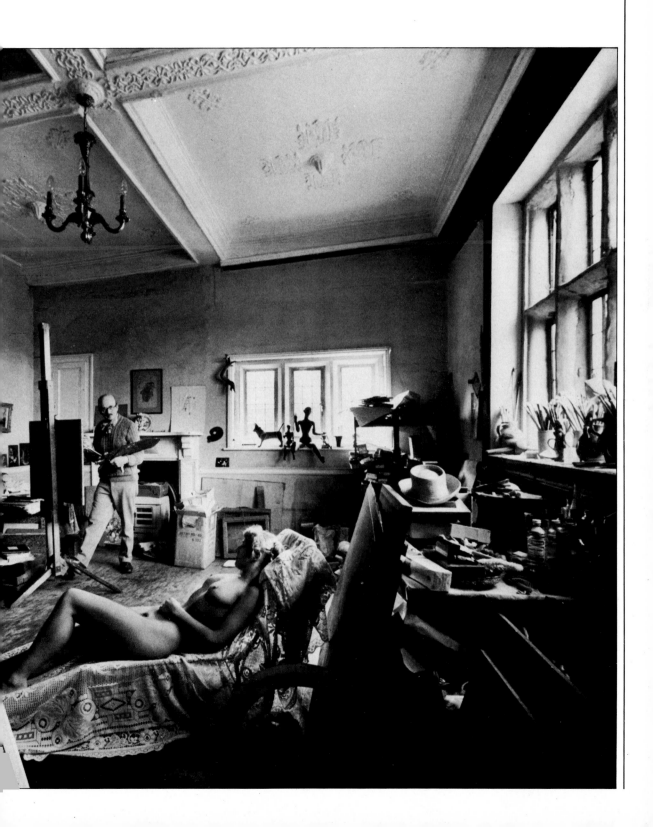

Finding and choosing props

Props, a word that has come to photography from the theater, where "properties" are those objects carried in a production by actors, can be used in nude photography to give models something to do with their hands and to engage their minds. Even when you extend the definition of props to include automobiles, locomotives and even small aeroplanes and boats, which are really locations, you are still giving the model something to hold on to or touch and a setting to work within.

The best props are those which can be used simply by the model, preferably with one hand. Two-handed props can cause the model to cross her body line with her arms, creating compositional problems that can be difficult to overcome. Particularly successful are everyday objects when used in an unexpected context. Complicated props, on the other hand, can make the model feel ill-at-ease and look awkward. The right prop is one that adds a final touch to the pictorial idea, supports the mood of the picture and occupies the model.

Controlling props ▽
A French canal lock keeper loaned me this boat and some of his ducklings. Because of the intense cold, I quickly shot a roll of film after the model had scattered grain to keep the ducklings from jumping out. *50 mm, 1/60 sec. at f4, Kodachrome 25, 81EF.*

Inexpensive prop ▷
Even the simplest domestic item can be used as the basis for an idea, especially if it is used in an unexpected way. This plastic bag became a useful prop when filled with water. *50 mm, 1/125 sec. at f8, Kodachrome 25, 81A and polarizer.*

Out-of-context props △
An apartment, decorated with billboard advertisements, gave me the idea for this simple bucket and brush picture. The props were the obvious choice to complement the witty setting.
28 mm, 1/125 sec. at f8, Kodachrome 25, 81B.

Location prop
Though this Tigermoth biplane may appear an expensive prop, it was in fact loaned to me by a flying club, which kindly parked it adjacent to some attractive flowers on a distant part of the airfield to enable me to take the strong perspective shot (left). The positioning of the model was dictated by the fragile surface of the aeroplane wing, which limited the areas in which she could work. By obscuring the model with part of the wing structure, the eye is more forcefully drawn to her than if she had been placed in an obvious position. By comparison, the smaller picture (above) was taken at the same session and was composed to increase the emphasis on the model.

24 mm, 1/125 sec. at f8, Kodachrome 25, 81B (left); 105 mm, 1/60 sec. at f8, Kodachrome 25, 81B, and polarizer (above).

When you find a good prop that will add to the mood of a shot and give the model something to do in the picture, make as full use of it as time and other considerations permit. Shoot as many different treatments as you and your model can devise, as it is easier to see which treatment is the best after processing.

Apart from the obvious logic of not wasting a valuable opportunity, there are psychological advantages to this approach. If, for instance, you concentrate on just one set-up for an hour or more, both you and your model will become stale and unimaginative. Movement and change of emphasis, on the other hand, which come with shooting a prop in a number of different ways, will loosen up the session and stimulate good ideas.

Do not ponder too long on different possibilities, if time is limited. It is far better to expend a few more frames of film, shooting every facet of the scene, and then make your decisions when you have the finished pictures in front of you.

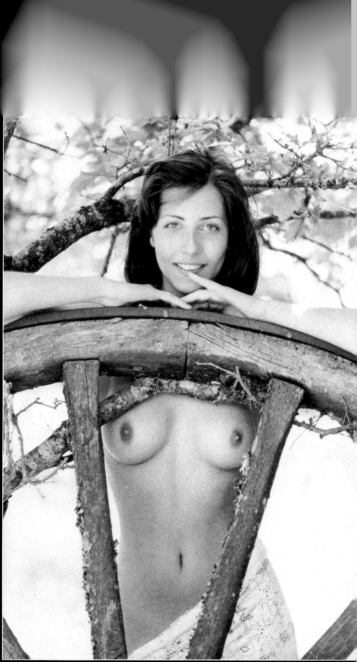

Background wheel ▽
The prop was used here as a background to accentuate the curves of the body. I asked the model to adjust her head-scarf, which gave the picture a natural look and modified the harsh effect of the top sunlight on her shoulders.
105 mm, 1/150 sec. at f8, Tri-X.

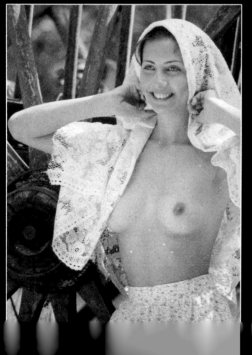

Exploiting design
Setting the curves of the model's body exactly in the gap between two straight spokes, emphasizes her shape in the picture above. Another arrangement (left) was used to exploit the shape of the wheel rim and give more space for the model's arms. In both cases the wheel was moved under a tree, which reduced the harsh top light, leaving only reflected light.
50 mm, 1/125 sec. at f5.6, Tri-X (both pictures).

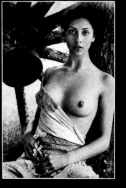

Scene-setter
Another treatment of the
wheel, made after the model
had changed her clothes
and hair style, explored a
less brazen approach. The
wheel became more of a
rural symbol than an actively
used prop. My original plan
was to shoot the wide-
angled picture, where the
model has demure, down-
cast eyes (right), but as I
was unsure of the success
of this I also made a more
direct portrait on a longer
lens (above), where I asked
the model to look directly
into the camera.
*28 mm, 1/125 sec. at f5.6,
Tri-X (right); 105 mm,
1/125 sec. at f5.6, Tri-X
(above).*

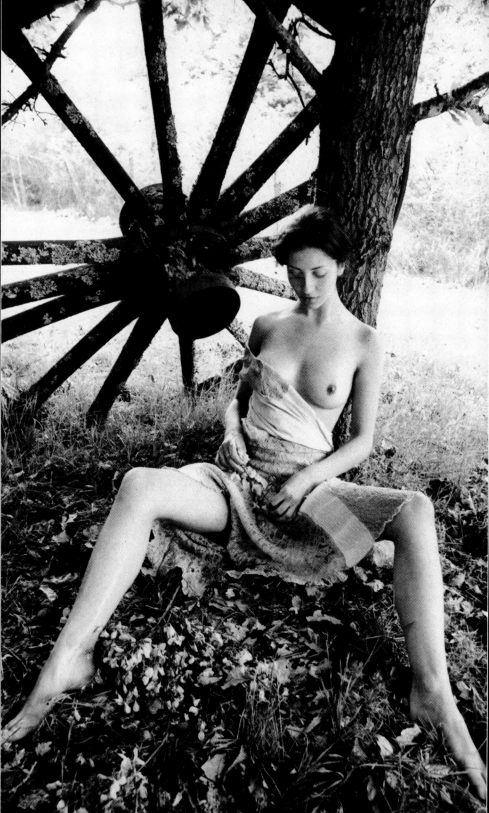

A day with a model

The ability to visualize a picture before you take the shot is vital in nude photography. Planning your session with a model is also important and you should prepare all the photographic and personal items in advance (see p. 154).

A preliminary, unhurried visit to the location is always helpful. Take some picture ideas, such as magazine tear sheets, a sketch book and a list of props suitable for the location and model. Inspect the possible picture situations, bearing in mind the uncertainty of the weather on the day of the session. Look, too, for potential possibilities as well as the obvious ones. Many situations, with minimal additions or alterations, can offer rewarding prospects. At the same time, look for basic picture ingredients – texture, pattern, perspective – which you can use in composing your pictures.

After you have studied the location, try to slot together some of your existing ideas for pictures with those the situation offers. This is not always easy to do alone and you would be advised to take either the model or a friend with you to discuss possibilities. The object of the discussion should be to produce a list of picture ideas (visuals) which fully exploit the potential of both location and model. Always analyze the model's best points and make the best possible use of them. For example, if she has shapely legs try to plan shots that will positively benefit from their inclusion; make the legs a focal point. Plan to make pictures that tax all your skills and those of the model. Vary the mood and atmosphere and try for changes of scale, even attempting different styles where you can. With experience, your own style will develop and certain types of picture will attract you more. At the beginning, however, it is better to try your hand at a wide range of approaches, from action to close-ups of the head. Then, when processed, select the most successful and build from these.

Once you have thought up four or five visuals for the day, place them in the order that will be most practical. For instance, you could begin with an attractive, natural action shot to relax the model and give you both confidence, and if water is involved it is sensible to take those shots before lunch so that the model can dry her hair during the noonday break.

Natural action to start the day – 8:30am △
The model was relaxed by this simple pose and the pretty styling works well in the soft, early morning sun. The swing was prepared before the session began. Bandages were used to fasten plastic flowers to the rope before the swing was hung in the tree and tested.
50mm, 1/500 sec. at f2, Ektachrome 200, 10CC magenta, soft filter.

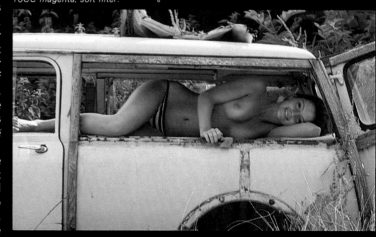

Weatherproof idea – 10:00am △
Framing the model in an abandoned automobile looks simple. In fact, boxes and a long pad of foam rubber were arranged inside to raise the floor to exactly the right height for the model. Shade from the roof helped create a beauty light for her, which was intensified by a white reflector laid on the ground close by.

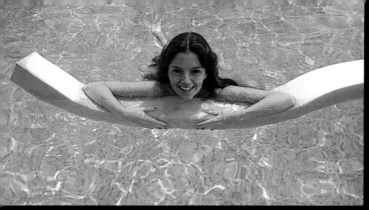

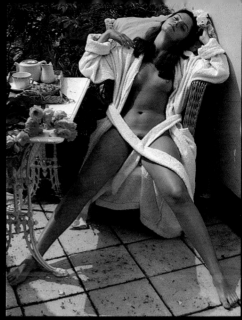

**Cooling off at noon —
2:00pm** △
The dirt and heat in the previous picture suggested a cool, simple pool picture for the next. Foam rubber used earlier gave the shot shape and supported the model in the water.
105 mm, 1/125 sec. at f4, Kodachrome 25, polarizer.

Relaxed pose — 2:00pm ▷
A model relaxing on a balcony after lunch falls naturally into this sort of pose, which would have been inappropriate earlier in the day. The pink roses and white wrap enhance the model's overall suntan, while the green leaves provide a contrasting background.
28 mm, 1/60 sec. at f5.6. Kodachrome 25, 81A.

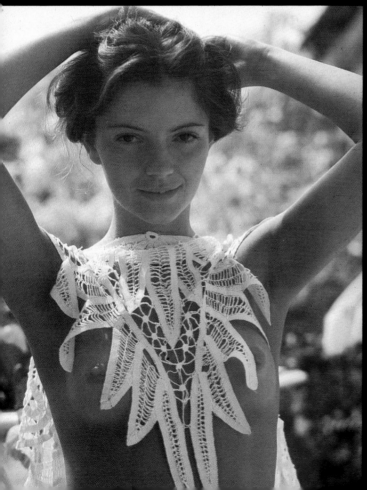

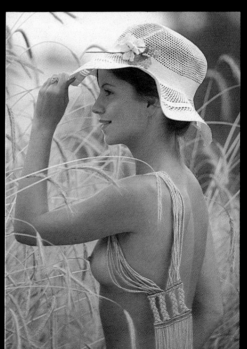

◁ **Improvized prop —
3:00pm**
I cut a tablecloth to provide the vital prop for this close-up. The picture was made by daylight, while the model was pinning up her hair for the next shot. An extension tube enabled me to shoot from very close in.
150 mm, 10 mm extension tube, 1/60 sec. at f4, Ektachrome 64, 81B.

Framed profile — 4:00pm △
The angle of the clear diffused sunlight took me out to the nearby fields for the last picture. The straw-colored hat worked well with the rye and, by asking the model to pull the hat down over her eyes, her arm formed a frame to strengthen the composition.
105 mm, 1/60 sec. at f5.6, Kodachrome 25.

The less-than-perfect model

Few models are perfect for all styles and types of nude photography. Nevertheless, most people who will pose for your photographs have some good points and one of the photographer's tasks is to identify these (see Assessing a model, p. 152) and take advantage of them in the selection and design of various picture ideas.

Paradoxically, the limitations imposed by your model's shortcomings can be a help in picture making. I find that a virtually perfect model can be photographically intimidating, for I then often have difficulty knowing where to start with so many assets to choose from. On the other hand, if the model's best qualities are limited to, say, good skin and a well shaped back you have a ready made "simple starter" and can get into your stride without feeling that the session is running away with you.

To both photographer and model, the emotional value of starting with easy, infallible pictures is immense. The compliments you can legitimately pay her for her contribution to a picture will build up her confidence, which in turn will detract from her inadequacies. Always remember that it is the model's spirit as well as her body that you are

photographing. The higher her spirits the better the atmosphere will be and the better your photographs.

If your model's problems are emotional rather than physical, it can be helpful if she is involved in the planning of the pictures. At that stage she can see your tear-outs and sketches, which will show what you are trying to achieve. Explain, with pictures, the value of basic ingredients, such as texture and pattern, so that you can create an atmosphere of joint effort in your session rather than making her feel exploited and depersonalized, as she might if she is asked to pose without involvement. Again, if your idea for a shot needs a prop you can ask her to help you find or make it, which is yet another way of involving her in the picture-making process. Encourage her to experiment with make-up and hair styles, but it is usually unwise to suggest extravagant transformations as this may obscure her individual personality. In other words, be considerate and use your imagination to help your model become the "perfect model".

Overcoming shyness △
Nervousness is inevitable in a model posing for her first nude pictures. By asking the model to pull the hat over her eyes and smile, she disguised her shyness and began to project a happy, extrovert feeling.
105 mm, 1/125 sec. at f5.6, HP5.

◁ **Stretching the body**
By using a wide-angle lens, minor inadequacies in the model's figure and limbs were disguised. The pose, which partially obscures the face and eyes, gave her a relaxed look. By not filling the whole frame with the figure, the ability of the wide-angle lens to stretch the legs was fully exploited.
28 mm, 1/30 sec. at f4, HP5.

◁ **Manipulating the emphasis**
Inversion can add glamor to a picture. In this shot, taken from a step ladder, I emphasized the model's attractive hair by spreading it out and keeping it nearest the camera. I carefully arranged the legs to lengthen them and shrouded the rather ample hips with draping.
50 mm, 1/250 sec. at f8, HP5.

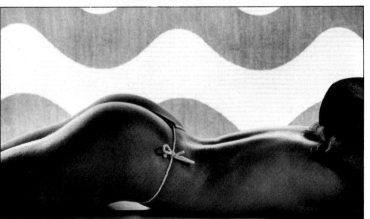

◁ **Safe starter**
I designed this picture as the first of the day, knowing that the model had a shapely back which, when photographed against this specially chosen fabric, would make an effective design. By covering the model's head with a hat, which repeated the background curves, her face was obscured, allowing her to concentrate all her thoughts on the control of her body drawing.
105 mm, 1/60 sec. at f4, HP5.

Useful formula △
A hairdressing-and-mirror shot is one of the nude photographer's favorite stand-bys, for it provides a familiar situation where the model can work in a relaxed way. Here, soft daylight from opposite directions enhanced the roundness of the body, while the model's stretching pose improved the body drawing.
105 mm, 1/15 sec. at f4, HP5, soft filter.

Arranging simple ideas at home

The problems entailed in finding a good location and a suitable model for it often tempt me to make my pictures at home, for familiarity and comfort can compensate for the absence of attractive outdoor features. I am also more relaxed on my own home ground and this affects the model, enabling her to work better. As long as you have a warm and private room at least five paces in each direction, there is nothing to stop your working there. Ideally, of course, you should be able to use all of your home, thereby multiplying picture possibilities. By studio standards most homes are cluttered and the biggest problem in setting up good pictures is to clear enough space both to work in and to allow some simple backgrounds. Detail pictures reduce these problems, of course, if you have limited space.

Another advantage in working at home is your familiarity with the movement of sunlight from window to window around the house. This enables you to plan sunlit pictures which would be difficult in unfamiliar territory.

Most homes contain useful props, but always bear in mind that action props are better than those that are merely held. Overfamiliarity with household objects tends to obscure much of their graphic impact, so look at possible items afresh.

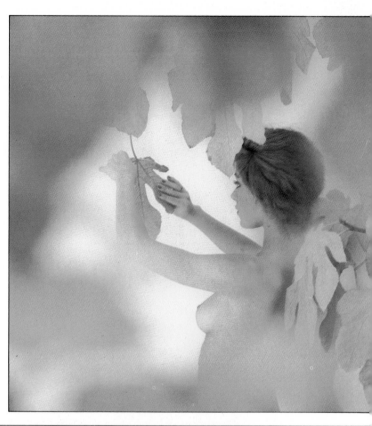

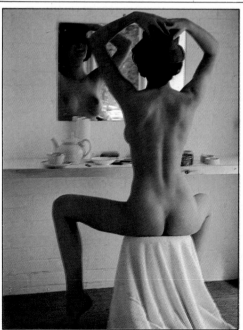

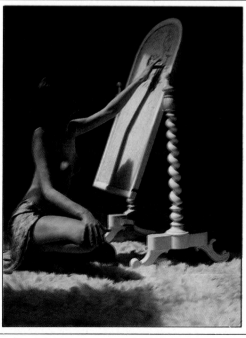

Readily available props
These pictures exploited the use of mirrors. In both cases, the model became absorbed with the prop and was thus less aware of the camera. Stretching to work with the mirrors also gave the models an opportunity to make good body shapes. *50 mm, 1/30 sec. at f4, Kodachrome 25, 81B (far left); 105 mm, 1/125 sec. at f5.6, Kodachrome 25, 81 EF (left).*

Found props
These two shots were
inspired by the hose
and tap, which I found in
my garage. Though my
original intention was to
shoot the picture above, I
have since come to prefer
the detail shot (right),
which was made as a
lighthearted extra at the
end of the session.
*50 mm, 1/125 sec. at f5.6,
Kodachrome 25, 81B
(above); 105 mm, 1/125 sec.
at f5.6, Kodachrome 25,
81 B (right).*

◁ **Simulating an exterior**
Though appearing to be an
exterior shot, this picture
was actually made by
daylight indoors against a
plain background wall using
fig tree branches as a prop.
*Bronica ETRC, 150 mm,
1/15 sec. at f5.6 Ektachrome
200, 81B.*

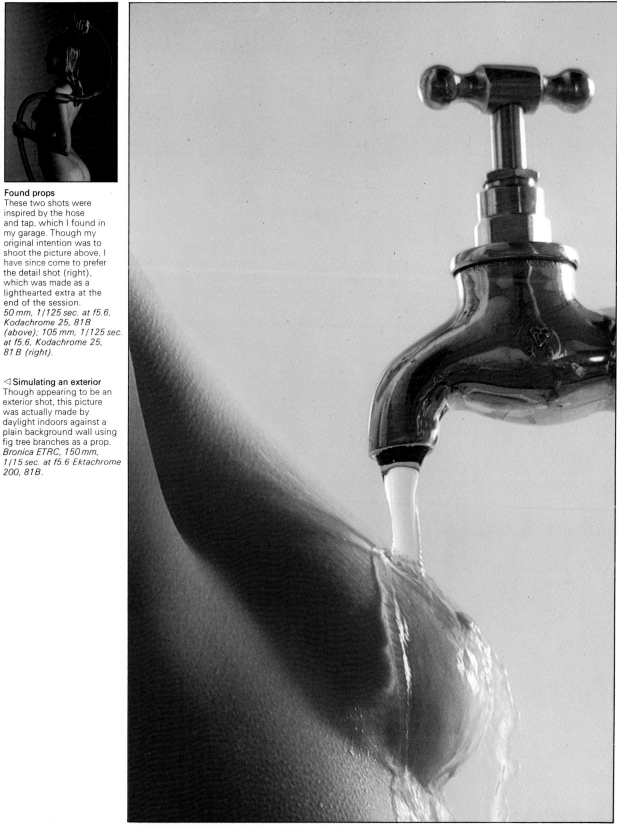

Pictorial detail

In contrast to full-length nude photography, which usually needs considerable space, a good location and a carefully worked out picture idea, detail shots are relatively easy to make. Nevertheless, they can often prove very effective pictures and have the additional advantage for the beginner that they usually exclude the model's eyes.

Because of the simplicity of close-up shots, they rely for success, more than does most photography, on your control of texture, form and, even more important, lighting. Close-ups, which usually require you to capture good skin quality, must be carefully lit to heighten the sense of the skin's softness.

The choice between using long- or short-focus lenses for detail pictures is one of the photographer's more difficult technical decisions. A longer lens is the natural choice for close-ups of detail, but its shallow depth of field enforces the use of a small aperture if the whole depth of the shot is to be in sharp focus. For nude detail work, sharp focus is usually essential and long exposures, requiring the use of a tripod, may be unavoidable. It is possible to help the model to keep still, however, by using an out-of-shot prop, such as a table or chair, for her to lean on. But even slight subject movement during long exposures reduces the sharpness of rendering, so that unless you are working in very bright light it may be necessary to use a shorter lens at closer range, to gain advantage of the greater depth of field, in order to shoot your detail sharply. Remember, that when using shorter lenses the drawing and perspective of the close-up image must be carefully adjusted by choosing a camera position that avoids distortion.

Extension tubes, used between the camera and the lens, enable you to focus on objects closer than would otherwise be possible and are often necessary for detail shots. Tubes offer better definition than do their cheaper alternative, close-up lenses, but automatic metering on some cameras is disconnected by them. If you do not have close-up attachments, try moving back from the detail you want to shoot, thus letting other elements enter the composition. These can complement skin color and add depth and variety of form to the shot. By doing this, an abstract detail becomes more related to the surroundings.

Low key △
I achieved sharply rendered skin texture and intense colors in this noonday shot by using a polarizer and slight underexposure A short-focus lens improved the depth of field and enabled me to include the poppies without distortion.
50 mm, 1/125 sec. at f5.6, Kodachrome 25, polarizer.

High key △
A soft, high key lighting style in combination with the rose gave this diffused daylight shot an abstract beauty which would have been lost if I had used a harder approach.
50 mm, 1/30 sec. at f5.6, Kodachrome 25, 10 CC magenta.

Shadow pattern △
Low sunlight shining through a bead necklace emphasized the form in this close-up, taken with a long lens. The strong light also allowed a sufficiently short exposure to arrest movement in the hand-held beads, while a small aperture provided adequate depth of field.
105 mm, 10 mm extension tube, 1/125 sec. at f8, Kodachrome 64.

Shadowless flash ▷
Ample light from a studio flash with a large diffuser and a floor reflector simplified the shooting of this sharp, textural detail. A low table, out of view, anchored the model's legs, guaranteeing a motionless stance, for the symmetry of the drawing was vital.
Bronica ETRC, 150 mm, 1/125 sec. at f8, Ektachrome 64, 81B.

The atmosphere of water

Water is the most photogenic of the natural elements when combined with the nude figure and will provide you with endless picture possibilities. Wet skin and water must be photographed extremely sharply if you want to emphasize their texture and feel.

Detail shots of part of the body with wetted skin are not difficult to shoot and are an obvious choice for the beginner. The full figure in water, however, can be more complicated to photograph, for controlling the model's position simultaneously in the water and in the shot can be difficult. Action shots of a nude swimmer or diver are effective, but here water turbulence tends to destroy the body drawing. I prefer to work with calmer water, using some sort of support for the model, either seen as a prop or hidden beneath her body. In this way, less effort is needed for her to keep afloat and

more attention can be given to arranging her in the picture. This control is especially important if you are using a shortish lens, perhaps to lengthen the model's legs by placing them slightly nearer the camera. For views from above the figure, get the camera high over the water – on a diving-board, for instance – and fill the frame of the shot with water. This will exclude background elements beside the pool, which would distract from the figure drawing.

All water pictures should be made when the day is at its warmest, but at this time the bright sun and blue sky can produce lighting problems. For example, the model will probably have to close her eyes or wear sunglasses if her face is directly in the glare.

Fast-moving water ▷
I had to take this picture very quickly as the rushing water in the Welsh mountain stream was extremely cold and I did no wish to prolong the model discomfort. I had already turned her face away from the camera to hide her unhappiness. The use of a polarizer heightened the tactile quality of the water on her skin.
105 mm, 1/500 sec. at f4, Kodachrome 25, 81A and polarizer.

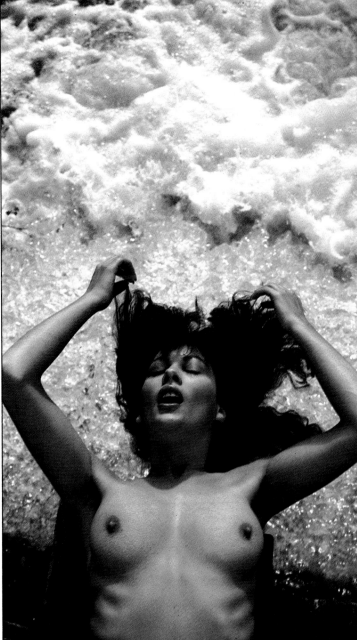

◁ Buoyancy aid
A child's inflatable serpent provided the model with support in the water and employment for her hand. By using a short lens to lengthen her legs, straight lines were produced to contrast with the snakey curves. Using a short zoom lens and shooting from a tall stool gave a choice of different framings.
40–80 mm zoom, 1/250 sec. at f5.6, Kodachrome 25, 81B and polarizer.

Frozen turbulence △
Shooting over a dam by a French canal enabled me to make this "dry" wet picture. I used a board to support the model (diagram right). A graduated filter with the gray section over the water prevented the white top half of the frame losing detail by becoming overexposed compared with the darker details of the figure.
50 mm, 1/500 sec. at f5.6, Ektachrome 400.

Photographing through water

Eye-catching photographs can be made by using natural elements in a graphic way. For example, water bends light waves and this distortion of reality can be put to pictorial use. One way of adding atmosphere and mood to a simple interior on a gray day is to flick "rain" on to a window with a brush. Another is to use a boiling kettle to put steam on glass and then explore its diffusing qualities. Water colored by vegetable dyes can also be photogenic and easy to use. On the whole, photographing through water produces the best results if taken by daylight.

If you are photographing in a bathroom, or indeed in any wet or damp situation, great care must be taken not to allow water anywhere near electric light sources or cables. Plug-in electronic flash units are particularly dangerous under damp conditions, so never take any risks.

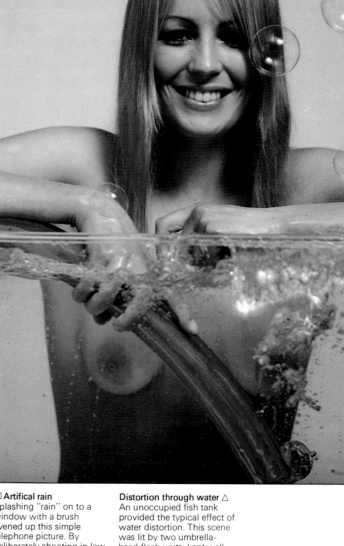

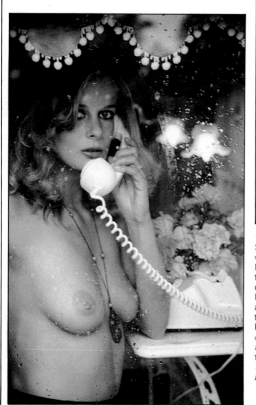

◁ **Artifical rain**
Splashing "rain" on to a window with a brush livened up this simple telephone picture. By deliberately shooting in low light, I was able to take advantage of the glow from the wall lamp to add mood. Reflections in the glass were eliminated by suspending a black sheet to block out the background.
105 mm, 1/30 sec. at f11, Ektachrome 200, 82B.

Distortion through water △
An unoccupied fish tank provided the typical effect of water distortion. This scene was lit by two umbrella-head flash units, kept well away from the tank.
105 mm, 1/125 sec. at f11, Kodachrome 25, 81B.

EVOLVING A STYLE

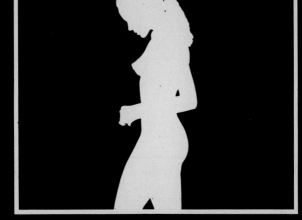

Posing the model

Posing is the last thing I want from a model; far better to let the pose come naturally out of the picture idea, keeping the limbs and body positions simple enough to make good shapes on the flat page. However, the action you have chosen for the picture, though possibly simple and natural, has to be adapted to make it pictorial and yet still believable. So analyze your model's position and her gestures carefully, making sure that every line helps to make the point of the picture.

Even the most experienced model needs your help. Nevertheless, a large mirror set up beside the camera can enable the creative and unselfconscious model to adjust her position in the shot under your direction. The most important thing is to give constant encouragement. Even if the session starts shakily, keep your doubts to yourself and photograph (possibly without film) while you make improvements. Remember, the camera looks at her with a cold, fish-like eye and it is your task to add warmth and inspiration.

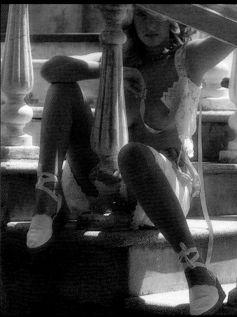

◁ **Avoiding harsh sun**
I turned the model's back to the hard sun and used the balustrade to provide design emphasis.
105 mm, 1/60 sec. at f5.6, Kodachrome 25, 10 CC.

Restricted light source ▽
By arranging the figure within the square of the beam of light, I was able to capitalize on the graphic value of the low angled light (diagram below).
Bronica ETRC, 150 mm, 1/15 sec. at f8, Ektachrome 64, 82A.

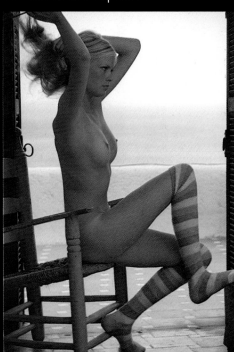

Casual variations △
Photographing while the model changes her hair style often gives freshness to an otherwise predictably posed shot. By offering the model support for her right foot, the silhouette drawing was improved in this indoor shot, lit only by daylight reflected from white bedsheets.
50 mm, 1/50 sec. at f4, Kodachrome 25.

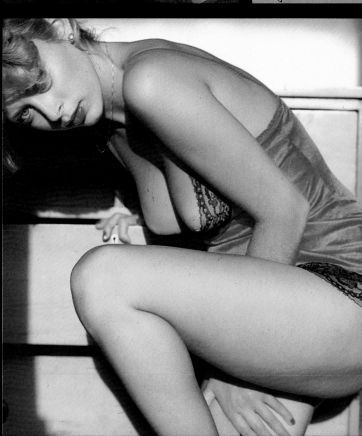

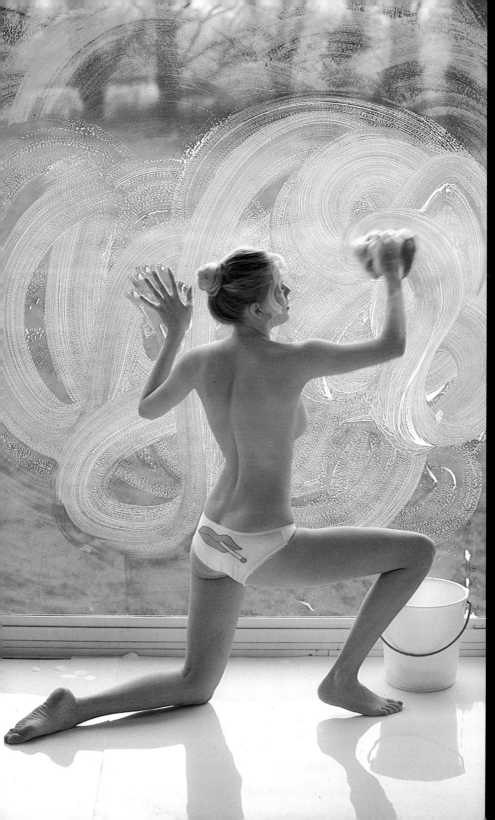

Striking pose △
The incline of a vast sand
dune on the French Atlantic
coast encouraged the model
to strike this pose. I
exploited the last rays of the
sun, which lit up her robe
but left the background in
subdued shadow.
*80–200 mm zoom.
1/60 sec. at f5.6,
Kodachrome 25, 85A.*

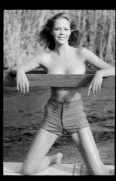

Deceiving the eye △
When photographing in a
public place where nudity
was frowned upon, I found
this conveniently placed
bridge handrail which gave
the impression in the picture
that the model was wearing
less than she really was.
*105 mm, 1/125 sec. at f4,
Kodachrome 25, 81EF.*

◁ **Graphic action**
Giving the model something
to do helps her to relax
while you are shooting and
makes for more "real"
pictures. It is an added
bonus if the model's action
and positioning in the
picture helps the graphic
quality. There were two
more subtleties to this shot.
One was to add white
water-soluble paint to the
soapy water to improve its
"drawing power", the other
to use white plastic sheeting
on the floor to provide the
reflected image.
*50 mm, 1/125 sec. at f5.6,
Kodachrome 25, 10CC
magenta and polarizer*

Styling the picture

Many of the best photographs found in glossy magazines owe their quality to stylists. These skilled organizers find props, locations and models for photographers. They are also adept at recognizing the needs and particular skills of individual photographers, using their expertise to create set-ups, filled with attractive objects, that will inspire successful pictures.

Most amateurs have to be their own stylist, but this work can be enjoyable and can be used to bring your own personality even more into the final picture. I start with a sheaf of pages torn from magazines, a sketch book, pens and some scotch tape. I then assemble and tape down various elements of images, cut from the magazine pages, that suit the shot I am planning. Once I have a feeling for the color and atmosphere I want, I sketch out the basic lines of the picture and list my needs for props and possible locations.

When searching for props, be flexible and recognize that the unexpected solution may be preferable. Not to do so is often expensive, since you may miss a good idea by stubbornly pursuing your first concept.

Assembling a scene ▷
Starting with only the bare walls of my daylit studio the stylist first found the screen in the background and used this as the basis for the color and mood of the shot. Complementary objects and pictures and even the model's wig were chosen to build up the final effect. The mixture of weak daylight filled in with artificial light further heightened the atmosphere in the shot.
28 mm, 1/60 sec. at f5.6, GAF 400.

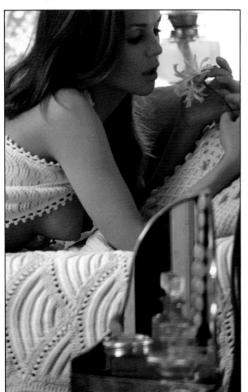

◁ **Textured pattern**
Textured fabrics in neutral colors and carefully positioned props to create depth set the style for this bedroom picture. Though the model's skin is pale, the stylist's choice of white fabric enhanced the skin color and texture. The model's instinctive lift of her shoulders ensures the clean drawing of the breast while the slight incline of her head and well placed hands underlines her professionalism and left me with no directing problems.
105 mm, 1/125 sec. at f5.6, Kodachrome 25, 81A.

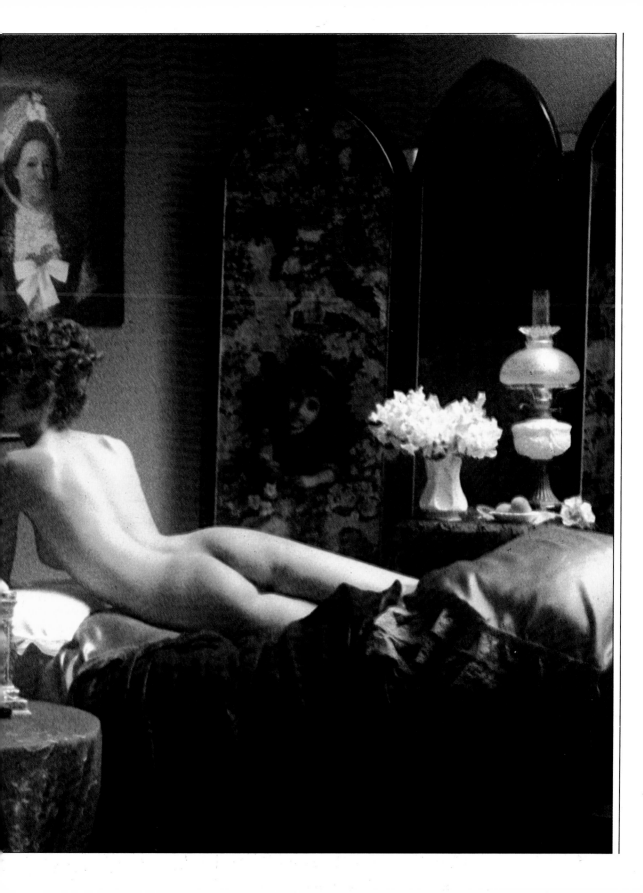

Variations in style

The photographer includes in his pictures the components he wants and rejects those which he does not. In this way he is, albeit unconsciously, expressing his personality, and through this his own style. Tonality, viewpoint, atmosphere, mood, direction and lighting all contribute to style.

It is wise for the beginner to consider the practical limitations that will shape the style of his pictures. A city-dweller with enough space and the necessary equipment might be able to specialize in graphic studio-type work, while someone living in the country might be drawn to a more realistic outdoor approach. In any event, by concentrating on pictures with similar technical and esthetic problems you will build up the confidence and ability to express your own style.

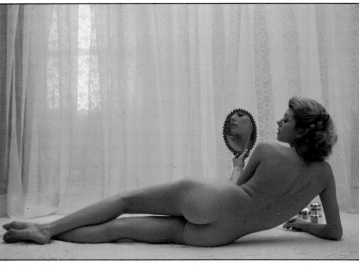

Relaxed abandon ▽
The overt sexuality in this daylight shot was deliberately diluted by the mundane setting and the inclusion of commonplace domestic props.
50 mm, 1/30 sec. at f8, Kodachrome 25, 10 CC magenta.

Beauty style △
Influences from classical painting dominate this period beauty shot. Soft overhead daylight from a skylight and a featureless, stylized setting shot with slight sepia filtration emphasize the model's pose.
105 mm, 1/8 sec. at f5.6, Kodachrome 25, double 81 EF.

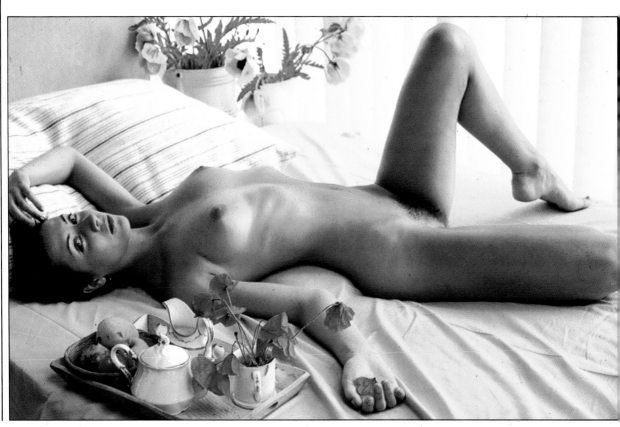

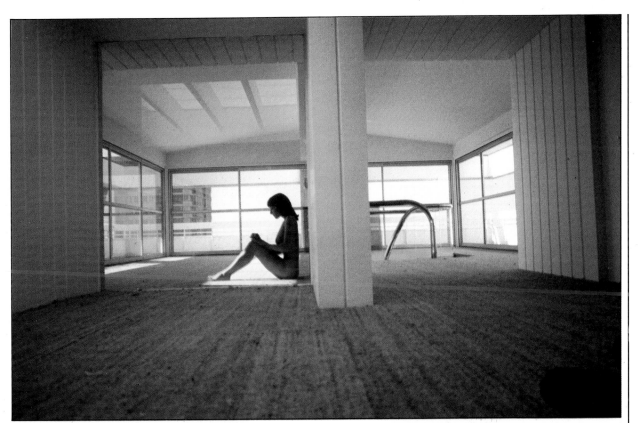

Design style △
The nude figure has been used as a "punctuation mark" to give point to the shot in this otherwise empty interior setting.
24 mm, 1/8 sec. at f11, Kodachrome 64.

◁ **Exotic style**
The simple studio treatment, with plain background lit by direct diffused flash, emphasized the model's symmetrical jewellery and her skin color. A more complicated set-up would have been distracting.
80–200 mm zoom, 1/125 sec. at f11, Kodachrome 64, 81B.

Reportage style ▷
The use of a long lens enhanced the voyeuristic element in this seaside shot. The realism is heightened by the relaxed pose and by hiding the model's face. Though this picture was made on a cold, blustery, gray day, the flatness of the light was combated by working under an overhanging building on a pier, which provided a dark background to create highlights on the model.
300 mm, 1/250 sec. at f4, Kodachrome 25, 10 CC magenta and 81 C.

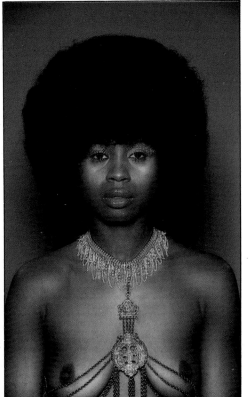

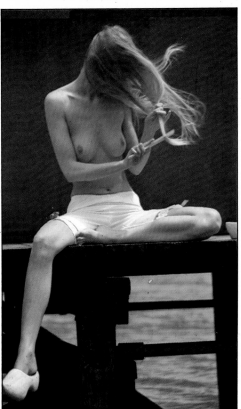

The erotic in nude photography is an elusive element. It is also far harder to assess than, say, mood, style or atmosphere and is almost exclusively dependent on individual reaction. Eroticism, I believe, is best achieved by soft, deliberately created mood and styling which suggests the model's state of mind rather than by blatant exposure. Other methods of projecting the erotic are the exploitation of the tactile skin quality of the model or even the suggestive power of the unseen in deep shadow. Perhaps the most important factor of all is to sharpen your powers of detecting the unexpected appearance of the erotic.

When planning pictures, first decide how you want to pitch the sexual message and discuss it with your model before shooting. It is a delicate area and one in which you must both be in accord, for without her co-operation, indeed enthusiasm, it will be difficult for you to introduce or strengthen the erotic power in your pictures.

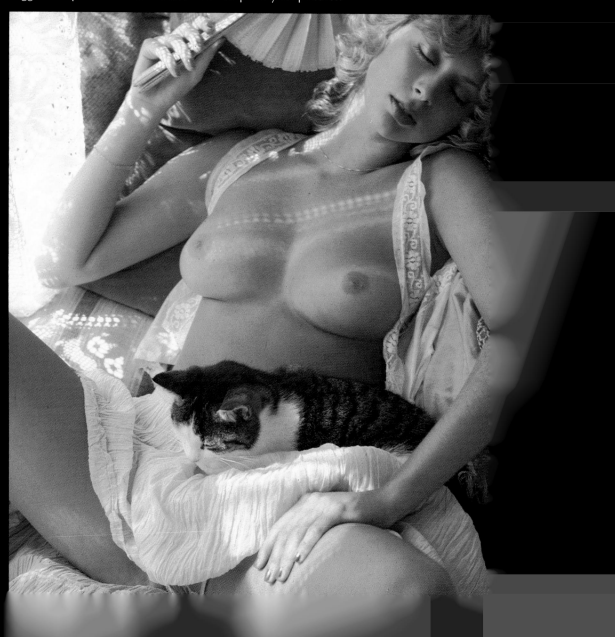

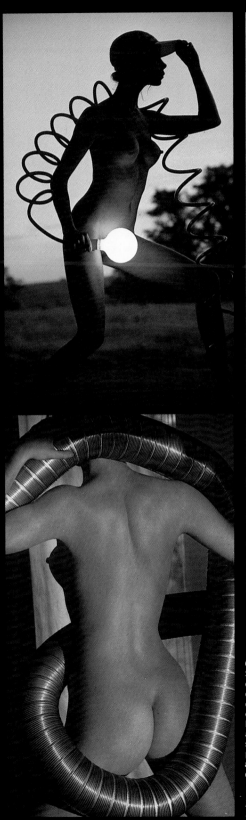

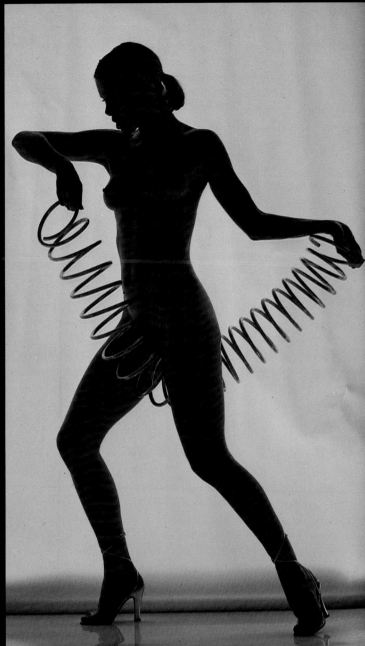

Compulsions
Sometimes a particular prop becomes a temporary
obsession with me, perhaps because of its graphic appeal
or its versatility. In the picture top left, the glow of an
office lamp used to complement the sky at dusk also
ensured modesty. A blue filter cooled the tungsten
lamp and enhanced the sky color. In the photograph
above, the spiral has been repainted and is used as a
simple graphic prop, shot against daylit tracing paper. The
picture on the left is a development of the other two, using
aluminium chimney-flue liner to make the shape. I used full
daylight with the sun reflected from a large plastic mirror.
*105 mm, 1/10 sec. at f5.6, Kodachrome 25, 82C (top left);
105 mm, 1/125 sec. at f5.6, Kodachrome 64, 50CC
magenta (above); 80–200 zoom, 1/125 sec. at f5.6,
Kodachrome 25, 81EF (left).*

Atmosphere from shado...

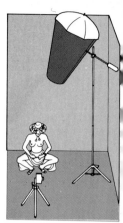

The potency of the unseen can be endlessly exploited in nude photography. Luminous soft-edged shadows are the natural counterpart to gentle highlights, which dramatize the most important points in a picture. In contrast, hard-edged shadows cast by unsoftened light create sharper, more graphic shapes. Your arrangement of shadows and highlights can emphasize texture, while subduing unwanted elements in the composition by putting them in shade. To take full advantage of the atmosphere created by shadows, great care is needed in placing the light source in such a way as to gain maximum sculptural effect. Where the light is fixed, it is the model who must move until you see the light falling as you want it.

By controlling underexposure, the camera enhances low key lighting set-ups and it may help you, when arranging the lighting, to view the scene through almost closed eyelids or through a dense viewing glass.

Rather than ... with lengthy lighting asse... and because exploiting shadow is ... science, I often shoot two q... sets of tr...sparencies. I use decreasing half-stop exposures from what I judge to be correct, with a different degree of shadow fill-in for each of the two brackets. I then choose the most effective density after processing, ideally using two projectors simultaneously to compare the different results.

Soft light from flash ▷
Sufficient headroom was essential in this location to allow me to place the flash far enough from the model to achieve even lighting over the full depth of the figure (diagram above). I set up the light at a height twice that of the model.
105 mm, 1/125 sec. at f5.6, Ektachrome 64, 81C.

Soft daylight shadow ▽
The arched ceiling of this Moroccan villa led me to treat an essentially simple shot in dark tones. Daylight from a window, covered on the outside with taped-on tracing paper, falls softly on the model's turned face. Although the socks and huddled pose help the shot, they were in fact necessary because of unexpectedly cold weather.
24 mm, 1/8 sec. at f4, Kodachrome 64, 81B.

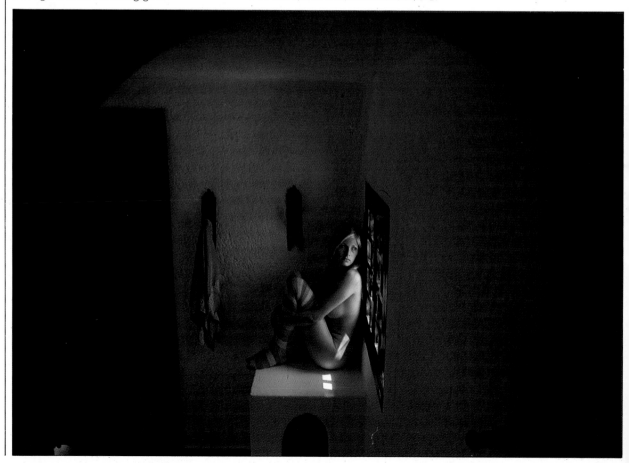

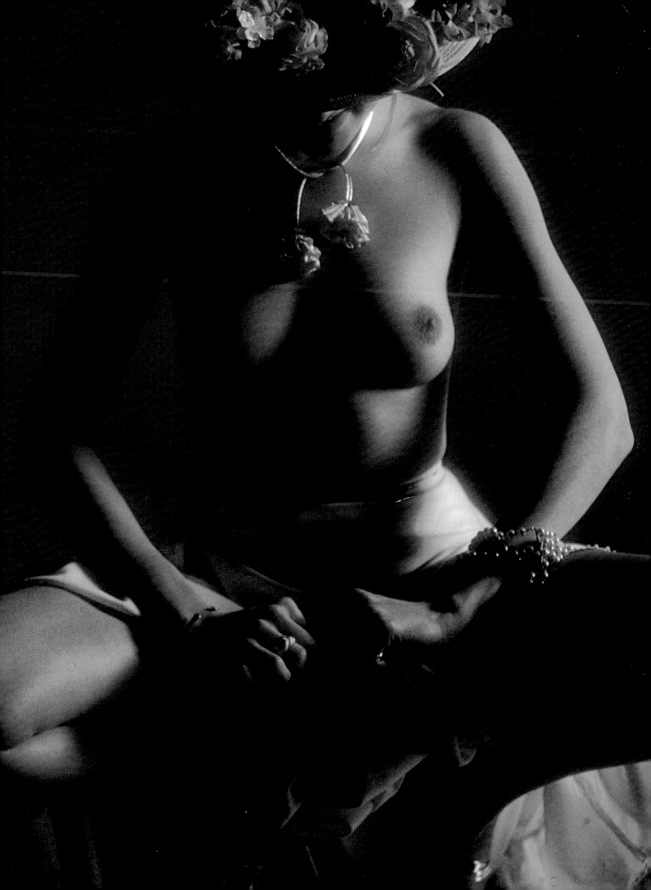

Mystery from light

One of photography's most rewarding challenges is to transform everyday scenes into images of mystery. To achieve mysterious pictures, however, you must extend your control of light to the extremes of the photographic spectrum.

Recognizing the mystery potential of a situation is not easy, but keep the possibility constantly in mind when you are shooting. If you detect hints of this feeling in a shot, examine ways to heighten it. For a start, try obscuring the face or shoot through a strong-soft or deep-colored filter. Extremes of over- or underexposure can also add mystery to the normal. When editing by projection, only discard your "incorrect" exposures after careful consideration. Perhaps it is not the picture you meant to take, but seen by more objective eyes than yours it may have some magic; the photographer is not always his own best picture editor.

Mysterious pictures can also be an escape route when you are trapped in a session with a disappointing model. By using only her best features and exploiting the mystery potential in the location, exciting images can be produced. To achieve them you must change your approach, both mentally and technically, from carefully recording the factual to deliberate projection of the fantastic and the bizarre.

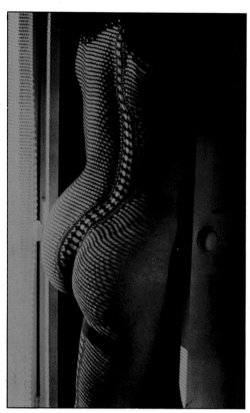

◁ **Patterned abstraction**
Clear, low-angled sunlight streaming through a bedroom curtain created this mysterious pattern. The original black and white negative was printed on a hard grade of paper and then re-photographed in color, using an 80 blue filter on the camera.
105 mm, 1/125 sec. at f11, XP1.

Atmospheric daylight ▷
While working with high speed black and white film on a dull, gray day, I was fascinated by the graphic potential of the model in this plain chair, set on the receding lines of the floor and backed by the emptiness of the window blinds. I shot on color film as an afterthought and was excited to find on processing that this frame (the longest exposure of the bracket) had picked up color from the bare floorboards and allowed the blinds to disappear into a mysterious haze.
28 mm, 1/8 sec. at f4, Ektachrome 400 pushed 1 stop, 81B.

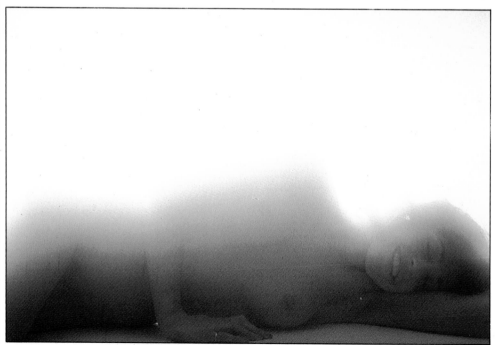

◁ **Mysterious soft focus**
By combining backlight from an electronic flash on the floor behind the model with strong diffusion created by smearing petroleum jelly on a spare skylight filter, a mysterious atmosphere emerged from a routine studio setting. The shot's mysterious quality was heightened by retaining the shadows, leaving the dark, unexplained areas to be filled in by the viewer's own imagination.
105 mm, 1/125 sec. at f5.6, Ektachrome 200, 81EF and soft filter.

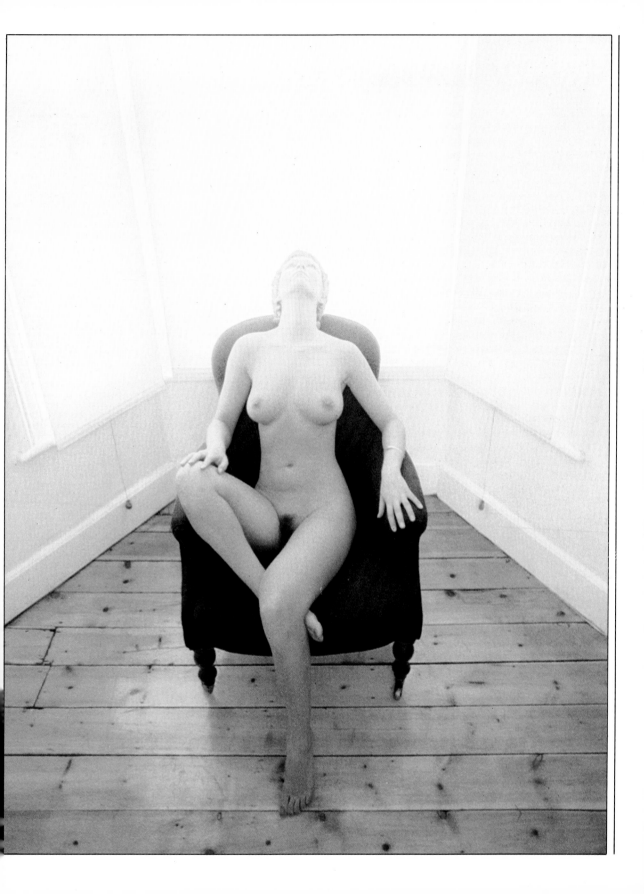

A sense of realism

On the two previous pages we explored the quality of mystery that photography can impart to nude figures. Here we examine the realism and the intimacy which photography is capable of recording. In the early days, photography was called "painting with light" and this has become even more appropriate with recent technical improvements, for today anything you see can be photographed somehow. When making photographs of the nude which depend on subtleties of light, it is not the camera's sensitivity on which you depend, however, but your own. You must be relaxed with your model, the equipment and the location, completely open to opportunities to capture delicate moods, enhancing them with changes in the light or setting so that these moods are transferred to the film effectively.

But how does one choose the best way to heighten reality in photography? Usually it is not by selection but by chance. In any passing moment as the cloud opens up to reveal the sun you must be ready to explore the richness of the light, shooting a bracket of three quick exposures. The secret is your esthetic and technical alertness to the changing qualities of the scene and the fall of light upon it.

Understated realism ▷
The degree of under- and overexposure given to a nude picture can dramatically alter the viewer's interpretation of the result. In this contrasty, sunlit bedroom scene, a more overexposed, generously filled-in picture might have given the viewer more information but would have destroyed the graphic power of the deep shadows, which confirm the air of realism. *50 mm, 1/250 sec. at f5.6, Kodachrome 25.*

Empty realism ▽
The long, low, warm rays of the setting sun confer a sense of realistic time and place to this otherwise empty picture. Even on gray days, the sun will often make a short appearance as it rises in the morning and shortly before sunset, and these can be productive times for nude photography. *24 mm, 1/15 sec. at f5.6, Kodachrome 25.*

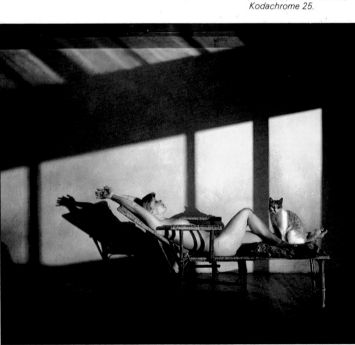

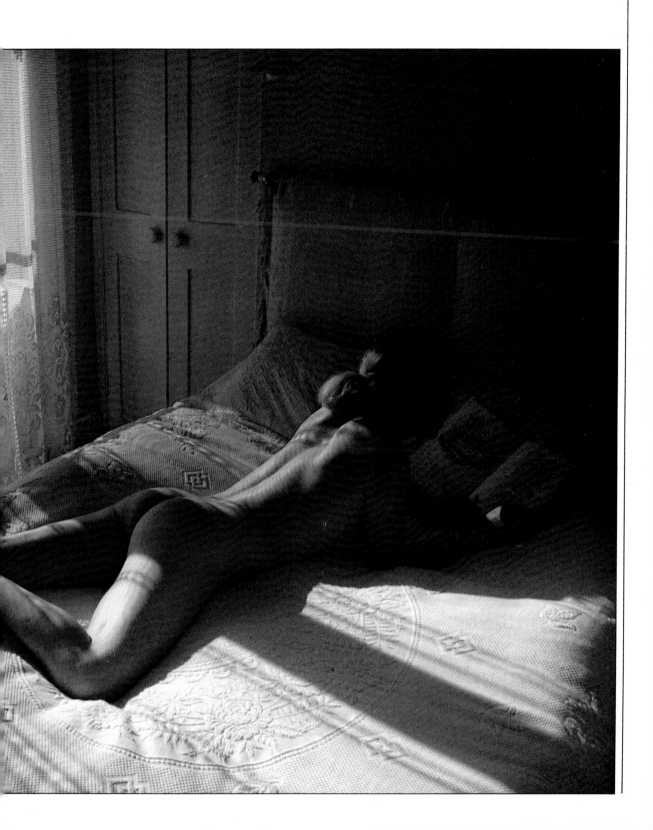

Style from treatment

Achieving a good set of negatives is only a beginning in photography. When you have chosen the best pictures from a session, you then have the pleasures of planning how they are to be printed and presented. These are some I chose for this Victorian pastiche.

Central to the shot is a Victorian photographer's background, which I had bought many years ago. I took it out of storage to act as the starting point when briefing my stylist. Careful thought had to be given to the choice of model, for there are fashions in figures and faces as there are in clothes. It was possible to give the model a genuine Victorian look by changing her hair style and make-up but it was crucial that she should have a figure and personality which we could convincingly adapt

to suit the mood of late Victorian England. My assistant and I set up the props in the studio, with a window behind the camera. This position gave the correct period feeling to the shot, for it was necessary for the light to flatter the model's curves and emphasize the generous fullness of the Victorian period.

Although I expected the daylight shots to be most rewarding, I also shot a simple flash set-up using a plug-in pack, reflected off white sheets. Starting with flash gave the model confidence, for she knew she did not have to keep absolutely still. We later tried some daylight exposures, which entailed her holding the pose for two or three seconds at a time, but this statuesque rigidity added period flavor as it was typical of the Victorian age.

Sepia tone ▷
Sepia toning was originally used by commercial photographers of the early 20th century as a means of rendering more permanent the unstable prints then made for family albums. Properly controlled, the process still has the same virtue and can add an attractive period air to a picture.
Bronica ETRC, 150 mm, 1 sec. at f4, HP5.

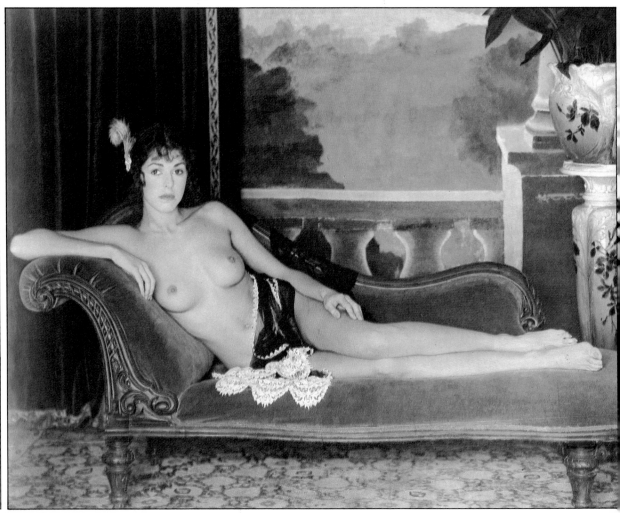

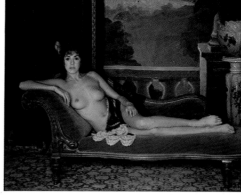

Modern color △
Even straightforward modern Ektachrome can project the period quality of a picture. In this case, it was important to emphasize the richer, warmer tones by using brown filtration. The tendency for cold, gray daylight to add a blue or magenta bias must be avoided if an older look is to be created in a picture.
Bronica ETRC, 150 mm, 2 sec. at f4, Ektachrome 64, 81EF.

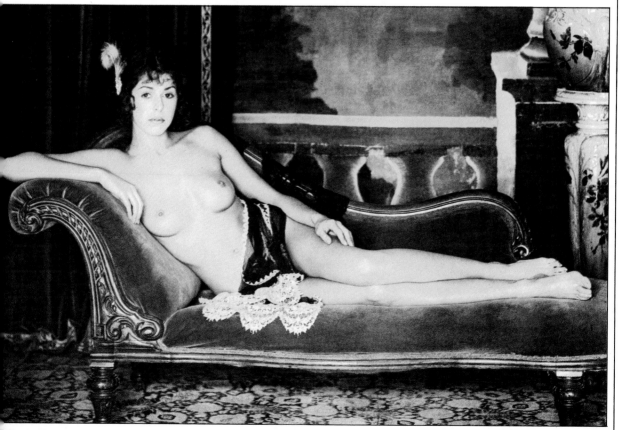

Handcoloring
efore color photography was invented, handcoloring was opular. The approach was close to watercolor painting, oluble dyes being applied with a brush as I have done ere. I used a flat-toned print on resin coated paper to cilitate the application of dyes. Nowadays, if period astiche is not your aim, felt tipped pens and spray paints n enliven black and white pictures.

Lith paper △
Here tonal scale as well as print color intensified the period atmosphere of the photograph. By using the high contrast of lith paper, which also has an attractive "antique" finish, the Victorian pastiche quality of the original negative was heightened.

Arresting action

Movement is an ingredient which blows some fresh air into a composition. Good light allows fast shutter speeds, which are essential to arrest action. Fast shutter speeds, however, are usually accompanied by large lens apertures, with their inherent lack of depth of field. This makes it difficult to ensure that your moving model is not only "frozen" when you shoot but that she is also in precise focus at that instant. One way to achieve this is by captive action – that is, action that only takes place within a fixed plane, like a swing. Another solution is to predict the course of the action and pre-focus on a marker in the shot, such as a twig stuck in the ground. Set the camera on a tripod, pre-set to the correct focusing distance and keep your eye on the twig and the model's feet, shooting as she passes the point. I always shoot my action pictures with some space around the figure in the composition, partly to allow for inaccuracy in framing and partly to give me an area for the figure to move into when I make the final crop.

Fixed point action ▷
By asking the models to stay near the umbrella pole, it was possible to make this surf picture on a long lens at a wide aperture in the knowledge that no depth of field problems would arise. The white foam reflected low sun and enabled me to shoot at a fast shutter speed.
300 mm, 1/500 sec. at f4, Kodachrome 25.

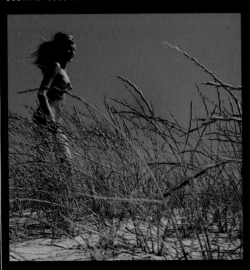

Zone focus △
This became an easy picture to take once I had asked the model to run past a fixed point on which I had pre-focused. Good light at noon on the beach allowed me to use plenty of depth of field from a short lens to keep the grass reasonably sharp and the loose framing of the shot gave the model space to run into.
28 mm, 1/500 sec. at f4, Kodachrome 25, polarizer.

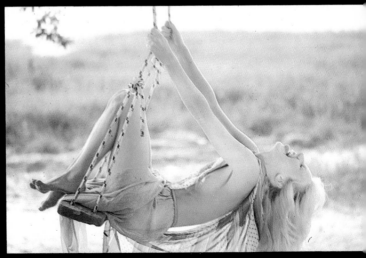

Repeated movement △
The fixed plane in which the swing moved minimized the focusing problem in this shot. Fast film and a wide aperture stopped the action. Uneven, late sunlight reflected from a mirror, boosted fill-in from white sheets.
50 mm, 1/250 sec. at f2, Ektachrome 200.

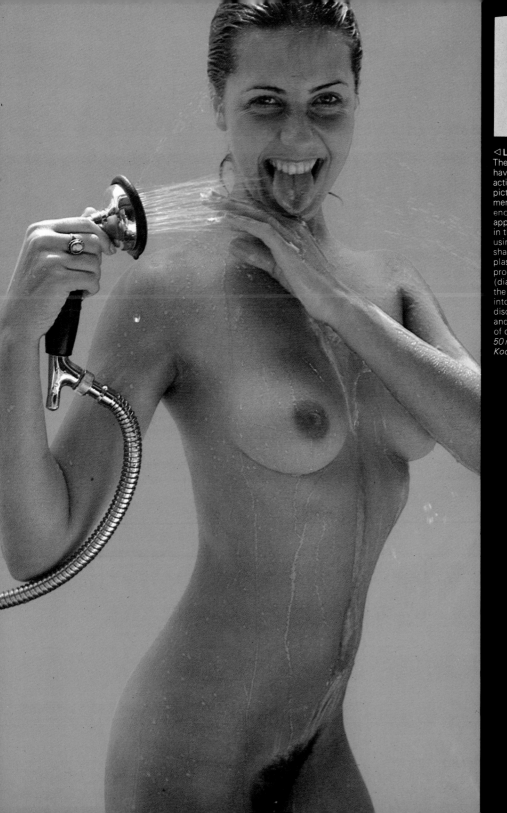

◁ **Limited action**
The whole subject does not
have to be moving to give
action quality to your
pictures. Here the move-
ment of the water was
enough to prevent the shot
appearing lifeless. Shooting
in the garden by daylight
using a reflector to fill in
shadows and a sheet of red
plastic as a background
produced this striking effect
(diagram above). To avoid
the danger of taking lights
into my bathroom, I
disconnected the spray head
and attached it to a hose out
of doors.
*50 mm, 1/250 sec. at f4,
Kodachrome 25, 81B.*

Becoming more abstract

By its nature, photography tends toward realism. The nude body, however, lends itself admirably to the abstract approach. When photographing for your own pleasure, therefore, there is no need to respect the rules and traditions of realism in presenting your image. You should use the nude model as a starting point in a design-forming exercise.

Start by watching nature's ways of suspending reality, for abstraction can come from distortions of views such as those seen through clear, deep water and heat haze. Sometimes you can introduce abstraction yourself by using extra-short lenses on the camera or by an unexpectedly placed light. The image can also be manipulated in the darkroom to heighten its unreal quality. Abstraction reveals facets of your own subconscious view of a subject and, by making you look harder at the image, can enable you to see reality more clearly.

Moving abstract ▷
By asking the model to move during the exposure, the reality of the figure drawing was replaced by an abstract moving quality. I used a short flash exposure at the beginning of a longer time exposure in tungsten light to avoid a completely blurred image.
105 mm, 2 sec. at f5.6, HP5.

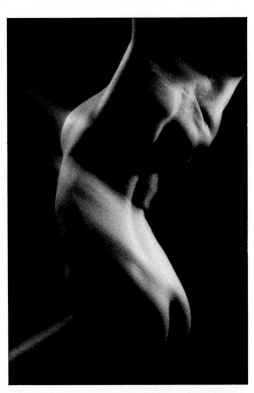

Abstraction through light ▷
By asking the model to work on a slatted platform with a quartz tube light on the floor beneath it (diagram above), I created an abstract feeling in the light with its unexpected angle and quality. I made the picture on a lens considered too short for normal figure photography to enhance the perspective and strengthen the composition.
Bronica ETRC, 40 mm, 1/60 sec. at f5.6, HP5.

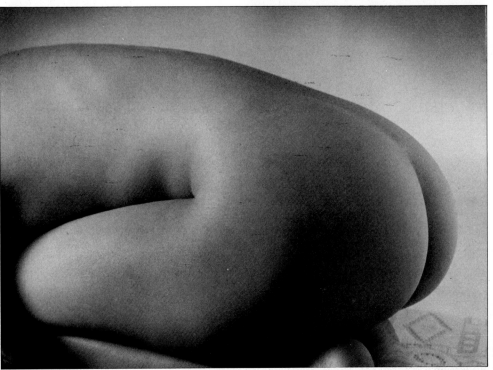

◁ **Unreal detail**
All the time you are photographing a nude figure, stay alert to the possibility of shooting a section of the body in isolation, particularly when the light falls on the figure in an arresting way. No two bodies are the same and when a good opportunity for a detail shot crops up, take it because you may not have the chance again.
Bronica ETRC, 150 mm, 1/125 sec. at f5.6, FP4.

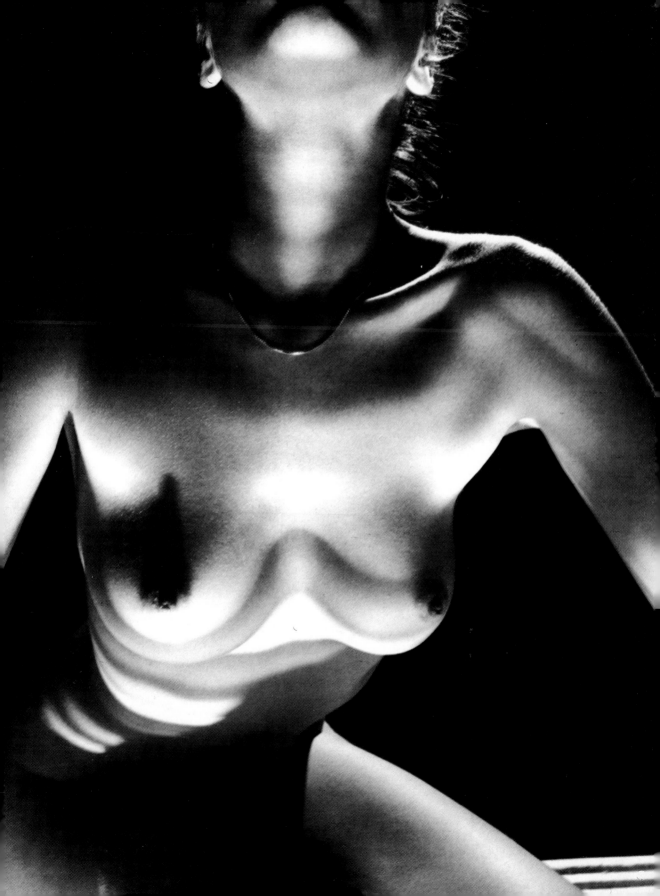

Conveying movement

The nude figure in action is one of the least explored areas of photography. Sports photographers excel at recording moving figures, of course, and industrial photographers use the technique occasionally, but the nude photographer seldom leaves his shutter open while his model moves. When attempting this sort of shot, the model must move as a light-toned figure against a dark background; if the background is light, the white of the moving image will become invisible.

I prefer my moving pictures to have some elements in sharp focus to heighten the feeling of action by contrast with the moving trace image. One way of achieving this is to combine a sharp but underexposed bracket flash image with a time exposure. Results are unpredictable, so it is wise to use old or unwanted film and, when editing the shots, to look for small details which could be enlarged.

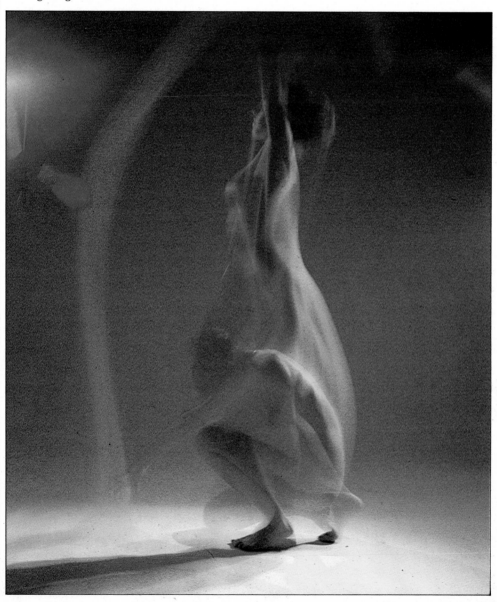

◁ **Movement with flash**
I achieved this mixture of moving trace and sharp image by making a time exposure, beginning with a plug-in flash exposure. The tungsten guide lamps in the flash head provided the light for the time exposure, which had to be made on a dark background to show the trace. I used colored acetates in the lamps, which were placed on each side of the model and facing toward the camera.
50 mm, 1/2 sec. at f4, Ektachrome 50.

Flashlight trace ▷
I attached a pair of red and green flashlights to a golf club, swung by a professional player clad in black, to create the moving trace (diagram below). Without winding the film on, I covered the lens with a black card, while the model, carrying an unlit club, took the place of the professional golfer. I fired a single flash.
50 mm, 2 sec. at f2, GAF 400.

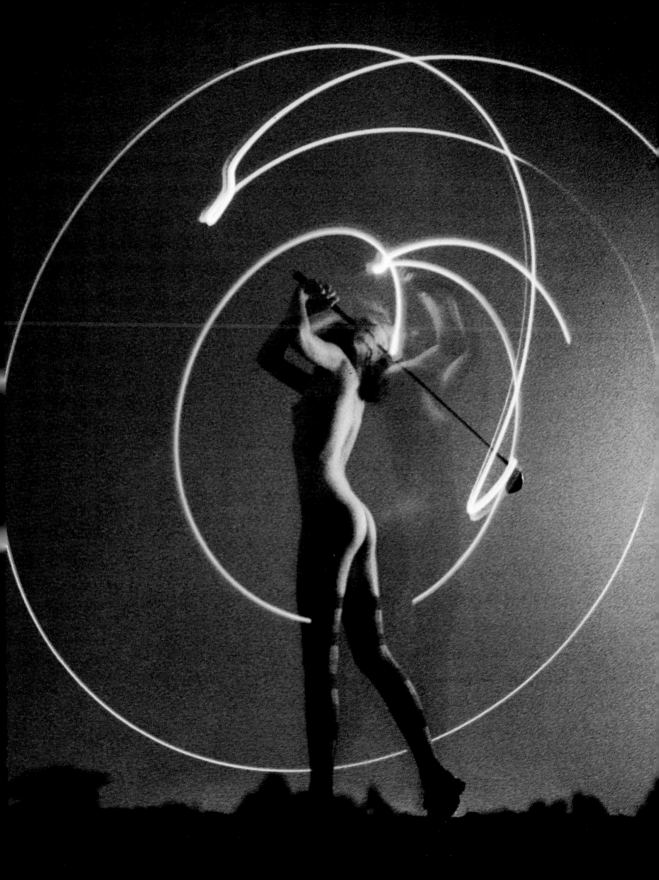

The final abstraction

When you are used to taking photographs in a realistic style it can be difficult to break away from the conventions with which you have been indoctrinated. Abstract photography, therefore, can be a challenge, even to the most experienced photographer.

In my case, a technical puritanism or possibly an early conditioning to the importance of clear tones in black and white photography, leads me to search for abstractions in isolated detail rather than the distorted image. How-ever, do not be inhibited by preconceived ideas of what "abstract" photography should be. Try different ways of extending your style by using your equipment, model and imagina-tion to the full. Having attempted some abstract studies, I feel that they have sharpened my vision and opened for me new ways of looking at things, bringing a strength to all the styles of nude photography to which I am drawn. The novice photographer, by trying abstract work, should be similarly rewarded.

Patterned abstraction ▽
Abstract images can be captured with any focal length of lens but I enjoy the patterns and shapes revealed by the longest lenses. I took this patterned abstract by asking the mode to lie on the floor, which I covered with a bedspread, and then photographed by soft daylight from a positio above her.
300mm, 1/250 sec. at f8, HP5.

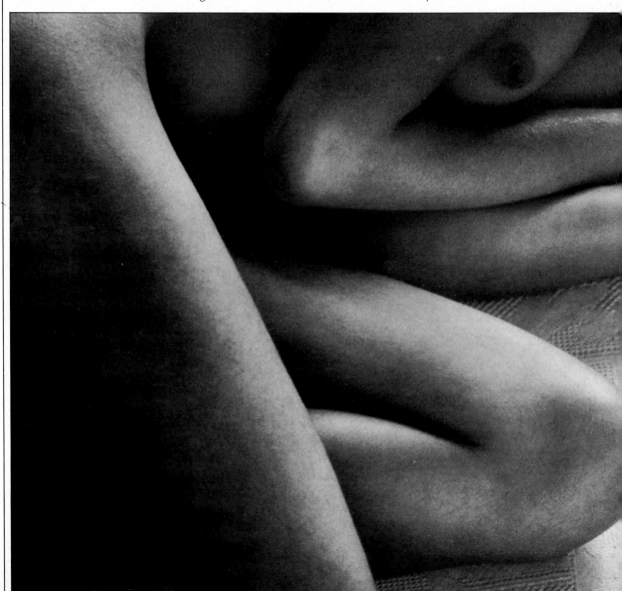

SPECIAL
EFFECTS

Filters for effect

The desire to personalize modern, mass-produced cameras, and the results achieved, has led to a proliferation of accessories. Many of them, used at the right moment, will improve your pictures; if wrongly used, however, they can vulgarize your work and destroy all sense of personality in it. Buy attachments only when you are sure they are needed. Should you want to discover if a certain type of attachment suits your work, first see whether a home-made or borrowed one will tell you what you want to know. For instance, a soft focus attachment can be made from a spare UV or other very weak colored filter which has been smeared with a little petroleum jelly. Fine black silk or even a cross made of two thin strips of scotch tape placed in front of a longer lens can also serve as a simple diffuser. For strong colors, I often use acetate.

Optical filters (multi-image, star burst, cross screen and so on) are less easy to make but are well worth trying. With these, as with all filters, the critical factor is knowing when to use them. One good rule is to make a careful assessment of the difference they make to the shot when looking through the viewfinder.

Adding color for drama ▷
This Moroccan view, shot against the light, would have been effective in black and white but it lacked excitement in color until I tried using strong acetate special effect filters. I asked the model to hold her pose while I used the camera on a tripod. I shot three or four brackets of three exposures each, using different filter combinations. When changing the filtration, I adjusted the exposure for the varying densities of the different filters. After processing, I projected the pictures and chose the combination which suited the shot best.
50 mm, 1/125 sec. at f5.6, Kodachrome 25, 50 magenta, 40 blue.

◁ **Multi-image symmetry**
The regularity of this simple shot meant that it was ideal for a multiple-image filter experiment. Adding color to warm up the white background and paying particular attention to the exact placing of the images by turning the filter ensured a symmetrical result. Multi-image filters are usually most effective when used on the shorter focal length lenses.
50 mm, 1/60 sec. at f5.6, Kodachrome 25, 85B.

Cross filter ▷
A mirrored plastic disk stuck over the model's eye reflected a spotlight into the camera. This was dramatized by the use of an optical cross filter on the camera lens to give this shot a bizarre feeling. The background was back-projected onto tracing paper by an ordinary slide projector.
Bronica ETRC, 150 mm, 1/8 sec., at f4, Ektachrome

Weak, soft filters
Sharp, modern lenses can
sometimes give an un-
glamorous accuracy to nude
photography, which is best
modified by the use of a soft
focus attachment. In both
these pictures the addition
of a weak diffusion filter
with its finely ground
surface takes the sharp edge
off the image and heightens
the atmosphere. Though
such a filter depends for its
action on diffusing the light
passing through it and
therefore has most effect on
the highlights of the picture
on the left, even a picture
composed largely of
shadows (far left) benefits
from softening.
*105 mm, 1/125 sec. at f5.6,
Ektachrome 200, 81C and
soft filter (left); 50 mm,
1/30 sec. at f4, Kodachrome
25, 10 CC magenta, 81A
and soft filter (far left).*

Simple front projection

A slide projector of some kind is usually available to most photographers and although it is not as manageable or as powerful as photofloods or spotlights, it can, on its own, be a perfectly usable tool for nude photography sessions. Even without slides, the hard-edged beam of light can throw weird figure shadows on a white wall or seamless paper behind the model. With the addition of a tracing paper screen and some realistic or fantasy slides, there is a new world of silhouettes open to you. If your space is restricted, put the projector in the next room, hang the tracing paper flatly in the doorway and photograph towards it from the room in which you are working. By incorporating one or two small spot lamps (inkies) fitted with barn doors, you have the equipment for a wide range of back projection pictures.

The art of lighting for simple back projection is to avoid spill from the lamps onto the screen, where it would degrade the projected image. It is now possible to buy special back projecton plastic sheet which reduces this problem, though it does not have such a high transmission factor as tracing paper. There is a tendency for the back projection image to be brighter in the center of the screen but this can be exploited by using sunsets or other center-weighted images as originals.

If the realistic approach of nude figures against a natural background lacks appeal, try using the projector beside the camera where you can project abstract pattern slides onto the body alone or onto the body and background at the same time. The choice of image is up to you but if you keep an eye out for patterned subjects you will find many opportunities to shoot material for projection.

Mediterranean scene ▽
Carefully chosen, your holiday transparencies can provide exciting backgrounds for indoor nude pictures. Here I used a slide projector to throw a transparency, via a short zoom projection lens, onto seamless paper. I placed the projector beside and above the camera. The model lay on a long box covered in black felt. I lit her with a heavily diffused and snooted 300-watt spot, positioned to match the sun in the background picture. On the floor by the camera, used a dimmed and diffused 60-watt desk lamp for fill in
50mm, 3 sec. at f5.6, HP5.

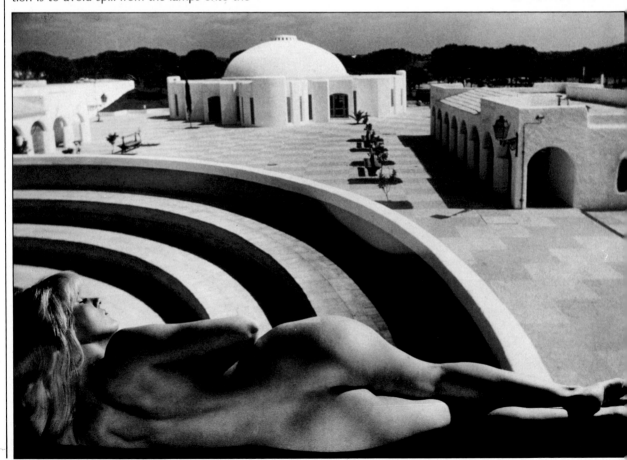

Photographing projected images

The domestic slide projector, despite its low light output, is capable on fast black and white film of bringing fantasy, mystery or strong graphic appeal to your pictures. To achieve these, you must build up a collection of suitable images for projection. You can even use two slides together, put in the projector to form a sandwich. When projecting onto the model's body you must assess whether the picture will work better with a plain background, as in the picture below right, or when it covers the model and the background, as in the pictures below left. There are no rules for this fantasy area of nude photography: you must simply follow your intuition and judge the results critically to build up your technique for the next time.
50 mm, 1/8 sec. at f2, HP5 (all pictures).

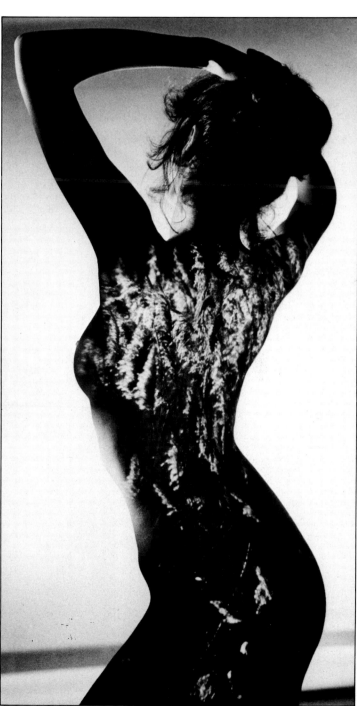

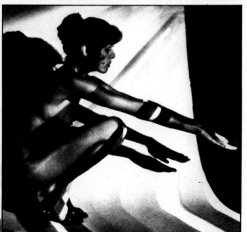

Lenses for effect

An unfamiliar lens is guaranteed to revitalize the jaded photographer. It will make you think about previously untried ideas and out of this mental exploration good photographs will very often emerge.

The excitement of using unfamiliar, extreme lenses can lead you into shooting pictorial clichés. You must, therefore, exploit the lens rather than letting the lens dominate you. If I am carrying an unfamiliar lens, I shoot first on my regular lenses and only when I am satisfied do I switch to the special lens to see what it will do for the image. My personal preference is for extra long lenses, that is lenses over 200 mm. Used in good light, out of doors, their drawbacks — small apertures and reduced depth of field – are not serious.

Mirror lenses have recently become much lighter than were the very early telephotos. Manufacturers have also overcome the problem of "doughnut highlights" which previously caused distracting patterns, in the background of water shots for example. As with all longer lenses, it is essential that a heavy tripod is used to achieve really sharp work at speeds below 1/500 of a second.

For hand-held work on short lenses, I often use a square fish-eye lens. I call it this because it fills the whole 35 mm frame to the corners but has the curvature of field that is associated with the round image fish-eye. I rent it occasionally for work in relatively featureless situations, such as flat beaches or empty rooms. This lens can dramatize the surroundings by its aberations, though it must be used with care unless you are deliberately seeking to distort the figure. When using this lens in my nude work I keep the model a fair distance away and place her in the middle of

the frame to avoid problems of distortion. I also take especial care not to photograph my own toes.

Zoom lenses can be manipulated to achieve a whole range of startling effects. By combining them with multi-exposure flash techniques or zooming during time exposure, effective images can be produced. One disadvantage of the zoom lens is that it is prone to flare. As I often photograph directly into the light, this leads me into complicated masking exercises to shade out the excess light from the lens. I often use a polarizing filter but am constantly irritated by the rotating front member, which on most zooms makes the orientation of all optical attachments extremely tedious.

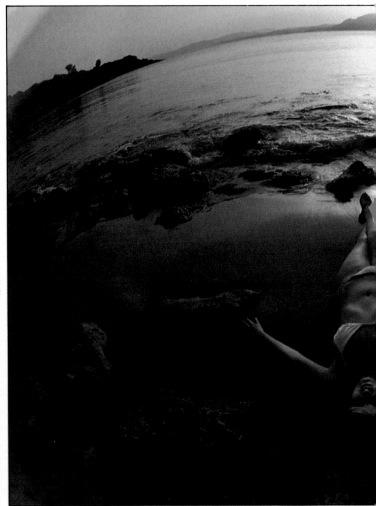

Fish-eye variations
When you have sun, sea, sky and a beautiful model, the "square fish-eye" will do the rest for you. It works best if you keep body distortions to a minimum by using the model in the middle of the frame (far right). If you do not (right), distortion of the figure is inevitable, but not necessarily disastrous.
16 mm, 1/125 sec. at f4, Ektachrome 200, 81EF (far right); 16 mm, 1/125 sec. at f5.6, Kodachrome 25, polarizer (right).

◁ Zoom movement
I surrounded the figure in this studio picture with fixed points of light, knowing that the "speed" effects of fully zooming during the exposure would elongate them and so strengthen the effect of movement in the image. In fact, the model did not move at all during the long exposure.
40–80 mm zoom, 3 sec. at f5.6, Ektachrome 50.

Long-lens effect ▽
One of the greatest virtues of longer lenses (over 250 mm on 35 mm cameras) is their ability to turn a simple background into an imaginative tonal arrangement, as in this empty cornfield picture. When shooting distant figures on the longer lenses, be alert to qualities in the landscape which can be incorporated with the figure to create graphic effect.
300 mm, 1/250 sec. at f4, Kodachrome 25, polarizer.

Montage and sequence

Habitual attitudes to photography, formed by the preference of newspapers for the single picture, have often blinded photographers to the power of a sequence of related shots. Yet projecting slides to your photographic club or friends is an ideal opportunity to show a well-chosen set of pictures, which are likely to convey a narrative and give more pleasure than near misses at brilliant, single shots.

Nude photography is well-suited to sequence treatment, whether it is variations of the obvious striptease idea or the sophistication of a subconscious fantasy series. By planning sequences rather than single shots, you will take some of the tension out of a session. In this relaxed atmosphere you should nevertheless be able to explore any single picture opportunities that crop up as you work your way through the sequence. Do not forget that you are trying to put over a story, where you need a beginning, middle and end. Ideally, always leave something to the imagination.

Though montage, a quite different concept, is a group label for combinations of existing images, it is, like sequences, an ideal way of projecting fantasy. These combinations are made either in the darkroom at the printing stage or afterwards with scissors and paste. I prefer the simplicity of darkroom montages, where the final print usually employs images specially designed to be printed together. If this is to be successful, there must be areas of predominantly white tones where the secondary images can be placed.

If the montage is to be made from cutting out and glueing down existing prints, the vital ingredient is patience. The result can be improved by subtle touches, such as using a fine emery board to chamfer the print edges and dying the edges to match the image tone to avoid white lines where the prints join.

If you make your montage prints on the soft side, with a full range of tones, the paste-down can be rephotographed. Careful lighting will help to obscure the joins and create a slicker result. Pasting down, if you have the patience for this, enables you to make pictures which transcend all practical and physical problems. Scenes photographed years before can be combined with your new model pictures and the only limit is the power of your imagination in choosing your images.

Enlarger double exposure ▷
As long as your montage has been well planned, the creation of a double print picture is simple. I ensured that the background tones of the component negatives were dense (white on the print) and that the negatives matched for contrast. I took care in positioning the image by using plain paper and pencil to sketch the ideal position of the two images to aid the correct placing of the enlarger easel when changing negatives. To simulate movement, the model's hair was blown by a domestic vacuum cleaner.
105 mm, 1/250 sec. at f5.6, FP4, 50 CC green (statue); 28 mm, 1/15 sec. at f5.6, FP4 (girl).

Atmospheric story
I chose a simple, dream-like story for this sequence, which I shot on infra-red black and white film to create a mysterious atmosphere. Technical factors, such as the need for a metal blade shutter rather than a fabric shutter on the camera, and the use of a changing bag to load the camera, made infra-red film complicated to use. It was also imperative that the correct filtration was used on the camera.
28 mm, 1/60 sec. at f8, Kodak HIE, Wratten 25.

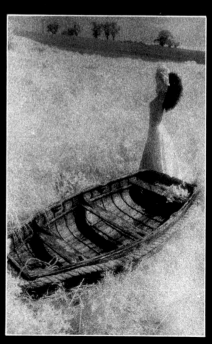

Multiples and sandwiching

A simple multiple image can occur when two transparencies are accidentally jammed together in a slide projector. Such unintentional superimposition may suggest to you the possibility of deliberately manipulating two uninspiring transparencies in one mount to produce a striking result.

So that one transparency can be seen through another, there have to be light areas in one which correspond with the darker detail in the other. A simple way to achieve this is to match the interesting parts of two transparencies in a cardboard mount with a smaller than normal aperture, say 24 × 24 mm instead of the standard 24 × 36 mm. This allows you to manipulate space and covers up any film rebate which might otherwise spoil the image. Another simple method of superimposition is to use two projectors and one screen. Dodgers, which are black cardboard disks mounted on wire used for controlling enlarging, are employed to hold back from one projector that part of the image which you wish to be filled in from the other. Freedom to adapt the relative size of the two images by moving the projectors is one of the advantages of this method. The slight deterioration of color quality when copying from the screen is a disadvantage, however. This problem is best overcome by avoiding natural subjects and sticking to extravagant colors where inaccuracy is not so obvious.

Some of my best superimpositions arise almost accidentally. For instance, I sometimes begin a shoot with what turns out to be unsuitable film. Before returning it to the unused film box, I mark the roll to remind myself that it has been partly used. When reloaded, I use the already exposed frames at the beginning of the roll to warm up the model, thus turning them into double exposures.

If your camera has a double exposure device you can, of course, design and shoot true superimpositions with ease. But it is that very ease that sometimes gives you a rather tame result by removing the excitement and the unexpected.

I look forward to the winter months when I have more time to explore multiple image duping. I have a drawer full of old snippets of images that I believe are right for combining with each other. They have only one thing in common: an area of plain tone, somewhere in the image, where the second image will fit.

◁ **Double exposure repeat**
Whereas some double exposures depend for their success on careful planning and exact image placement, this picture is the result of the random re-exposure of about three frames of already exposed film, which had been wound back into the cassette. The elements have conveniently fallen into place to make a repeated pattern. I had to ask the color laboratory to leave my film uncut after processing. If I had not, this set of pictures would have been destroyed in the automatic machine which is used for mounting transparencies. *50 mm, 1/15 sec. at f5.6, Ektachrome 50 (first exposure); 1 sec. at f2, (second exposure).*

Simulating grain ▷
To give an old-fashioned grainy look to this color torso, I first exposed a film, the same size as the final transparency, to white cardboard on which I had scattered a mixture of lentils and dried white peas. After processing, I chose one of the lighter exposures from this shoot and inserted it in the camera back through the slot which is normally used for the magazine closing sheath. Thus the image of the girl had to pass through the lentil film before it reached the magazine. The close proximity of the lentil film to the shooting film meant that the lentil image was still sharp and gave a mottled look to the body. *Bronica ETRC, 150 mm, 1/4 sec. at f.5.6, Ektachrome 200, 81A.*

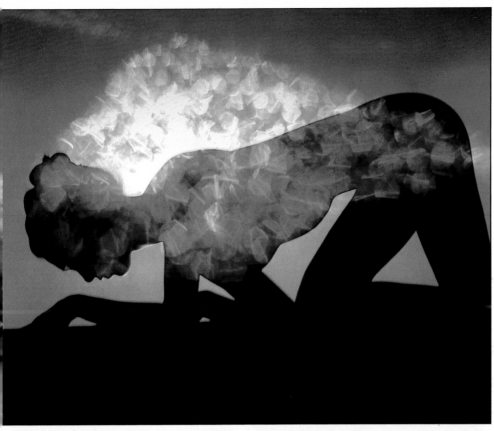

◁ **Straight double exposure**
After I had taken this silhouette by tungsten light in the studio, I spotted the glittering reflection from the lurex threads in the model's wrap, which was thrown over the studio stool. Lighting the wrap with a bright green spotlight, I re-exposed the film carrying the latent image of the girl with the purple background to the green sparkle. I guessed at a suitable position for matching the two images.
Bronica ETRC, 150 mm, 1/2 sec. at f5.6, Ektachrome 50 (both exposures).

◁ **Shooting the screen**
Two slide projectors, one with the face of the girl, the other with a jungle palm illustration, were focused on the same screen. Before the images were re-photographed to make this combined picture, I drilled two holes in the screen to coincide exactly with the model's pupils, then covered these two holes with green acetate and put two small electric flashlights behind to make the eyes glow. A final touch was to use a cross-screen filter on the camera when re-photographing the screen image to emphasize the green highlights.
Bronica ETRC, 150 mm, 1/2 sec. at f4, Ektachrome 200, cross-screen filter.

Effects in black and white

One of the many attractions of the black and white process is the ease with which you can experiment with manipulating images in the darkroom and in the many styles and techniques which you can use to present your negatives. Many people enjoy these processes for themselves, but for most photographers the reason for deviating from the standard print is to revitalize dull pictures. Selectivity is still important if you are to impose textures or changes of contrast in your pictures. Images with a basically simple shape and design and containing a full range of tones, with emphasis on middle tones (grays), are preferable. Some image manipulations such as bas-relief and solarization (not illustrated here) can be used with more complex images, though care must be taken at all stages to ensure that the effect of the treatment you use is enhancing the feel of your picture.

It is worth remembering that manipulating images in the darkroom need not always be a wholly scientific process. Always be ready to experiment and seek the unusual.

Mezzotint
To illustrate a few of the many treatments that can be applied to a full toned black and white print, I applied three techniques to the same print. This section is made by rephotographing the original print through a mezzotint negative screen, kept in close contact with the copy negative.

Linear 25 line
This section of the picture was rephotographed as above but I used a line screen negative. These effect negatives can be bought from a sophisticated photographic dealer.

Three-tone separation
Tonal separation is achieved by rephotographing the print onto two line film negatives with different exposures. I made this print from a combination of the two negatives. One negative provides the gray tone, the other the black. The white is unexposed paper.

Enlarging through tissue paper △
For the abstract print above, which is made from the same negative as the picture near right, I sandwiched fine tissue paper with the negative while exposing through the enlarger. This type of treatment is usually best suited to simple shapes and images.
15 mm, 1/125 sec. at f8, HP5.

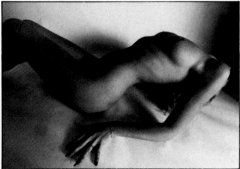

Printing through an overlay ▷
I stretched fine oriental paper flat over the printing paper
during exposure to the negative through the enlarger to
produce this patterned effect. For a successful result with
pictures such as this, it is essential that the paper is ironed
free of creases before use and is in perfect contact with the
printing paper while exposing.
105 mm, 1/60 sec. at f5.6, Tri-X.

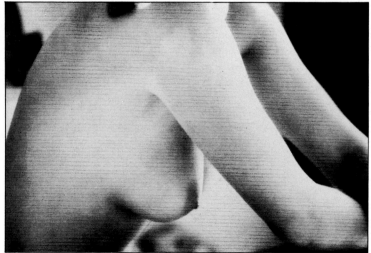

Color printing variations

Ever since color materials were invented, photographers have sought creative ways of bending the scientifically accurate colors so carefully built into the film and paper by the manufacturers. To abandon "correct" color frees you to explore new moods and styles and create unexpected results. If you choose to manipulate at the printing stage, you are not risking the safety of your camera originals and can therefore be uninhibited in your use of strange and unpredictable colors.

Though planning is essential to the success of most photographic enterprises, there are some areas where chance can help to form your results. Nude pictures based on graphic power, rather than realism and charm, can be treated after exposure to produce results where strong, unrealistic color emphasizes the shapes and further depersonalizes the image.

It is not essential that you have darkroom or color processing facilities to achieve interesting results in this field. Black and white prints can be chemically toned in daylight and the better custom printing laboratories will enthusiastically co-operate in achieving the desired filtration effects with your negatives on the enlarger. Even instant pictures, such as Polaroid SX 70, can be manipulated and their image and colors dramatically altered. Methods include chemical after-bath treatment and maltreatment of the print surface to encourage the emergence of colors in the substructure of the paper, which can enliven a dull picture.

Among the treatments available after shooting are the simple weighting of enlarger filtration on color prints and chemical toning of black and white prints. Successful results can also be obtained by printing transparencies onto non-reversible paper to obtain a negative result. Black and white negatives can also be used in a color enlarger to make single color prints on color paper. A more elaborate print system is the gum bichromate process, which is capable of exquisite results but requires a great deal of skill and care.

The list is long and, if you are interested, you should consider other print manipulation techniques described in specialist books.

Color toning ▽
I used a French chemical toning kit to produce this result from an even-toned black and white print on resin coated paper. Though the results of toning can be unpredictable at times, the technique allows reject prints to be put to good use at a later date.
50 mm, 1/60 sec. at f5.6, HP5.

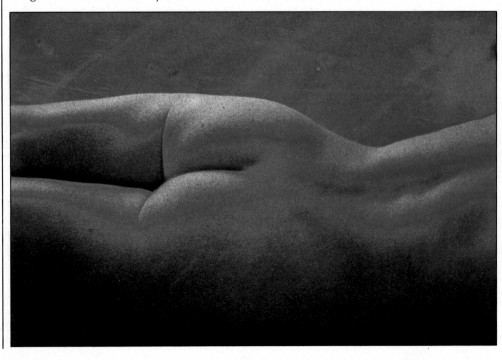

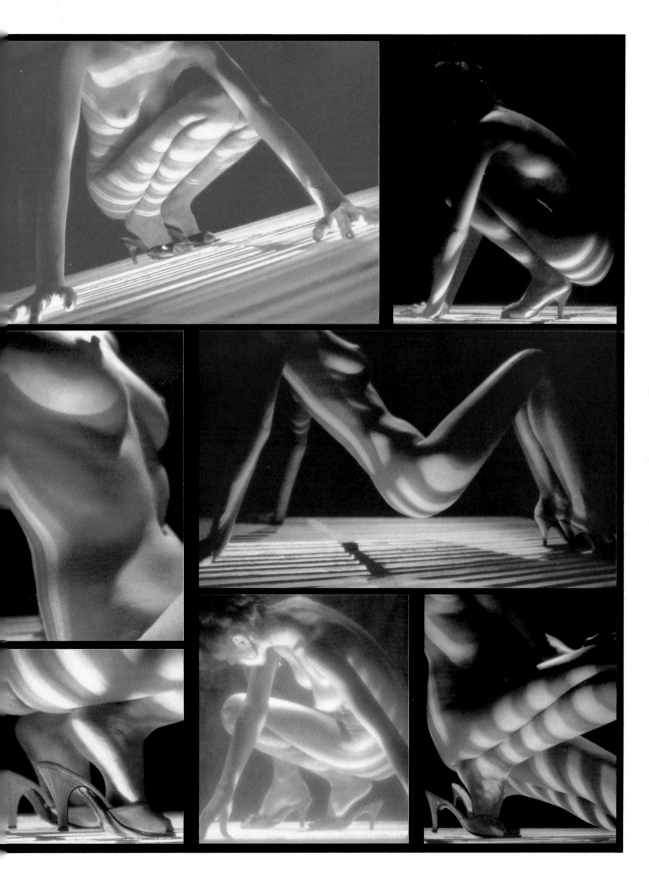

Improvements through make-up

Make-up and hair styling can greatly add to the polish of your pictures, although there are limits to the improvements that can be achieved. Ideally, it is better to use make-up skills to improve the appearance of a good-looking model rather than to transform an unattractive one. Make-up can hardly give a chiseled profile to a chubby face but it is certainly capable of sharpening good bone structure and can also successfully disguise skin blemishes and shadows.

It is worth time and patience to gain the model's agreement with the improvements you want to make to achieve a photogenic look, for it is her patience and enthusiasm that will enable the improvement to take place.

1 Before make-up is applied, the model's face lacks shape and is speckled with freckles. Her hair was attractive enough for the hairdresser to plan a style that emphasized its natural look.

2 The correction process involves masking out blemishes and concealing shadows with white make-up. It is applied so that the edges of the masked areas blend with the surrounding skin. The hair is prepared by rolling it in heated rollers.

3 The foundation process means covering the whole of the face and neck with foundation a shade lighter than the model's skin. By using a damp sponge, it is possible to avoid both an edge line and disturbing previously-applied correction. Finally, shadow and highlight lines are drawn.

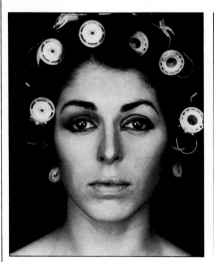

5 After powdering the face, eye make-up starts with brushing and filling-in eyebrows with pencil strokes. Black pencil lines are applied to the eye and along the socket line (right eye), and blended outward to overlap with highlights on the browbones and center of the eyelid (left eye).

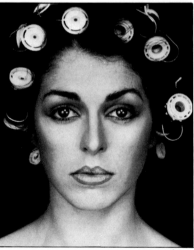

6 Mascara is brushed on the eyelashes and the lashes are combed to separate them. The lips are outlined for shape with a dark lipbrush. Lips must be dark for black and white photography since pale colors reproduce as white.

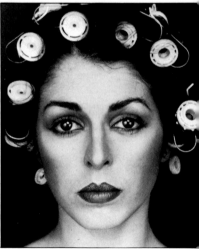

7 Final lip color is created from lipstick, applied with a lipbrush. Powder blusher is brushed lightl onto the cheeks and temples and a check is mad to ensure that all edges are well blended and tha no shiny areas remain.

Make-up for black and white photography

For a really professional finish, invest in a full range of make-up for your models. The following materials and equipment were used for the exercise on these pages.

Blemish stick	Lipstick and pencil
Shadow concealer	Damp make-up
White foundation	sponge
Covering foundation	$\frac{1}{4}$ in brush
Dark foundation	Shadow brush
Translucent powder	Eyebrow/eyelash
Dark and highlight	brush
powder shadow	Powder brush
Powder blusher	Powder pad
Black mascara	Lipbrush
White, brown,	Cotton buds
black pencils	

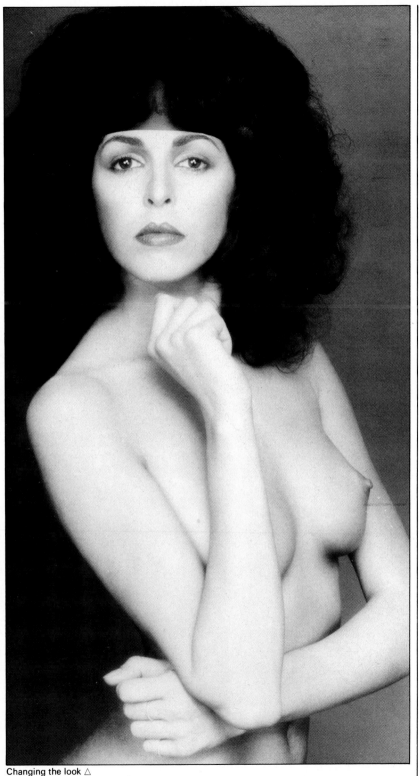

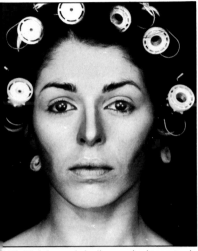

4 Highlighting and shading emphasizes natural bone structure. Blended light areas are made high on the cheek bones, brow bones and center of the chin and nose. Dark areas to create shadows are made under the cheek bones, and at the sides of the nose and jawline to thin them.

8 Hair rollers are removed and the hair softly arranged to complement the shading of the face. Remember that hair rollers should be left in place until the last moment, when the photographer is ready to shoot.

Changing the look △
After completing these step-by-step make-up pictures, I asked the hairdresser to change the model's hair to produce a different look. She added a ribbon on the forehead and back-combed the rest of the hair.
Bronica ETRC, 150 mm, 1/125 sec. at f5.6, FP4

Professional hair and make-up

If you are lucky enough to have the help of a professional hair or make-up specialist, you will quickly see how he can transform a model's appearance. Good artists in these fields not only improve on nature but work with the photographer to help generate picture ideas, using their hair and make-up skills to emphasize the point of a picture. You should, however, avoid clashes of temperament; you, the photographer, are endeavoring to get the shot right and the hairdresser must be content with a supportive role. Another problem when involving other creative people in a shooting session is that you must give them time to perform their tasks satisfactorily.

To overcome the problem of expense, it is worthwhile approaching a talented local hairdresser, showing them your pictures and asking if they are interested in working with you. Often they are enthusiastic and will assist you with arranging your model's hair in return, perhaps, for some photographs of hair styles for their window display.

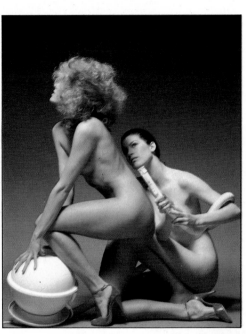

◁ **Contrasting hairstyles**
A hairdresser exploited the hair characteristics of the two models for this studio flash picture. The blonde model slept with her hair in numerous tiny curlers and frizzed it out in the morning. The dark girl's hair was slicked back forming a complete contrast of style. *Bronica ETRC, 150 mm, 1/125 sec. at f8, Ektachrome 64, 81A.*

Body paint fantasy ▽
While the make-up artist created a cloud fantasy on the model's skin with water based paints, I built a wooden box and filled it with tissue paper so that the model would appear as an expensively packed present. Lighting from a fish fryer covers the back evenly, a necessity when you do not wish to introduce shadows. *Bronica ETRC, 50 mm, 1/125 sec. at f8, Ektachrome 64.*

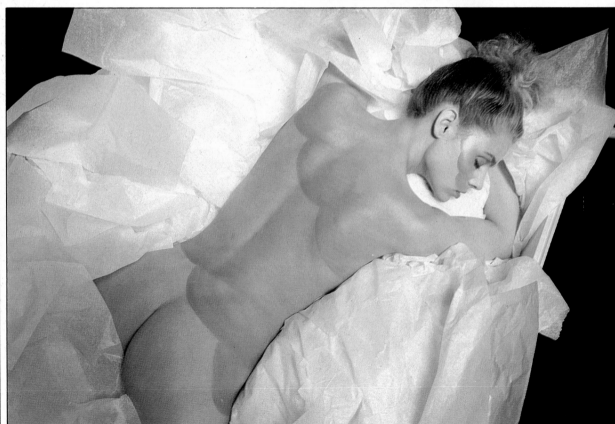

APPENDIX

Equipment and accessories

For my nude photography I need to concentrate as much as possible on directing the picture and so, while shooting, I like to avoid making adjustments to my camera. The solution is an automated system pre-programmed to allow for the circumstances of the shot. I would therefore recommend that you should buy the best automatic 35mm through-the-lens camera body that you can afford. I prefer the Nikon FTN system, with a shutter speed priority automatic meter, fitted with manual override.

One of my most useful accessories is a remote firing cord some two meters long for the autowinder on my Nikon FTN. I find the autowinder invaluable, for it prevents my missing good pictures while winding and the long cord gives me the chance to put the camera in unlikely places and yet still shoot comfortably without shaking the camera body.

Lenses

Much more important is your choice of lenses. My first choice would be a medium-short but fast lens, for example a 28mm with f2 maximum aperture. Anything between 24 and 35 mm is acceptable but the wide aperture is important. Shooting figures on a lens as short as this demands care, but if you master the technique by perseverance and critical examination of the results you will find that it gives you greater freedom when working in difficult conditions. The next lens I would buy is a 105 mm telephoto, again with a maximum aperture of at least f2, but anything from 85 to 150 mm will do. It is advisable that lenses have the same size threading on the front element to enable you to change filters and lens hoods easily.

Though many cameras are sold complete with a normal 50 mm lens, it is in fact a lens which comes quite low on my list of priorities. After the 105 mm lens, I would hope to acquire a 300 mm telephoto lens,

My camera system ▷
My personal camera equipment is as uncomplicated as I can make it, for carrying excess gear on location saps vital energy. In addition to simplicity, I seek reliability and versatility. This set-up gives me both.

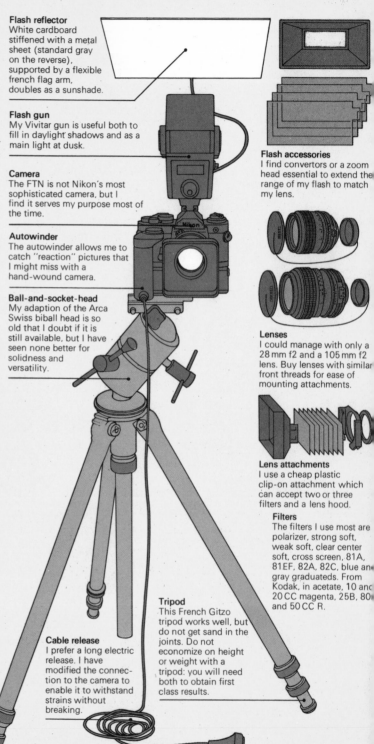

Flash reflector
White cardboard stiffened with a metal sheet (standard gray on the reverse), supported by a flexible french flag arm, doubles as a sunshade.

Flash gun
My Vivitar gun is useful both to fill in daylight shadows and as a main light at dusk.

Camera
The FTN is not Nikon's most sophisticated camera, but I find it serves my purpose most of the time.

Autowinder
The autowinder allows me to catch "reaction" pictures that I might miss with a hand-wound camera.

Ball-and-socket-head
My adaption of the Arca Swiss biball head is so old that I doubt if it is still available, but I have seen none better for solidness and versatility.

Cable release
I prefer a long electric release. I have modified the connection to the camera to enable it to withstand strains without breaking.

Tripod
This French Gitzo tripod works well, but do not get sand in the joints. Do not economize on height or weight with a tripod: you will need both to obtain first class results.

Flash accessories
I find convertors or a zoom head essential to extend the range of my flash to match my lens.

Lenses
I could manage with only a 28 mm f2 and a 105 mm f2 lens. Buy lenses with similar front threads for ease of mounting attachments.

Lens attachments
I use a cheap plastic clip-on attachment which can accept two or three filters and a lens hood.

Filters
The filters I use most are polarizer, strong soft, weak soft, clear center soft, cross screen, 81A, 81EF, 82A, 82C, blue and gray graduateds. From Kodak, in acetate, 10 and 20 CC magenta, 25B, 80 and 50 CC R.

with an aperture of not less than f4. Failing that, a long zoom, say an 80–200 mm, would suffice, although the revolving front element creates endless problems if you use graduated or polarizing filters or any front masks.

Accessories
A really solid tripod as tall as you are and as heavy as you can manage to carry is a marvellous investment, but it should be equipped with a practical pan-and-tilt head. I prefer the quick action of the ball-and-socket type. Personally, I find little use for rack-and-pinion gear on my center column and use a simple screw locking ring. I dislike tripod screws for the time-consuming business of using them to attach the camera to the stand. Instead of them, I use a shaped camera plate,

permanently bolted onto the underside of the Nikon body, which fits into a quick release clamp on the ball-and-socket head.

For flash, I use a small on-camera Vivitar system, but the new dedicated adaption which allows flash exposure measurement to be conducted through the camera lens via the camera's own internal meter is attractive. As I use filters regularly, this simplifies my work by including an automatic filter allowance in the flash calculation. With my flash I have a full set of colored acetates. I find the ones supplied by the manufacturer do not give a very subtle range of colors and I have therefore acquired acetates from other sources over the years. I also have diffusers and light-reducing neutral density filters, together with remote cord for the flash. For camera filters I mostly use the Cokin system.

Care of equipment
To avoid losing small items of equipment on location, I arrange them in labeled spaces in my camera bag. I also keep all my lens caps in the bag, drilled and tied together in pairs for each length of lens and labeled accordingly. In this way, I am aware of any missing item when packing to leave from a location.

◁ **Carrying essential equipment**
Useful items in an accessories bag include matches, candles, scissors, scotch tape, various clips, some spare batteries, string, a hammer and some pins. It is also wise to include make-up products for the model, together with baby oil and a mirror. Other, less obvious but essential items to be included are listed below.

Accessories bag
Reflector sheet
Nylon diffusing net
Photoflood bulbs
Staple gun
Plug-in dimmer switch
Camera tape
Rubber bands
Adaptor
Safety pins
Stiff wire
Flashlight
Nails and screws
Invisible thread

Clamps
Lamp acetate clip
Low-level tripod plate
Modeling clay
Connection blocks
Smoke pellets

Sources of inspiration

If you are going to spend a day or two, or even a few hours, photographing nudes, you will need to do some planning. I advise you to visualize well in advance some of the pictures that you may be taking, but for this you will need reference material. If, like me, you become committed to picture-making you will find that you will take reference pictures at every opportunity, for ideas crop up in all facets of daily life. I either jot down the idea on a piece of paper or make a rough sketch to remind me of the idea later. These jottings are combined with ideas clipped from magazines and newspapers. Many photographers find inspiration in the work of great painters and sculptors and even in book illustrations. The key is to be constantly alert in your daily life to every visual possibility. Nor should you ever underrate your own work as a source of ideas, for failed pictures can be reshot.

I use an "ideas board" as a source of immediate inspiration when I have to think quickly. I divide the board into sections, such as "interiors", "exteriors", "mood" and so on, so that different areas of my work have their own space. When I am planning a photography session, I assemble in a folder some of the ideas that suit the model and the situation. I then use these to compile a props list and to choose the correct clothes and equipment for the photography session.

The pages that I tear out for inspection are seldom nude pictures and are often

Studio ideas △
My notice board is a hodge-podge of ideas, comprising clippings, Polaroid pictures and commercial information which reminds me of picture ideas I want to investigate or equipment that I should like to test. In no way is the notice board intended to be a creative thing. It is merely a reference place where I can store information.

Recommended reading
Having never worked as an assistant to another photographer, I think I have been more affected by the published work of great photographers than I might otherwise have been. The pressures of life as a working photographer leave me little time for reading but I have always bought books produced by photographers whose work excited me. These are some I admire:

White Women
Helmut Newton, Quartet, London (1976)

Masterpieces of Erotic Photography
Arrow Books, London (1979)

Trouble and Strife
David Bailey, Thames & Hudson, London (1980)

The Nude in Photography
Arthur Goldsmith, Octopus Books, London (1976)

You Can Sell Your Photos
Henry Scanlon, Harper & Row, New York (1980)

The Book of Photography
John Hedgecoe, Ebury Press, London (1976)

without merit but give me the starting point for a nude picture idea.

When you discover a possible location for a shooting session make some reference pictures which explore all the potential angles that you can find. Imagine the model's pose or action in these reference pictures and examine all the lighting choices of the situation. When processed, these pictures will tell you much about the location and give pointers to its effective exploitation. Do not underrate your own past work as a source of ideas.

Location ideas △
I often tear out magazine or newspaper pictures which, though in their own right have no particular esthetic merit, contain a germ of an idea which I can apply to a forthcoming project. In the same way, I pin up reference pictures of a location which may have been unsuitable for that project but where I saw possibilities for its future use.

Exterior location ideas △
Some of the pictures on my board would seem to be far removed from nude photography, but it is their graphic qualities, such as the scale of the man and the ship in the top picture or the man and the building in the bottom picture, which remind me of visual qualities that I would like to get into my pictures more often.

Model sources

An attractive, talented model is the best possible spur to achievement in nude photography. If you have adequate means and live within the range of one of the world's centers of advertising photography, you can hire professional models without difficulty. If, however, you have limited resources or live in a remote area, you will most probably experience some difficulty in hiring suitable models. This is certainly a problem but one that can be resolved. For instance, young dancers, actresses and fashion models all need good photographs to advance their career and may be prepared to pose for you if you can help solve this problem for them. Other possibilities include art schools, and models and others in the hair-dressing and beauty trades. Many of these people require really glamorous photographs, which are difficult to come by and are expensive. If you can provide these, you have a big lever for obtaining more help with your modeling problem.

Approaching a potential model

When asking a friend, or for that matter a complete stranger, to model for you, a simple request will hardly suffice. The strongest inducement you can offer is your own talent for photography. Before you even consider approaching a model to pose for nude pictures, therefore, you must develop your skills to the stage where you can produce arresting and attractive portraits and full length pictures. Such studies embrace most of the basic problem areas of nude photography and if you can offer good photographs, well organized and presented in a portfolio, this will be a strong inducement to a prospective model.

Secondly, you should have established a reputation for reliability and professionalism, so that the model will know you to be trustworthy. Be sensitive to the fears and reluctance which she may feel about nude modeling.

It is seldom wise to approach single strangers, as your motives may be misunderstood. Far better to approach girls in a group or a girl with a male escort. You can then ask her to bring a companion to your home for a friendly but professional discussion of your present picture-making plans. If your prospective model is attractive but does not wish to pose naked, do not put pressure on her; you may still be able to arrange a rewarding shot with her clothed. Moreover, she may well suggest another model, for one of the best ways of getting suitable subjects is recommendation by word of mouth.

If your prospective model could conceivably be underage, make a point of finding out how old she is before arranging a session. As a minor is not entitled to sign a release document, you must involve a parent before photographing.

Joining a photographic club

If you meet with no success in your search for a model, another possibility is to join a photographic club. Here, sessions are arranged where a novice model works with a group of amateur photographers, who all contribute to her fees and work simultaneously (see pp. 156–7).

The perfect situation

As you extend your photographic talent and your reputation for reliability, you may be approached by models anxious to work as professionals. It cannot be stressed too strongly or too often, however, that whether your models are professionals or not, they are entitled to patient, kindly treatment from the photographer and must be assured of his absolute integrity.

Professional models

Many model agencies are to be found in smaller cities as well as large centers. Should you consider using their services to supply a nude model, the normal procedure is for you to telephone them first and explain your requirements. If they do not know you, they will probably suggest a meeting. They can then see examples of your work and you can inspect photographs of their models and discuss fees.

Negotiating fees

It is important to remember that the agent is in fact employed by the model on a percentage basis and therefore it is the model who makes final decisions over whom she will work with and what fees

Model cards

Agencies encourage their models to produce cards, sometimes called composites, made up of photographs of the model and some information about her. These can be helpful to a nude photographer but, since they are designed to promote the model's interests, they must be viewed with care.

As with advertised merchandise, the most important point is to watch out for the details that are omitted. For instance, a superb set of photographs showing a model's talent and charm but always cut off above the knee may suggest that her ankles are ungainly.

Model measurements on a card, even if accurate, can be misleading. For example, bust measurements can tell you more about the size of the model's back than her front and you may be wise to ask for more precise details. Regard with suspicion what is said about the model's complexion and hair color. Retouching on a card can easily remove skin blemishes, so that if a perfect complexion is required be sure to check this aspect with the model or her agent. Hair color and style are often changed and this can

Marilyn

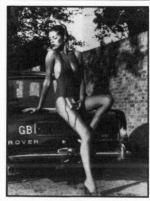 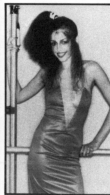

LEGS
DANCER
BEAUTY

Height 5′ 9″/1.75 m
Bust 34″/86 cm
Waist 22″/56 cm
Hips 34″/86 cm
Dress 10/38
Hair brown
Eyes brown

SMITH'S AGENCY

greatly affect the model's value to you. Similarly, you must ask about body marks caused by sunbathing in a bikini or operation scars.

The secret is to study the card carefully and be sure that the model can recreate, without professional help, the impression that she gives in her photographs.

Model card
Measurements on a composite are as important as pictures of the model. Study them carefully and learn to relate them to your photographic needs.

she wants. If you are asking a model to work out of normal professional hours or to do work to which she is unaccustomed, you must give the agency time to clear this with the model concerned. On the other hand, if you feel the agent is asking too high a fee for a particular model, ask them to offer a lower fee. You could suggest that she might benefit from working with you, that you could, for example, improve on the quality of the pictures in her portfolio. Insist that the agent passes on any offer that you want to put to her. In this way you will be assured that, if she does not wish to work with you, it is her personal refusal that has prevented your photographing together and not because the agent is trying to extract a high fee partly for his own benefit. All model rates are negotiable between photographer and model and on whatever the model earns the agent draws commission.

The agent's job

If you are not known to the agent, whose job it is to protect the model, you may be asked to pay in advance of the modeling assignment and to provide references of your good character. Do not be offended by this; it is a sign that the agent is doing his job conscientiously. When the model is not available, the agent is also responsible for confirming details of the assignment, such as the use to which you intend putting the pictures, travel arrangements and all the practical considerations surrounding the session. A friendly relationship with an agent can be mutually beneficial. He is certain to have new models on his books who need portraits for their portfolios. If you have talent to offer he may suggest that you photograph one or more of his models free in return for a selection of pictures, which must, of course, be to the model's specifications.

Assessing a model

Payment

One small help you can give the agent is to inform him of the amount paid to the model. This makes it simple for him to collect his commission. Do not be tempted by an unscrupulous model who suggests that though you made your first contact with her through an agent you should subsequently contact her direct, without his knowledge, and thus help her avoid paying commission. In the long run, this will only ruin your own reputation in the trade as a whole.

One of the inducements you can offer a model is to suggest that she is paid at the time of the photography, for she will probably be more inclined to work with you if she is certain of immediate payment rather than having to wait until some weeks after the session.

Travel and other arrangements

If your model has to reach you by public transportation, the traveling arrangements must be understood between you. Ideally, the instructions should be passed to the model in writing, with a telephone number which she may call if any problems arise. You must also tell her how much she will need for fares, for which you will, of course, reimburse her. Provide her with a list of accessories to be brought. Remember that a professional model may have other engagements to follow yours, unless you are hiring her for an entire day. It is thus imperative that you are ready to begin the session when she arrives and that you finish at an agreed time to enable her to reach her next assignment on time.

A word of warning

If you are an inexperienced photographer of nudes, there is a danger in using a professional model for you may find that she has more confidence and knowledge than you. In my experience, such confidence is often the result of her frequently working in a style that you may not necessarily wish to follow. In other words, she may be in the habit of posing in certain predictable and obvious ways, which can make it difficult for you to create pictures which reflect your style.

Whether you choose a professional model or an amateur for your first shooting session, it is vital that the session should be a pleasant social experience as well as photographically successful. The model should leave you as a friend, with a feeling of achievement in having made good pictures with you. Ideally, she should be paid immediately the session is completed. Human conflict is sometimes unavoidable, of course, but if you can create a friendly, relaxed atmosphere you will not be short of models for long.

The following list of hints, which has been drawn up to help you make a success of your first session, are general in nature and cannot make allowance for different people's individual situations. It may seem that the items on the list are a matter of common sense and the ordinary courtesies of a considerate host. It is certainly true that they will quickly become second nature to you, but at your first session, with so many technical problems to resolve, it is easy to disregard inadvertantly your model's sensibilities. A short check list may therefore be helpful.

Go to some trouble to welcome your model. If she has not been to your studio room before, take some time to show her around. Make sure that there is somewhere private for her to change and provide her with a shelf for her cosmetics, a chair, a mirror with a light and a box of tissues. You should also make sure that there is a convenient electrical socket for any hair appliances.

It is essential to be well prepared with ideas, some of which must already be set up. Placing lights, loading your camera and all the other time-consuming preliminaries must be arranged in advance to keep delays to the minimum. As a general rule, always start with a simple shot where success is virtually guaranteed. If, once the model is nude, you discover inadequacies previously unsuspected, a discreet rearrangement of your shooting plans may be necessary.

Remember to photograph a generous number of non-nude pictures that you can later give her, making sure that they are in the style she wants. Modeling is tiring work, so allow her plenty of breaks from

The ideal model ▷
There is no such thing as a perfect model. Most models, however, have some qualities with which you can make good pictures.

Height
For nude modeling, height is not critical provided the body is well proportioned.

Face
When assessing a model's face, do not forget that there is no need to take your pictures head on. A good profile is just as valuable as a good full face.

Neck
A long, thin neck is desirable but the lack of it does not make a model unusable. It is important not to let her hunch her shoulders, so shortening the neck further.

Bust
Perfect bust size is, of course, a matter of taste but overlarge breasts can all too easily dominate your pictures. Firmness rather than size is more important.

Waist
A small waist is best in a nude model but remember that its appearance in a picture will depend on its proportion in relation to the breadth of the hips and shoulders.

Hands
Long, fine bones in the hands are a great asset for they help you draw the lines of the figure more cleanly.

Hips
In a professional fashion model, large hips are difficult to disguise but in nude modeling they can be given a Rubenesque allure.

Thighs
Perfect thighs for a nude model reduce continually from the hips to the knees with no bulging in the middle section, but this is a quality seldom found.

Legs
The longer and thinner the better in nude photography. With good legs and good skin you can make excellent pictures even if none of the other factors is perfect.

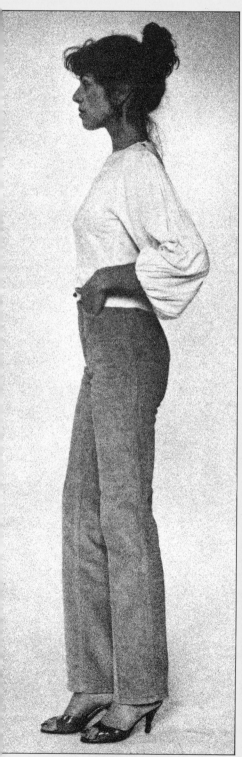

shooting and offer her frequent but always sincere encouragement and praise.

Try to give the impression that the session is going well, even if you have doubts, and create an atmosphere of a rising tempo of achievement as the session progresses. Always end on a high note and never try to squeeze in one last, quick shot. By the end of the assignment the model will be tired and you less inventive. After the photography, try to arrange a meeting with the model so that you can discuss results with her.

Finally, and perhaps most important of all, remember that the shooting session was a business arrangement between you and, while it is pleasant and helpful to be on friendly terms with your model, she is entitled to be treated with consideration and respect. Over-familiarity on your part will only discourage her from working with you again.

Model test ▽
I am sometimes uncertain if a potential model is photogenic or not. To determine this, I ask her to allow me to take a series of pictures which show her in different outfits and from a variety of angles in changing light. These pictures, which I make quickly in black and white, give me all the information I need to assess her strong points and reveal any which I would do well to avoid in a future shooting session.

Organizing a session

To achieve a successful day's shooting with a model largely depends on efficient planning and organization in advance. Ideally, you should have a planning meeting with the model some days beforehand. Make sure you have your location selected and have worked out the main pictures, so that this meeting enables you to discuss clothes and props (some of which the model may be providing herself) and gives the model a chance to discuss her hair and make-up for each shot. The meeting can also provide the opportunity to reach agreement on the terms of the deal — fees, rights and hours of work — and to ensure that she knows the travel arrangements you have made.

Organizing travel plans is not the photographer's only responsibility. In addition to providing most, if not all, of the props and clothes and all the photographic equipment necessary, he must also provide refreshment and such domestic comforts as clean towels and make-up mirrors as well as some form of shelter on the location.

On the day of the session I try to spend at least two hours organizing my pictures before the model arrives. When she does, I have a further discussion with her so that she has some idea of what we plan to do in the course of the session. This is never time wasted. On the other hand, an unpunctual model can be a source of frustrating delay, as can one who travels to the shoot in tight clothing that leaves marks on the skin which take time to fade.

The rest of the session
It is important to give the day a balance of easy pictures to start with, then progressing to more difficult shots as the model gains confidence. Allow plenty of time for relaxing breaks for her between shots and it will help to bring about a pleasant relationship if you take extra film for some portraits, possibly not nude, which you can give to her later.

The ideal postscript to a successful day is to meet the model a week or so later and project the best pictures for her. Have the reject pictures to hand as well, in case she wants to learn by her mistakes — or perhaps point out some of yours. It is at this projection meeting that some models prefer to complete the formalities of signing model releases, for having seen the pictures and found them decent they will then have the confidence to do so.

Efficient planning and briefing avoids mishaps and helps to start the day on a harmonious note. Harmony is essential to a successful shooting session, for few good pictures come out of an unhappy atmosphere. It is solely the photographer's task to create a happy mood in a group.

Practical check list
A smoothly run shooting session depends on attention to a mass of detail, making it impossible to memorize all the points for which you and your helpers are responsible. By using lists it becomes clear who is accepting which responsibility and whether those responsibilities have been discharged. A check list, to which you can add from time to time, enables you to concentrate on the picture planning and merely take a quick look at the list to check all the details before you leave.

Interior location

On planning a shoot or visit, check:

Mains voltage
Plug types
Fuse loading

Privacy from neighbors; if poor, take nets

Wall, ceiling colors. Take white sheets, if necessary

Heating controls and fuel

Sounds: tape etc

Daylight timing position

Arrange permission to use props already in location

Exterior location

On planning a shoot or visit, check:

Accessibility

Transport

Privacy

Trespass

Changing facilities

Toilets

Weather cover

Daylight timing position

Insects

Animals

Studio

Before booking studio, be sure to check who is responsible for:

Blown bulbs in their lamps

Torn or used background paper

Accidental damage to equipment

It is also useful to know about:

Studio timing

Can you run over the booked time and, if so, are there penalities?

Who sweeps up and cleans dressing room and studio?

The shooting schedule

A nude photography session is a complex affair, which may depend for its success on a number of people. All of them — model, assistant, stylist — need to understand exactly the routine to be followed at the shoot and must also be sure who is responsible for each detail of the organization and planning. This schedule therefore itemizes the aims and timing of the day and lists everything which must be assembled before and on the day to avoid time-wasting confusion.

Location	Beach Clubhouse, Deban River, Suffolk Telephone: 123 4567
Model	Marilyn Phillips Agent: Phil Cape. Telephone: 234 5678 Model fee: Standard day rate to include all rights in all pictures Booked: 8:30 am to 5:30 pm (start and end on location)
Accessories arranged	Model's own make-up, hair and beach jewelery
Travel	Unit to leave studio at 6:30 am Vehicle: VW Golf Passengers: MB (photographer), SL (camera assistant), MP (model)
Lunch	Bushmay Inn Booked: 12:45. Telephone: 345 6789

 Camera equipment

Nikon and Bronica bag

Normal film stock bag plus extra b/w fast film and Polaroid

Large accessories box

Two extra blocks for low level stand base

Small stepladder

 Lights

Two super pups

All stands

All long leads

Color acetates

Roll of Roscoe scrim

 Props and clothes

String hammock

Rope

Cushions

Lace slips

White headscarf

Skipping-rope

Sunglasses

Starting to photograph

I am always tense before shooting and most of the models I work with take at least an hour or so to settle down. I therefore suggest that you plan the start of your session with psychological factors in the forefront of your mind. For instance, your model will be encouraged if her first pictures involve using a pretty dress or wrap which you have obtained for the photographs. Remember that lively action pictures at the beginning of a session help to dispel tension for you both. Your generous praise for her work at this time is most valuable.

A session will go better if your planning is meticulous but open-ended. You can then take advantage of chance developments in the session without continually worrying about fixed time commitments and the fulfilment of your schedule. Limiting the use of unfamiliar equipment or untried techniques on a session will also help to relax you, as will the inclusion of some simple, easy-to-shoot pictures during the day's work.

Making the session run smoothly

Photographic technology is boring to most people and you must master your technique so that it becomes second nature to you and enables you to chat happily to the model while you are in fact thinking of the countless technical details that help make good pictures. That is not to say that you cannot involve an intelligent model in the picture-making process. The Polaroid camera is ideal for this purpose, but a big plastic mirror will suffice. The mirror can also help you to teach the model those little touches of skill which you should have picked up by looking at other people's pictures. For instance, in a full length shot, by turning her foot toward the camera and not showing the heel, the model can seemingly lengthen her leg. Another element of the photographer's role as a teacher is to show his subject how modeling can be a mixture of acting, dancing and personal fantasy. Helping your model to create the mood you seek to record will always be more profitable than merely asking her to smile and look happy.

The camera club

Photographic societies and camera clubs exist in many cities and large towns and are also sometimes found in association with offices and other places of work.

The purpose of the camera club
Their facilities and aims vary enormously. Some have no permanent meeting place but make do with the temporary use of shared accommodation, while others have their own meeting and exhibition facilities, darkrooms and sometimes one or two studios equipped with lights. These bigger clubs offer their studios to members at a modest hourly rent and frequently provide models at reduced fees. They may sometimes arrange programs of instructional evenings, when lectures are given by tutors in different aspects of photography, and usually offer good photographic libraries and magazine collections. Sometimes they possess slide collections, enabling you to examine the work of others. Finally, the better-run clubs may promote slide and print competitions, mount exhibitions and organize sessions for critical discussion.

There are a number of questions you should ask about a club's facilities before you decide to join. If the club does set up group shooting sessions and provides a model, it is important to know if there is a limit to the number of members taking part in each session. More than about six or seven photographers taking pictures in the same studio simultaneously renders the exercise valueless.

Private sessions in a club studio
Many clubs hire out their studios for private use and you may be tempted to take advantage of this facility. Before you do so, however, it is important to establish who is responsible for the costs which may be incurred. For instance, who pays for any unavoidable damage that you may cause, such as tungsten bulbs that blow out, and if there is seamless paper available in the studio you need to know if you are expected to pay for its use.

Club darkrooms
Some camera clubs have darkrooms which you can rent, usually by the hour.

Before you decide to take advantage of this, however, you must make certain what this arrangement entails. For example, it is essential to know whether the club provides chemicals, such as print developer, stop bath and fixer. You will normally be expected to provide your own photographic paper and small tools.

Studio sessions
Once you are a member of such a club, you will be entitled to take part in studio evenings, when a model is booked by the

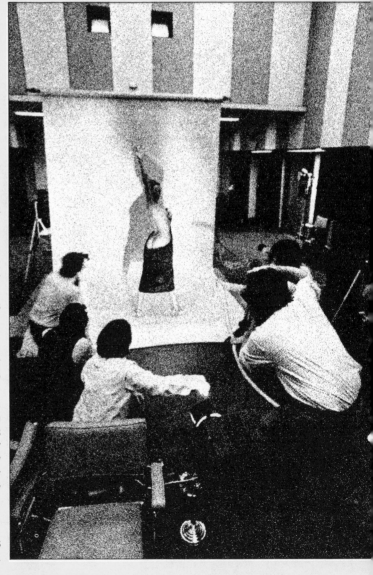

Cinema into studio ▽
The photography club of many large companies is the office cinema or conference room, converted for club evenings into a studio by the addition of seamless paper and tungsten lights. Nude photography sessions draw much support, as you will see from the member's picture below, and this club is fortunate in having a spacious setting.

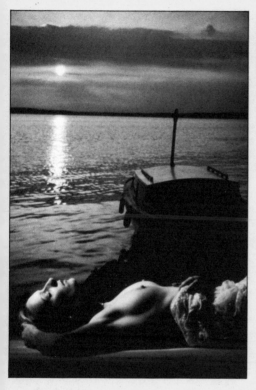

◁ **Enterprising club pictures**
A club member shot these pictures in color at a club session. The back projection shot (far left) was worked out with the help of the other members, who provided a slide projector and background slides. The shot on the left owes its success to its simple graphic qualities, which would not have been possible without the umbrella which the model brought with her.

club and paid for jointly by its members. This is one way to get started in nude photography, but it has its disadvantages.

The pros and cons of club membership
With a group of six or more people, all sharing the same model and lighting, there is inevitably unhelpful pushing and shoving for the best positions; moreover, your relationship with the model will necessarily be distant and this may inhibit your creativity.

On the positive side, however, you will be relieved of responsibility for lights and other equipment save your own camera and these sessions will enable you to study the work and methods of others. Often, of course, the models fall into the less-than-perfect category (see p 94) and the advice in that section should be followed. Sometimes these models can be hired privately and will do location work with you on your own.

The biggest drawback to joint photography sessions is that all too often little thought is given to advanced planning and organization. It follows that too much reliance is often placed on the model's instinctive poses and ideas and her overused supply of props. In such cases, it is worthwhile suggesting other locations and organizing trips yourself, for example to a fine house or to a park in summer. You may also find that greater emphasis is given in these clubs to technology and equipment than to that of making pictures. Nevertheless, a local club can provide you with a good beginning in nude photography, until such time as you have the confidence to move on to better, more independent work.

Starting your own club
If no club exists in your area, it is worth ascertaining how much support there might be for one. A small advertisement in a local newspaper, or a note on an office notice board, will probably bring an enthusiastic response from people with similar interests, with whom you can then discuss the possibility of joining together to form some sort of club.

Equipping your studio room

The ideal studio room, like the ideal model, does not exist. For example, if the room is big enough to enable you to take all the pictures you might ever wish to, it will be too big to heat economically and will certainly be too big to engender a pleasant, relaxed atmosphere. I believe a more important consideration is the quality of light in your studio room. A reasonably large window, or better still two, preferably looking out to open sky, provides an excellent source of light without too much loss of privacy. Ideally, the windows should be at right angles to each other, so that you can use one as your main light and the other as a back light, clip light, side light or fill in.

If you are not going to use daylight but artificial illumination, the color of the walls and the height of the ceiling are important. If color photography is your main interest, a white ceiling is then essential and ideally it should be at a height at least twice that of your model to give you the space to use your lights to maximum advantage.

The next most important requirement in a studio is plenty of built-in closets, where you can pack away all the non-technical items which I find essential to a nude photographer. You will also need shelf space for reflectors, props and lights.

It is helpful if your studio gives access to a room where the model can change. This might be a bathroom, but in any event it must have a mirror and a good make-up light. The model will also appreciate some sort of dressing table or shelf on which to put her make-up materials and a chair or stool for her to sit on. While she is both making-up and posing, pleasant music can create the right mood.

Minimum studio ▽
The conflicting needs of adequate working space and storage for equipment and props necessitate a dual design for a photographer's room. One plain white wall can serve as a projection screen, shooting background or big reflector. Furnishings, all chosen with an eye to prop value, are best kept to a minimum, while ample storage closets accommodate most of the equipment. Blinds can be used to control daylight and the photographer's best pictures can be displayed on the walls.

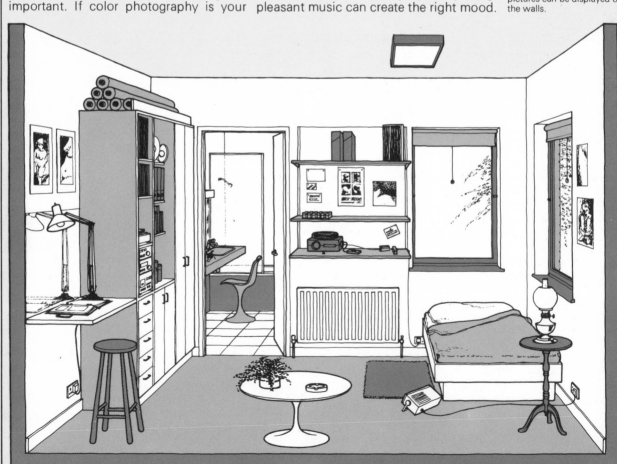

Equipping a studio

There is no limit to the amount of money that can be spent when equipping a studio for nude photography. Here are some of the simpler pieces of equipment which I have chosen as ideal for a club studio or for an advanced amateur.

I am fortunate in having two studios. My favorite is a large, specially built daylight studio room with a glass roof facing south and with sliding glass doors. It has no permanent equipment and sparce but carefully chosen furnishings.

I have equipment both to control and to produce light. Some old spots and floods and two or three plug-in flash packs are augmented with a wide range of reflectors, both black and white, mirrors, diffusers, barn doors, snoots, umbrellas and a home-made diffusion box (fish fryer).

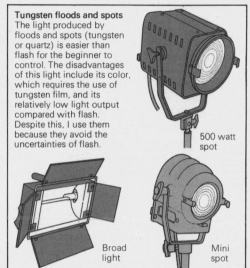

Tungsten floods and spots
The light produced by floods and spots (tungsten or quartz) is easier than flash for the beginner to control. The disadvantages of this light include its color, which requires the use of tungsten film, and its relatively low light output compared with flash. Despite this, I use them because they avoid the uncertainties of flash.

500 watt spot

Broad light

Mini spot

Flash equipment
But for the inability of the human eye to assess the quality of flash light, this would be the only light for me. As it is, one needs a flash meter and, for critical work, a Polaroid back will be a substitute for any amount of experience. I use a combined flash head and power pack with controls to vary the flash and the light intensity independently.

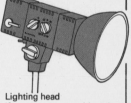

Lighting head
If you use a motor drive, the re-charging rate of the power pack must keep up with your shooting speed.

Honeycomb spot and filters

The honeycomb, a recent development, channels the light into a spot-type beam.

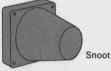

Snoot

A simple form of control, but less efficient than the honeycomb, to give a spotlight effect.

Barn doors

Adjustment of the flaps can produce any shape of light.

Soft screen

Most artificial lights are hard and any means of softening this is valuable.

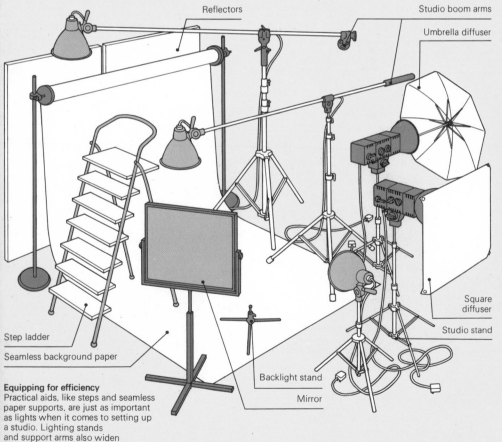

Reflectors

Studio boom arms

Umbrella diffuser

Step ladder

Seamless background paper

Backlight stand

Mirror

Square diffuser

Studio stand

Equipping for efficiency
Practical aids, like steps and seamless paper supports, are just as important as lights when it comes to setting up a studio. Lighting stands and support arms also widen the range of effects.

Creative editing

The editing of photographs is not an incidental chore to be undertaken in a spare moment some time or other after the shooting. A nude shooting assignment is not complete for me until I have carefully edited all the pictures and decided what is going to happen to each. Nude photographs in particular are in need of careful selection, for important but delicate questions of taste can sometimes be decided only when the photographer examines his pictures critically.

Editing color transparencies

Editing your pictures will teach you much, for your failures will not be repeated if you analyze them carefully and identify the cause of failure. Similarly, successful pictures need to be scrutinized, frame by frame, to discover what caused their success. For this reason, I instruct the color laboratory not to mount my films. I ask them to give them to me uncut and I then assess them minutely with a good magnifier on a lightbox before mounting. I study the frames in the same order as the edge numbering on the roll, looking for what I was trying to achieve in each picture. Some photographers write notes or refer to their original notes at this stage.

Working my way through the pictures slowly, I assess the results of my various ideas and different technical approaches. I draw generalized conclusions about the session under the following headings: Did I achieve my goal and, if not, why not? Did the model work well? Was the location ideal? Did the session cover a wide enough range and produce a sufficient diversity of pictures? Are there one or more potential star pictures in the set? Was the technical level high, the exposure bracket correct and the color balance as I wanted it to be? Has the laboratory produced clean film, free of scratches? Lastly, I check the character of the color film to assess its performance and also its suitability for the task.

Having made this general assessment of the whole session in its uncut form, I take a grease pencil and mark the edge of all the acceptable frames for mounting in cardboard mounts. At the beginning of the film on the acetate sleeve I write the total number of frames that I have marked in the roll, to ensure that none is missed when the film is mounted. The question of what level of acceptability to choose is difficult, for photographers have different needs and standards. If I did not have

◁ **Aids to editing**
If you work on small format film, as I do, your editing must be conscientious. A home-made light box (left), with bright daylight fluorescent tubes under flashed opal glass set flush in the bench, is useful and you must use the best magnifier you can afford. I keep cardboard mounts in various sizes in drawers, together with grease pencils, scissors, envelopes and other essentials. My combined magnifier and viewing light over the bench is useful for critical examination of the contact sheet. The shooting record book is kept up to date as pictures are chosen. If your transparencies are already mounted, the stack loading 35 mm viewer (above) is a convenient way of making a preliminary selection of the best pictures from the set.

Editing in easy stages

1 Uncut film from processing laboratory.

2 Sort film into shooting order.

3 Examine and assess for faults and successes by magnifier.

4 Decide sorting scheme. Label boxes for sorting.

5 Mark down edge of useful frames with grease pencil.

6 Cut up and mount creatively. Put all reject pictures aside for future clearance.

7 View all mounted slides carefully and allocate to file boxes.

8 Discard rejects after second viewing later.

◁ **Comparing pictures**
When a large number of mounted transparencies have to be edited, I use a stack loading projector in tandem with a magazine projector. I run a set of similar pictures quickly through the stack loader and I then transfer the slide I like best to the magazine. Then, with this picture permanently on the screen, I again run all the others in the stack loader to verify, by comparison, the accuracy of the choice.

commitments to others, I would put most of my pictures in a garbage can but we all have somebody who wants to see or have copies of our pictures. Certainly you may wish to give pictures to the model and "thank you" pictures to someone who has lent you a prop; possibly, too, you will need transparencies for a club competition. You will, of course, want to keep your very best in a file. To make sure that all these needs are met, I suggest you take a set of empty plastic boxes and write on them the heading under which you are going to sort the pictures after they have been mounted — for example, "Model give aways", "Thank you pictures", "Club competition". "Best set" and so on. I also watch out for odd frames which I call "Idea pictures" and put them in a separate box. These are shots which may not be completely successful but have some quality or hint of an idea which might be adapted for use at another time. In addition, I also look for pictures which do not work in the way I intended but which have areas of image within the frame that I could later use for duping.

Editing by projection

All this sorting into boxes is done from a lightbox or projector after the transparencies have been mounted and carefully viewed. For a big editing involving large numbers of transparencies, I work with two projectors, a stack loader and a magazine. The pictures are run through the stack loader fairly quickly and I choose what I think is the best frame, transfer it to the magazine and then re-run the material from which the best frame was chosen with the selected picture projected at the same time. In this way, the best can be instantly compared with the rest as they are side by side on the screen in front of me. When I am sure that all the best pictures are edited into boxes and sheets, I keep one reject transparency to help me illustrate my entry in the log book. Keeping a record of all the sessions that you undertake may be tedious but is worth the time and effort.

Do not throw away rejected transparencies immediately. I seal mine in an envelope, writing on it the name of the model and the date of the session. A month or two later, when I have a spare hour or so, I have a thorough clean out. By this time my first excitement with the pictures has abated and I can re-examine the rejected material before it is discarded. My view of the pictures can change and I sometimes find successes which I missed at the first editing. Unfortunately, the photographer is often not the best person to choose his pictures for his view of the shots can be subjective. He is often looking for pictures which fulfil his original plan and which show the successful achievement of his intention. But in fact, good pictures can also be the result of the unexpected and you must watch out for this in editing, as you did when shooting. I like to edit with a friend whose judgment I trust. I find that such a person will often alert me to qualities in some pictures which I was not seeking but which may have merit. In editing, as when shooting, always keep an open mind and catch the happy accidents with which most photography abounds.

Presentation

Black and white editing

Color negative and black and white editing are enjoyable because there is an element of craftsmanship in the task. A transparency is a relatively final statement of the quality of the shot but negatives and contacts are a half way mark from which you can go in many directions, using all the tricks and skills of the darkroom to achieve exciting and often unexpected results. Basic equipment for black and white editing is similar to that for color work, comprising the best magnifier you can get hold of and a good light to view the contact sheet. Mark your pictures with a grease pencil or a felt tip pen, preferably in blue or black because red, orange and yellow become invisible under the safelights of the darkroom. I like to make my contacts on glossy paper for maximum clarity and before I examine them I write up the log book and insert the strips of negatives into a loose-leaf filing book. However carefully you examine contacts from small negatives, there are often surprises when you enlarge and I suggest that from the pictures that you prefer you make a postcard-sized enlargement, which I call a guide print, to assess the qualities of the picture. Write technical notes and information on the back, which will simplify matters when you make a final print on bigger paper.

The information given earlier about transparency editing applies in part to negative and contact editing and similar systems can be organized.

◁ **Picture storage**
Good pictures deserve proper storage. Hanging plastic wallets with stand-up identification tabs, in a file drawer, makes a dust-proof and attractive way both to file and to show your transparencies. For black and white, I suggest you file your negatives and contacts in opposite sides of a loose-leaf file book, which can be numbered to match your negative index.

Having found a suitable model, organized a successful shooting session and carefully edited and chosen your pictures, it is equally important to show your pictures with the same care. The praise and encouragement that well-presented pictures will bring from your friends will stimulate you to try even harder and keep you going through the bad patches that inevitably come to all photographers. The basic rule of presentation is to choose your pictures carefully and never show those you do not like. Destroy your failures and do not bore your friends with them.

Showing your prints

When showing prints, be sure that you cut down the number that you are going to display and that they are carefully spotted and retouched (see right) before mounting. You can mount your prints in a book, which can be either of the plastic sleeve variety where the pictures are slipped in behind translucent plastic covers (these have the advantage of being quick and easy to use but they take away some of the quality of a print), or you can use the more complicated system of mounting your pictures in ring binders on cardboard mounts. Alternatively, if you have mounting facilities, choose cardboard of a color appropriate to the picture you wish to show. Spot the prints with great care, possibly adding your signature and a date to the mount. Then either pin these to a wall or, if the pictures are good enough, use a frame and glass to hang them for permanent display.

Do not be reluctant to spend time and energy on the presentation of your work. It is not until a picture is either hanging on a wall or in a well organized book that you really get a feeling of what you have achieved and how you are progressing toward a professional standard.

Slide presentation

If you prefer to keep your work in slide form, as I do, it is worth organizing a slide tray of your best pictures which you can show to your friends from time to time. I believe it is worth treating these projection sessions with a certain formality. Limit the number of pictures that you put

Simple retouching

Blemishes on prints cannot always be avoided but they can be removed with the right tools. For this you need a sharp scalpel, spotting medium and very fine sable brushes.

Using a scalpel
To remove blemishes, gently scrape the emulsion from the print surface. It is also possible to lighten tones.

Spotting
With a fine brush apply spotting medium of the correct thickness and color. Always start with the darkest areas.

Corner

Non-reflective glass

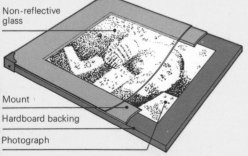

Mount

Hardboard backing

Photograph

Mounting prints
Prints can be mounted wet with appropriate glue, dry with dry-mounting tissue or with spray mount.

Dry mounting
To dry-mount prints, use tissue coated on each side with a shellac-like material which melts with heat. One side sticks to the mount and the other to the print. A domestic iron can be used although proper tacking irons and presses are available.

1 Clean the mounting cardboard and print.

2 Attach tissue to print back with tacking iron.

3 Trim tissue to fit print.

4 Secure corners of tissue to mounting cardboard.

5 Use hot press to fasten print to cardboard.

Spray mounting
Some adhesives suitable for photographic mounting are available in aerosol form. You simply spray lightly over the back of the print, lower the print on to the mount and allow it to dry under gentle pressure.

◁ **Framing prints**
You can make your own frame out of any suitable material. The simplest is passepartout, which just binds together the mounted print, a mat (if necessary) and a sheet of glass on all four sides. Wooden moldings or metal extrusions for frames must have a suitable cross section and be of sufficient strength.

into the presentation, make sure that they are the correct way round and free from dust, and choose a running order for them which makes sense and will enable you to talk about them intelligently during projection. To this end it is necessary for you to have a couple of private rehearsals, making sure that all runs smoothly. Appropriate music can be a helpful addition to a presentation and I like to bring a touch of theatricality to the entertainment by arranging seats in advance. If you can obtain a dimmer switch, so that the lights can be softened for the show, you will have done all that you possibly can to sharpen your guests' enjoyment of your picture show.

If you become really enthusiastic about slide presentation, the sky is the limit. For example, two- or three-projector shows, possibly using more than one screen with synchronized sound and images dissolving and shifting from screen to screen, can produce highly effective results.

If you are a beginner, all these schemes may seem far from your simple, tentative nude pictures. It is only if you develop a sense of value in your work, however, that you can expect other people to take your efforts seriously. You will often find that friends press you to show pictures that are not successful. You should resist this and be definite in your own assessment of what is a success and what is not, showing only those pictures in which you have real faith. It is sometimes hard when people have helped you by contributing their time and effort, but only by doing this can you create standards from which you can progress to better pictures as time goes by.

Professional considerations

To say that the business of making and selling professional nude photographs is competitive is indeed an understatement. Automatic cameras are becoming easier to use every day and publishing and advertising companies are coming to accept the technical adequacy of the 35 mm transparency. These technological simplifications have led more and more young people to take up photography.

Selling your pictures

The good nude material you see published in reputable photographic magazines, books and calendars usually comes from one of two sources. Either the material is commissioned by a publisher, who pays the photographer a fee and expenses, or the publisher goes to a stock photograph library where the pictures that he needs may be held on file. There he will choose a number of pictures from different contributing photographers to fill his pages.

Commissioned work

The accepted route to getting commissioned work is to prepare a portfolio of your best pictures. These should match the style of, say, the magazine you wish to work for but hopefully be better in quality and idea content than those which have hitherto been used in it. By persistent pressure you may, if you are lucky, get this portfolio in front of the art director of the publication and if your work is outstanding he may take your name and address. Then, if one of his regular photographers is unavailable, you may be given a chance. Most art directors, however, are under constant pressure from would-be photographers and illustrators who want to work for them, while those photographers who are already established go to great efforts to maintain and even improve the quality of their work so that they will not be replaced by newcomers.

The stock picture library

On the stock picture side the situation is not very different. If you own complete copyright and have a signed model release form for good nude photographs of originality and style, you may be able to interest a stock library in putting them on

their files to await a prospective purchaser. But nude pictures have a long life and a library has probably been collecting them for a decade or more, so that your photographs will be in competition with the world's best, collected over the years.

Remuneration

With these pressures building up on both sides of the market, it is not surprising that page rates (that is, the fee paid for the use of a picture by space) are not moving forward at a pace to match inflation. The only photographers whose work sells on a large scale are those who are either endlessly energetic or who have a sharply original but widely applicable style.

Models' rights and releases

Whether you pay your model a fee or not, she still owns the image of herself on film until you have acquired the rights to it from her. When negotiating this, you would be advised to use a standard model release form, as provided by the Photographers' Association in your own country. The often complex wording of this document in fact merely states that in return for paying the model a specified sum for posing on a certain day, she releases to the photographer the right to sell or otherwise dispose of the photographs referred to in any way he wishes. A copy of this document is sometimes

Perfect presentation △
You should prepare a portfolio of your work if you intend seeking professional assignments from magazine or advertising art directors. A portfolio usually takes the form of a large loose-leaf book or case in which carefully prepared and presented samples of your best work are simply mounted to give a clear impression of your style and talent. By using individual plastic coated mounts or alternatively the loose-leaf system (above), individual pictures can be added or removed from the presentation to match the need of your potential client. I try to avoid showing mounted 35 mm transpariencies on a light box. They must be projected to do them justice.

demanded by buyers of photographs to protect themselves against all possible claims by the model. Some models prefer not to sign the model release form until they have seen the pictures and know them to be decent. Others may choose to exclude from the release specific uses for the pictures, such as display on billboards. Yet others may ask you to delete some territorial areas from the release. These and other exclusions cause obvious problems and should be avoided if possible.

Photographer's copyright

Once you have a release form, the pictures are available for sale unless there is any doubt as to your ownership of them. This can occur if the photographs were made at somebody else's request or in return for a fee. Ensure, therefore, that you are the sole owner of the pictures before attempting to negotiate sales. If there is any remaining doubt, you must get signed papers to establish your ownership.

If you are satisfied that the photographs are yours and are fully released to you, you can then attempt to sell or lease them to anyone in your own country or elsewhere. This is done country by country, and you must keep careful records of what rights you have sold in each area.

Public liability

Public liability bears no differently upon a photographer than someone involved in any other activity. If you cause an accident to a member of the public, he can make a claim against you. Where necessary, protection from a claim can be obtained if you take out the appropriate insurance. This insurance can also be extended to protect you from other misfortunes.

Public decency

The subtleties surrounding the law on decency are complex and it is difficult to take out policies against possible infringement. However, if you are always sensitive to the views and privacy of other people, your photography will be unlikely to offend. Be especially careful, however, to acquaint yourself with local customs and laws before you start work, as these vary greatly from country to country.

Today's automated cameras can, in skilled hands, take marvelous pictures under most conditions. Abnormal pictures can often come from normal conditions and from stretching the photographic rules to the limit. The serious worker will have a strong background knowledge of the practical physics and chemistry that are the scientific foundations of modern photography. It is unnecessary to commit all the facts to memory, but a basic understanding is valuable and the ability to put your hands on the required information instantly will always save time while a good picture might otherwise slip from your grasp.

I recommend that you carry a small notebook containing technical information. Record in it the oddities of your equipment. For instance, I have found that my 300 mm lens is about one stop faster than the marked aperture and this has to be allowed for when shooting. To notes such as this, I suggest you add your version of some of the chart information on these pages, ready to help you when you are shooting under difficult conditions.

Color temperature ▷
The color temperature of your light source will influence the appearance of the final image. Color temperature is measured in Kelvins. This chart shows the color temperatures of the most common light sources. Daylight films are designed for color temperatures between 5200K and 5800K. This is the color temperature of average daylight in central latitudes. Special films, balanced for 3200K to 3400K, are available for use with tungsten lighting.

Inverse square law ▽
To keep exposure constant while allowing for the inverse square law, the aperture size must be increased by 1 stop every time the distance between the light source and the subject is doubled.

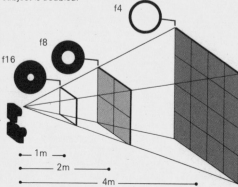

Kelvins (× 1000)

Key
□ Artificial light
■ Natural light

□ Household candle

2 —

□ Oil lamp

□ 25–50w bulb

□ 100–200w bulb

3 —
□ Projector lamp
□ Spotlight
□ Tungsten halogen
□ Over-run floodlight

□ Fluorescent tube
■ Moonlight
4 — □ Clear flash bulb

5 — ■ Daylight (high latitudes)

□ Electronic flash
■ Standard daylight (based on mean noon sunlight in Washington DC)
6 —
■ Cloudless sky, bright sunshine

■ Average American daylight

7 —

■ Noon daylight, overcast sky

8 —

■ North light, blue sky

9 —

Index

Acknowledgments

A photographer of the nude cannot make his pictures alone and I am dependent on help from many people.

First, I should like to thank my wife, Pam, who cheerfully copes with the disruptions to family life caused by my work. She also looks after my pictures meticulously, so that I can always find those I need quickly.

Many models have been involved in the production of this book and I am grateful to them for their patience and help. I am especially grateful to my assistant, Steven Lott, who has worked on the project from the beginning.

I have been fortunate in having the help of Bill Rowlinson and Gene Nocon, who printed my pictures beautifully, and Juliette John, whose subtle black and white retouching enhances so many of these pages.

I must also express my gratitude to Jackie Douglas, who guided me through the minefield of illustrated publishing, and Roger Bristow, without whose inspiration many of these pictures would not have been conceived.

I am also indebted to the following people: Camilla Costello, for her help with props; Susan Griggs and her staff for their help and co-operation; Nigel Parry of the Esso Camera Club for allowing me to use his pictures (pp 156–157), and Christina Saunders for hairdressing and make-up (pp 118–119, 142–145).

Some of my pictures were made on assignments and my thanks are due to Avon Tyres, Ben Sayers Golf Clubs, Bridgestone Tyres, GAF Films and Mintex Brake Linings.

Dorling Kindersley would like to thank the following people and organizations for their help in producing this book:
Ron Bagley
F. E. Burman Ltd
CETA Colour Laboratories
Teresa Cross
Headliners
Leaderline Artists Ltd
A. Mondadori
MS Filmsetting Ltd
Negs Photographic Services Ltd
The Photographers' Workshop
Telegraph Sunday Magazine
For design and illustrations:
David Ashby
Polly Dawes
Jackson Day Design
Sue Wilks